# Dancing at the Louvre

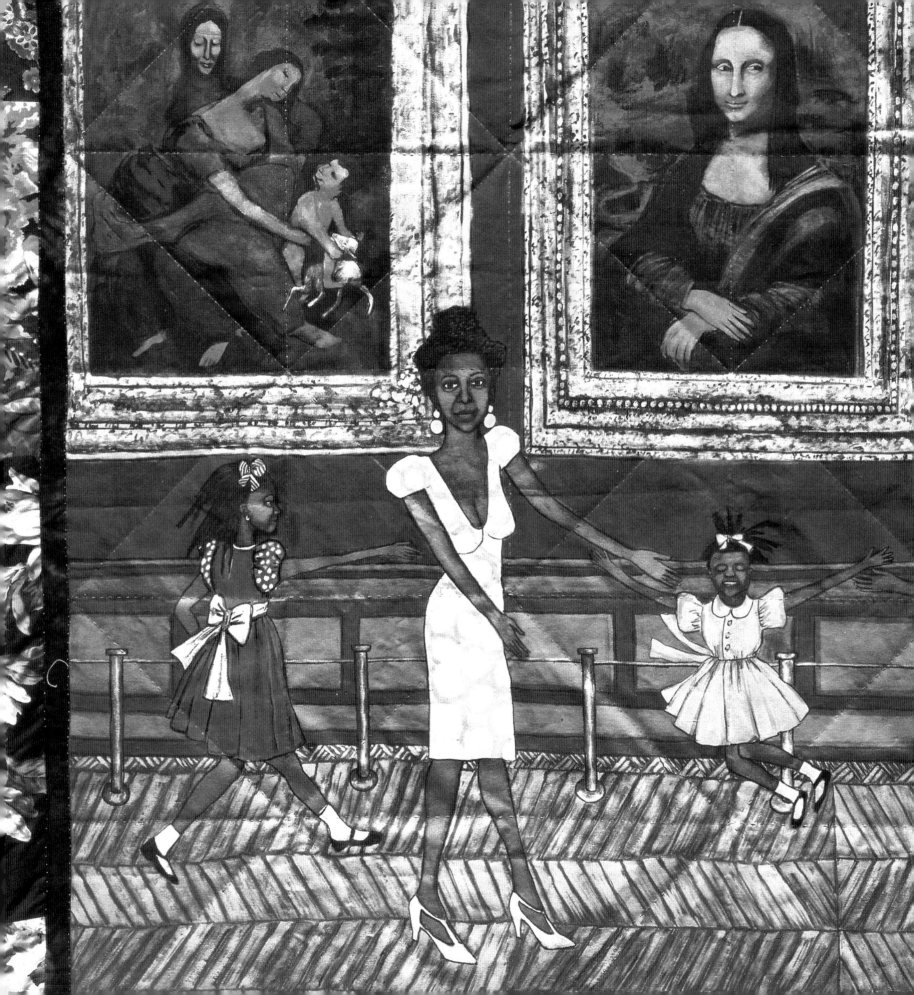

# Dancing at the Louvre

Faith Ringgold's

French Collection

and Other

Story Quilts

Dan Cameron,

Richard J. Powell,

Michele Wallace,

Patrick Hill,

Thalia Gouma-Peterson,

Moira Roth,

and Ann Gibson

NEW MUSEUM OF CONTEMPORARY ART

New York

UNIVERSITY OF CALIFORNIA PRESS

Berkeley    Los Angeles    London

Dancing at the Louvre:
Faith Ringgold's
French Collection
and Other Story Quilts

EXHIBITION

organized by Dan Cameron

NEW MUSEUM OF CONTEMPORARY ART

New Museum of Contemporary Art
583 Broadway, New York, NY 10012

*Curator:*
Dan Cameron
*Exhibition Supervision:*
John Hatfield
*Exhibition Coordinator:*
Melanie Franklin
*Installation Coordinator:*
Tom Bromley
*Programs Coordinator:*
Raina Lampkins-Fielder
*Tour Management:*
Melanie Franklin, John Hatfield

CATALOG
*Editor:*
Dan Cameron
*Project Director:*
Melanie Franklin
*Design & Production:*
Seventeenth Street Studios
*Copy Editors:*
Tim Yohn and Sue Heinemann

PROJECT SPONSORS

AT&T

John S. and James L. Knight Foundation
Richard Florsheim Art Fund
Andy Warhol Foundation for the Visual Arts

"Faith Ringgold's *Picasso's Studio*" by Ann Gibson. Copyright © 1996, The University of Chicago Press. Reprinted by permission of the publisher.

"*The French Collection:* Momma Jones, Mommy Fay, and Me" by Michele Wallace. Copyright © 1997, Michele Wallace.

"Quilt Stories: A Selection" by Faith Ringgold. Copyright © 1991, 1997, Faith Ringgold.

Chronology for Faith Ringgold from *We Flew over the Bridge* by Faith Ringgold. Copyright © 1995 by Faith Ringgold. By permission of Little, Brown and Company.

University of California Press
Berkeley and Los Angeles, California

University of California Press, Ltd.

© 1998 by The Regents of
the University of California

Library of Congress Cataloging-in-Publication Data

Dancing at the Louvre : Faith Ringgold's French collection and other story quilts / Dan Cameron . . . [et al.] ; the New Museum of Contemporary Art, New York.
    p.    cm.
    Catalog of an exhibition to be held at the Akron Art Museum and five other museums between Jan. 24, 1998 and October 10, 1999.
    Includes bibliographic references and index.
    ISBN 0-520-21429-3 (alk. paper)
    ISBN 0-520-21430-7 (pbk. :alk. paper)
    1. Ringgold, Faith—Exhibitions.  2. Afro-American quilts—Exhibitions.  I. Cameron, Dan. II. New Museum of Contemporary Art (New York, N.Y.)  III. Akron Art Museum.
    NK9198.R56A4   1998
    746.46'092—dc21                    97-31079
                                                     CIP

Printed in Canada

9  8  7  6  5  4  3  2  1

# Contents

Akron Art Museum, Akron, Ohio:
*January 24–March 22, 1998*

Berkeley Art Museum and Pacific Film Archive,
Berkeley, California:
*May 13–August 31, 1998*

New Museum of Contemporary Art,
New York, New York:
*September 30–December 20, 1998*

The Baltimore Museum of Art,
Baltimore, Maryland:
*January 27–April 11, 1999*

Fort Wayne Museum of Art,
Fort Wayne, Indiana:
*April 30–June 27, 1999*

Chicago Cultural Center,
Chicago, Illinois:
*August 7–October 10, 1999*

# Acknowledgments

BECAUSE FAITH RINGGOLD'S contribution to American art is so broadly based, one of the most frequent occurrences in organizing an exhibition of her work is the startling recognition that her influence and the trace of her ideas can be found practically everywhere. From storyteller to feminist, from historical revisionist to painter, she shows that creative expression is meaningless unless it is accompanied by a journey deep into the self, and her story quilts stand as colorful proof that no part of life is too personal or political, too trivial or fantastic, to become transformed into an inspiring work of art. For this reason, the New Museum's greatest debt of thanks is owed to Faith Ringgold herself, for both her endlessly inspiring oeuvre and her generous temperament.

This exhibition could not have taken place without the considerate support of those foundations which have chosen to recognize contemporary art as the field where some of the most lasting achievements of the human spirit prevail. These patrons include the AT&T Foundation, the John S. and James L. Knight Foundation, the Richard Florsheim Art Fund, and the Andy Warhol Foundation for the Visual Arts. We are also indebted to those museums and individual lenders to the New Museum who have graciously parted with cherished treasures to help make this project a success. Although these lenders are listed elsewhere, certain individuals who helped arrange the loans deserve special thanks: Jeffrey Bergen of ACA Galleries, Madeline Murphy Raab, and Judith Stein.

The New Museum is honored to be collaborating with several major U.S. art museums on the tour of "Dancing at the Louvre," and we want to express our appreciation to the directors of these institutions, as well as the registrars, curators, and other staff members who have worked on the exhibition. The opportunity to copublish the catalog with the University of California Press has provided the New Museum with an opportunity to reach far more readers than would have been possible otherwise. We are particularly grateful to its director, James Clark, for all his efforts in making it happen. In this spirit, we would also like to extend our deepest thanks to the catalog authors for their insights into Faith Ringgold's work and their cheerful acceptance of the tight deadlines.

My colleagues at the New Museum have been particularly unstinting in their support of this project from its inception, and I would especially like to recognize Marcia Tucker, the director; Charlayne Haynes, the managing director; and Dennis Szakacs, the director of planning and development, for their invaluable guidance and collaboration. Melanie Franklin, the curatorial administrator, has once more proven, this time through the expert organization of both the tour and the catalog production, that her energy and organizational skills are essential ingredients in the success of the New Museum's programs. The patience and meticulousness of John Hatfield, the exhibition director, in arranging loans and budgets; the innovative merchandising plans of Amy Chen, director of finance and administration; and the inspired public programming initiatives of Claudia Hernandez and Raina Lampkins-Fielder in the Education Department have made organizing this exhibition a special pleasure. Last but not least, special thanks to intern Yukie Kamiya for her careful assistance and research, as well as to Grace Welty, Faith Ringgold's assistant, for her constant solicitude and good humor.

—DAN CAMERON
Senior Curator

THERE ARE SO MANY people to thank for this catalog, the accompanying exhibition, and all the good things that have come to me at this sweet time of my life. I cannot begin to thank everyone, so I will just mention those who are directly involved with this wonderful book and the exhibition of my work curated by Dan Cameron at the New Museum. Thank you. Thank you. Thank you. All of you.

Now to make some very special remarks about some very special people. When I first met Marcia Tucker, I never dreamed that some twenty-seven years later she would be the director of the New Museum, one of the most innovative contemporary fine art museums in America, and that I would be having a show there. And when Dan Cameron first told me about the proposed show of my work at the New Museum I was hardly prepared for the in-depth treatment my work would receive and the exhibition's exciting travel itinerary to other art museums across the country. Distinguished art historians, critics, and curators—Moira Roth, my daughter Michele Wallace, Thalia Gouma-Peterson, Ann Gibson, Patrick Hill, Rick Powell, Dan Cameron, and Marcia Tucker—have written generously and brilliantly about my work for this book,

and I am enormously delighted, even though I will now need a hat two sizes larger or more.

My dealers, Sydney, Jeff, and Dorian Bergen, are just what all artists need to face the world. Makaela, Conner, Julie, Michael, and all the others at the ACA Galleries could not be more helpful to me. My many collectors, both public and private, who have unselfishly agreed to loan pieces for this two-year traveling show, are to be especially thanked. I'm glad they like my work and will miss having it around. My quilter's assistants, Connie Haile, Leanne Pierce, and Sandi Braccey, who did such a good job of completing the hand-quilting on the current *American Collection,* "saved my life"—if you know what I mean.

Looking back, I must thank Denise Mumm and Gail Liebig, good friends who worked with me on *The French Collection*. And Melanie Franklin, of the New Museum, who kept our communication on texts and pictures moving beautifully. And Grace Welty, my assistant, who has been on the case every step of the way, from the beginning to the end, and has never missed a beat. And last, but first of all, my darling husband, Burdette Ringgold, who helps me always and hinders me never.

—FAITH RINGGOLD

# Foreword

FAITH IS A FORCE. Her incredible intellect, her outspoken and articulate public voice, her opulent physical presence, and her inimitable smile have cut a wide swath through an impossible thicket of "no's" and landed her, triumphant and at the height of her powers, before an enormous, cheering crowd. Her work is a stunning visual History of Histories—her own, her family's, that of the African American artist in the United States and abroad, of social activism and feminism in the New York art world of the late 1960s and early 1970s, and the history of historical omission by virtue of race and gender, anywhere and everywhere.

The tools she has used from early on (overlooked or misunderstood in those days) have become the favored methods of today's artistic avant-garde, although they are rarely marshaled with Faith's unique blend of chutzpah, energy, and skill. They are, in no sensible order:

- keen wit, a sense of play (fair or otherwise), satire and self-satire, irony, mischievousness, and plain old fun.

- collaboration (with her mother, her daughters, other artists—in fact anyone who could be enlisted for the cause at hand). I know this from personal experience. In the early 1970s I was part of Faith's merry band "Art Without Walls," a group of "art workers" who trekked out to the women's prison on Riker's Island to teach courses in mask making, theater, poetry, and my own feminist specialty, consciousness-raising, called "career counseling" for funding purposes.

- a liberal use of the vernacular—your regular, everyday, ordinary old experience—transformed so that most folks can find something wonderful in common with the art that she makes.

- a tendency to upset apple carts. Faith makes quilts, dolls, costumes, drawings, and children's books with equal care and enthusiasm, giving the lie to the idea that artists should be consistent, specialize in a single medium, and stay away from anything too closely associated with "women's work." In her hands, dismantling the hierarchy that places fine arts above crafts goes a long way toward showing up the social hierarchies that set up this distinction in the first place.

- dancing, instead of maintaining a respectful silence, at the great Western temples of culture—or anywhere, for that matter, where the protocol says, "You may NOT…." After all, culture belongs to each and every one of us, right? And we're allowed to delight in it any way we'd like.

We're proud to present "Dancing at the Louvre" at the New Museum, and to be able to send it to other institutions that also feel that Faith's work, like Faith, is a force to be shared, enjoyed, learned from, and reckoned with.

—MARCIA TUCKER
Director

Richard J. Powell

## Introduction

### Faith Ringgold's French Connection

I N FAITH RINGGOLD'S recently published memoir, *We Flew over the Bridge*, there is a black-and-white photograph of the artist that I find compelling. Taken in New York City in 1970, on the occasion of the infamous "People's Flag Show," it presents Faith Ringgold flanked by two other artists, Jon Hendricks and Jean Toche. While Hendricks and Toche exchange words, Ringgold sits coolly between them. The busy patterns on her raincoat and dress seem the complete emotional opposite of her detached attitude and quiet, pensive manner. With her eyes lowered, her lips sealed, her purse tightly clutched, and her body language conveying disregard for empty "art talk," Ringgold seems to communicate her disdain not only for the absurdity of that particular moment but also for the superficiality and, at times, the futility of art protest.

The Faith Ringgold in this 1970 photograph is a far different Faith Ringgold from the one we have come to know over the years. Ask the average art critic about the aura that surrounds Faith Ringgold, and what you're most likely to hear are the buzzwords *politics, protest, black power, feminism.* Yet, if you were to take the sum of Ringgold's words and deeds and to line up all of the paintings, sculptures, textile works, books, and performances she has created, what you would have before you is an extraordinary range, all growing out of a vast reservoir of intellectual, emotional, and social concerns. Perhaps what we can see in the 1970 photograph of Ringgold is someone at the center of controversy who thinks critically and deeply about her life in art: reflections that, as seen in Ringgold's multi-paneled series *The French Collection,* touch on the truths and mythologies of modernism.

The truths Faith Ringgold visually plies us with are (1) that women and men of African descent significantly figure in matters of art and art history, and (2) that audiences are

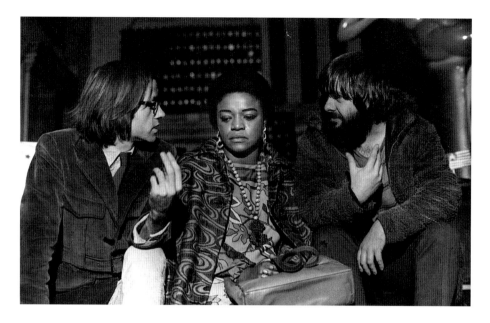

position—which allows the center to be dominated by a nude Willia Marie and the painted products of an artistic collaboration—suggests that the genesis of French modernism is female subjectivity, and its development is akin to an interracial (or intercultural) liaison.

Of course, a major part of the allure of *The French Collection* is Faith Ringgold's license. Ringgold is an adept creator of fictional characters and impossible encounters; she mixes the actual with the improbable to revise life scripts under her painted and pieced guidance. Whether it's the story of an eight-year-old girl flying over New York City's George Washington Bridge or a missive featuring Matisse's Chapel as the setting for an African American wake and gathering of the elders, Ringgold's myths underscore the capacity of the storyteller to control the language, images, and very structure of the narrative. In *The French Collection* Ringgold recalls two of her artistic predecessors in the modern Francophone art scene: "Le Douanier" Henri Rousseau and, closer to the present, the Haitian master Philomé Obin. In the works of all three, what one sees is a universe where, through the expressive details of nature and an all-encompassing, panoramic representation of society, artists transmit the iconographic, sensorial, and magical dimensions of the world(s) in which we all live. Ringgold's *Wedding on the Seine* (1991), like Rousseau's *View of the Bridge at Sevres* (1908) and Obin's *Crucifixion of Charlemagne Péralte for Freedom* (1970), transforms a seldom seen side of reality into a fantastic apparition, reminding viewers that the strangeness and extraordinariness of an everyday existence are in the discerning eye of a bold and unfurled imagination: an inner vision that is just as likely to emerge from a trained artist from Harlem as from a French or Haitian artistic "outsider."

The "magic realist" dimensions of Ringgold's *French Collection* also resonate with select works by another New York City–based artist: William Henry Johnson (1901–70). In the dozens of paintings that form Johnson's *Fighters for Freedom* series (c. 1944–46), the artist's steadfast focus is on historic and episodic portraiture—the lynching of a rebellious slave, a massive grouping of early-nineteenth-century abolitionists, or the historic 1943 meeting of world leaders. This focus is revisited by Ringgold almost fifty years later. In *The French Collection,* picnics, quilting bees, dinner parties, and outdoor cafes become Ringgold's sites for celebrity-saturated extravaganzas. Renderings of prominent African American women like Sojourner Truth,

capable of embracing not only an elitist, museum-sanctioned "high art" but also a "people's art" that knows no class boundaries or social distinctions. Pictorial narratives that employ pieced, painted, and dyed fabrics—reminiscent of nineteenth-century quilts yet firmly situated in late-twentieth-century aesthetics and art practices—provide the basis for Ringgold's forays into these historical and cultural facts.

Ringgold reminds us throughout *The French Collection* that France and the immortal city of Paris—the spiritual "home" of modern art—were also the sources for a modern identity among many African American artists. In the black artistic consciousness—for artists at the turn of the twentieth century, such as Henry Ossawa Tanner and Meta Vaux Warrick Fuller, as well as for more contemporary figures like the novelist James Baldwin and Ringgold herself—Paris has loomed as an Eden for those who would otherwise perish in America's cultural tundras. Ringgold's vision of French society—for the most part a positive image of tolerance, yet admitting dehumanizing acts of racism and sexism—shows how African Americans found France a hospitable environment, although one where racial and cultural differences frequently operated as charms (or fetishes). In two of the panels from the series, Ringgold's African American female protagonist, Willia Marie Simone, serves as model and muse to Henri Matisse and Pablo Picasso, France's twin deities of modern art. Yet the placement of these two art giants on the periphery of the com-

Madame C. J. Walker, Zora Neale Hurston, Rosa Parks, and Faith Ringgold miraculously appear alongside such legendary figures as Vincent van Gogh, Henri de Toulouse-Lautrec, Ernest Hemingway, William H. Johnson, Romare Bearden, and others. As in Johnson's *Fighters for Freedom* series, Ringgold's willful juxtapositions of famous European artists with equally famous Americans—black, white, artistic, and activist—suggest that African Americans played an intrinsic part in Western cultural enterprises. That Ringgold's historic couplings, like Johnson's, are not entirely whimsical, but rather based on real affinities and shared experiences, is part of the unspoken power of these paintings.

Another aspect of the unspoken power of *The French Collection* resides in each painting's pieced fabric border. Tie-dyed, floral, and chromatically coordinated with the fantastic paintings that they frame, Ringgold's borders bring to mind the raincoat and dress on the chic African American woman sitting between Jon Hendricks and Jean Toche in the 1970 photograph.

If I could have "read" this photograph (and Faith Ringgold's mind) in 1970, and if I had known *then* what I know *now* about her, I would have connected her haute couture manner with her first transatlantic trip to France, with her mother, Willi Posey, and her daughters, Barbara and Michele, in tow, all dressed to the nines. I would have understood the subtle yet fundamental connections between a life lived in proud, stylish elegance, Ringgold's artistic rediscovery of fabric in the early 1970s, and a career of eternal struggles and triumphs. I would have been privy to the psychedelic waves in her wardrobe and art, and an eyewitness to the events that led up to Willia Marie tossing a "flower power" bouquet into the Seine. And I might have suspected that *even* in the midst of a 1970 art protest, there was enough high fashion and French crinoline and black satin in this woman to survive the infamous New York Tombs, not to mention the anticipated spells of racism and sexism in the art world. Indeed, this 1970 photograph of a fashionable Faith Ringgold foreshadows the truths, myths, and beauty of *The French Collection.*

Dan Cameron

## Living History

Faith Ringgold's
Rendezvous with
the Twentieth
Century

HE GRADUAL TRANSITION from the postconceptual strategies of "pure" appropriation adopted by artists in the late 1970s and early 1980s to the working through of unresolved sociocultural issues that serves as one of the prevailing artistic modes of the 1990s marks one of the least-noticed yet all-pervasive changes in the making of art in the United States today. Without this perspective, one might see the present selection of Faith Ringgold's *French Collection,* displayed with several story quilts that have preceded and followed this series, as simply a curatorial attempt to develop a fitting context for breakthrough work by a major American artist. From the broader standpoint of artistic relevance, however, this project, like its subject, aspires to a somewhat higher goal. As a self-contained narrative summarizing one artist's relationship to the main artistic developments associated with Paris from 1895 to 1925, *The French Collection* is one of the most imaginative efforts in American art to reconcile the critical inquiry that drove appropriation with the revisionist approaches to history that have prevailed over the past decade. Of even greater significance, however, is the argument that *The French Collection* places Ringgold's art squarely and somewhat unexpectedly at the center of artistic discourse in the United States at the precise moment when the aspiration toward a truly global art community and the need to address the dilemmas left behind by history are no longer mutually exclusive forces. Perhaps even more to the point, it seems increasingly likely that an artist can no longer work toward one without actively engaging the other.

Appropriation was arguably the most vexing critical problem raised by American art in the 1980s. Following a series of rumbles that began with the Whitney Museum's "Art about Art" exhibition in 1978 and the appearance of photographic strategies of appropriation in the work of such younger artists as Sarah Charlesworth, Sherrie

*5*

Levine, and Richard Prince, the Duchampian tactic of "borrowing" past works of art was quickly adopted by aspiring painters and sculptors, who saw in it a last vestige of the avant-garde's much-vaunted capacity for shocking its public. In response to postmodernism's lure and by comparison with the concurrent wave of European painters who favored primitivist or neo-fauve styles, certain American artists sought to extend Marcel Duchamp's and Andy Warhol's assault on the status of the unique handmade object as well as to challenge orthodox approaches to the stylistic and cultural dialogue between European and American art. History in the form of quotation or pastiche became a conceptual tool for artists working to further loosen modernism's grip on contemporary art's capacity for self-invention. The result, which might be broadly described as the lessened influence of most hierarchical models for setting artistic limits and priorities, had the added benefit of rapidly opening up the field of historical inquiry to incorporate an array of sources and combinations that, because of the twentieth century's unwavering attention to the new, had never been welcomed into modernism's lexicon.

By the end of the 1980s, a new set of concerns entered the art world's frame of reference, dealing less with the trace of modernism's past in art's present than with broader questions of cultural representation that arose once the links between authorship and representation fell under increased scrutiny. This shift was not so much a replacement of one set of hierarchies for another as it was the result of a gradual evolution of the information system linking the art world: once the problem of cultural context had made itself felt through acts of appropriation, the expression of this concern moved away from a direct plundering of known sources for one's work toward challenging previously held assumptions about American art's relationship to historical European models of taste. A broad base of artists whose work challenges cultural orthodoxy in terms of race, ethnicity, gender, and sexuality began to lead the national dialogue on theory and practice, and in so doing they have enabled that discourse to metamorphose into its current manifestation: a kind of global network of local substructures, in which the most radical practice in one corner of the world may suddenly assume mainstream proportions in another, with barely a pause for breath in between. The notion of a collective body of experience circulating around the world in the form of distinct local

struggles against the homogenization of culture is the solution that the present moment is offering for the problems of culturally specific representation within a global information structure.

Within this new equation, the role of historical narrative has shifted considerably during the past ten years. Because of the gradual emergence of a more conceptually based model for referring to the past, and because appropriation led the way to accepting historical inquiry as a legitimate tool for creating culturally specific representations, artists working in the United States today no longer feel constrained by the previously established academic approach to research into earlier epochs. As the pluralistic notion of multiple histories has replaced the monolithic idea of a single history, artists have begun rummaging through the historical dustbin for indications of how the constraints of the more recent past worked to preserve an unacknowledged exclusivity in the way that historical precedents have been articulated and applied to the present. Particularly among artists from previously underrecognized communities, the urgent push to open up the past to current artistic investigation indicates the need to draw attention to the identity politics reflected in the collecting and exhibition policies of museums and other cultural institutions, and while doing so to point to ways in which this often exclusionary focus can be broadened to reflect more accurately the history and concerns of various audiences.

As Faith Ringgold herself has acknowledged, the seeds for this program of historical revision were planted relatively early in the twentieth century. While *The American Collection* series, on which she is currently at work, contains iconographic references to the work of older African American artists such as Aaron Douglas and William H. Johnson, its most relevant source is Jacob Lawrence's *Toussaint L'Ouverture* series, painted in 1937–38 to commemorate the life of one of the central figures in the Haitian struggle for independence.[1] Lawrence himself has stressed that he embarked on this series because he believed his community suffered from the lack of historical material relating to the African experience in America: "I didn't do it just as an historical thing, but because I believe these things tie up with the Negro today."[2] Ringgold also credits Lawrence for inspiring her to work pictorially in series, beginning in 1988 with her five-part series *The Bitter Nest*.[3] According to her, the sequential format not only lends itself easily to history-based research by emulating the chapter form of a book,

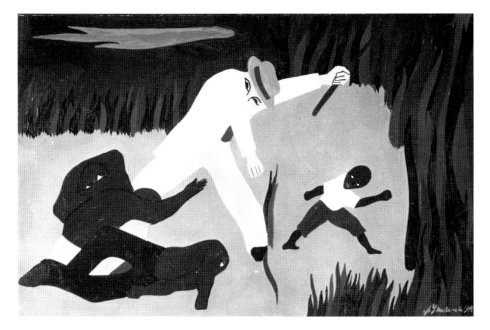

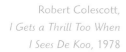

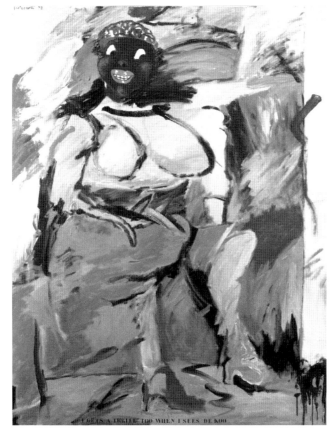

Jacob Lawrence,
*Toussaint L'Ouverture
Series, No. 7
("As a child, Toussaint
heard the twang of the
planter's whip and saw
blood stream from the
bodies of the slaves."),*
1937–38

Tempera on paper, 11 x 19"
Collection of The Amistad
Research Center, Tulane
University, New Orleans.
Courtesy of the artist
and the Francine Seders
Gallery, Seattle
Photo: Chris Eden

Robert Colescott,
*I Gets a Thrill Too When
I Sees De Koo,* 1978

Acrylic on canvas, 78 x 66"
Collection Rose Art Museum,
Brandeis University, Waltham,
Massachusetts, gift of Senator
and Mrs. William Bradley

but it also enables her to take on weighty issues without the pressure of having to say everything in a single painting.

Other artists of Ringgold's generation and later have embraced historical imagery as well, but with markedly different intentions and results. Robert Colescott emerged as a pioneer in this area with the swirl of controversy that greeted his 1975 painting *George Washington Carver Crossing the Delaware,* a work that gave form, albeit ironic, to Colescott's frustration at the way U.S. history was taught.[4] By reformulating the famous Emanuel Leutze composition so that one of the precious few celebrated black figures in modern American history is seen leading an assortment of cooks, Jemimas, cotton pickers, and vaudeville musicians to a rendezvous with destiny, Colescott makes the viewer uncomfortably aware that the names and faces of the true heroes in the resistance to slavery and its aftermath have been all but lost to a contemporary viewing public.[5] This strategy of using parody to draw the viewer's attention to a gap in history becomes more focused on contemporary myths of art history in paintings like *I Gets a Thrill Too When I Sees De Koo* (1978), in which Colescott substitutes a stereotyped Jemima face, with the requisite red kerchief tied around the head, for Willem de Kooning's anonymous female subject. Colescott's intention here is not to denigrate the accomplishments of abstract expressionism, but to call attention to the notion of absence and anonymity in de Kooning's female subject, which in turn raises the question of what broader cultural context may have existed for this act of erasure in the pre–civil rights 1950s.

Within the past decade, a number of African American artists have gained increasing critical and curatorial attention for addressing issues of historical representation with a wit and directness noticeably absent from the original formula for appropriation. Taken collectively, their work presents a new framework for considering the implications of *The French Collection,* especially in relation to Ringgold's more explicitly political art from the late 1960s and 1970s. One example of how boundaries between biographical fact and fiction are carefully crossed and recrossed occurs in Lorraine O'Grady's *Miscegenated Family History* series, through which, since the early 1980s, the artist has explored issues of lost or unresolved genealogies as they pertain to her own sense of identification with other cultures.[6] Glenn Ligon's 1993 series of runaway slave handbills, which incorporate textual descriptions of the artist as viewed by others, constructs this history-based nightmare

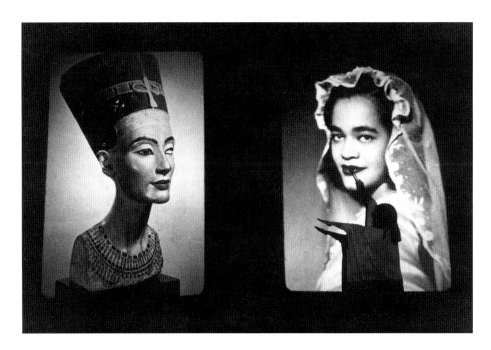

**R**AN AWAY, Glenn. He is black. He has very short hair and eye glasses. He has quite light skin tone (faded bronze). Not tall. No noticeable accent. Wearing a plum-colored shirt, long-sleeved, and shorts. Very casual and stylish in appearance. He is wearing a bead bracelet (stones – a mixture of black-and-white). He has big hands and fingers. When he walks his feet cross each other a little bit. When he talks, he usually has a big smile towards you, yet he faces you from a slightly different angle. He looks at you from the corner of his eyes. His voice is very calm.

within the context of a body of work in which metaphors of visibility point obliquely to the issue of race. In Fred Wilson's celebrated *Mining the Museum* project of 1992–93, the artist sifted through the storage areas of the Maryland Historical Society in Baltimore for artifacts from the slavery and early emancipation eras and then presented his findings to the public in a temporarily rearranged permanent collection, providing an abrupt and deeply unsettling visual confrontation with a previously concealed history. Even Kara Walker's cut-paper silhouettes depicting elaborate fantasies of interracial violence and debauchery, which at first glance might seem aesthetic opposites to Ringgold's story quilts, share the goal of reconstructing the narrative of history from the perspective of someone who is clearly dissatisfied with the officially sanctioned versions.

The national artistic discourse has shifted so profoundly over the past several years that at present we find ourselves "discovering" Faith Ringgold's work at the forefront of arguably the most challenging and transformative developments in contemporary American art. As one can actually read between the lines in *The French Collection,* art history and history in the broader sense have finally caught up with Faith Ringgold, an artist who has been repeatedly marginalized: first, for creating politically based work in the 1960s and early 1970s; then, for making autobiographical work reflecting her experiences as an African American artist born in the wake of the Harlem Renaissance, whose artistic maturity occurred in the midst of the civil rights and women's movement eras; still later, for privileging such media as quilting and doll making over more conventional painting and sculpting techniques; and last but not least, for having developed a large and devoted following, mostly outside of what is generally understood to be the art world.

Not unlike her near-contemporary Andy Warhol, Ringgold possesses a particular genius for transforming the narrative of her personal development into a form of popular myth. Her gift may not have won her fans in the rigidly conceptual wings of the appropriation movement, but Ringgold has more than compensated for this lack of support through her achievement as an author, especially of children's books, during the past ten years. Two noteworthy characteristics of these books are their formal and conceptual continuity with the rest of Ringgold's art and their remarkable capacity for stirring the reader's empathy. The narrative voice in books like *Tar Beach* and *Aunt Harriet's*

*Story Quilt.*[7] In this 1986 work, we are drawn into every step of the artist's crisis: first, as a woman who wants to feel good about herself; second, as someone struggling to get her body to conform to cultural norms of beauty; third, as a person whose intelligence and political sensitivity allow her to see all the inherent contradictions in her position; and finally, as the artist who is inspired to transform the whole dilemma into an artwork. By the time Faith at last takes the weight off, it is clear to her viewers that even this accomplishment has been robbed of its pleasure, since we have moved, with the artist, through the torturous thoughts and actions behind this loaded topic.

A narrative of epic dimensions, *The French Collection* functions as a meditation on the individual's relation to history, granting as much importance to what may have happened as to what surely did or did not. In the most direct and literal sense, it is a tribute to Ringgold's mother, Willi Posey. A dressmaker and designer, Willi Posey was able to visit Europe only in her later years, but she could have almost doubled as Willia Marie Simone, the Atlanta-born protagonist of the twelve story quilts, who goes to Paris at age sixteen in the 1920s and leads a life that no African American woman artist could have dreamed of having at the time. Not only does Willia Marie meet all the artistic and literary luminaries of the day, pose for Picasso, and attend Josephine Baker's birthday party, but she actually "makes a name for herself in the modern art movement" and eventually retires from art-making as the owner of an artists' cafe.[8]

Examining *The French Collection* as a series, one senses that Ringgold's ambitions for the project grew while she worked on it: the first story quilt, *Dancing at the Louvre*, tells of a spontaneous moment of youthful rebelliousness, and one of the last works, *Le Cafe des Artistes*, highlights Willia Marie's maturity by incorporating "A Proclamation of the Colored Woman's Art and Politics," complete with a "prediction" of what the rest of the twentieth century might be like for aspiring women artists of color. In between these two story quilts, the fictional narrative frequently gives way to the author's attempts to confront and overcome the effects of racism: *Matisse's Chapel*, for example, depicts the deceased members of Ringgold's own family gathered together in front of the famous stained-glass windows, while Willia Marie's letter relates a true hair-raising story about slavery passed down from Ringgold's own great-grandmother.[9]

Because the thin line in *The French Collection* between fiction and historical narrative is constantly being blurred, our

*Underground Railroad in the Sky* is instantly recognizable as Ringgold's own, and much of their impact comes from the author's ingenuity in inviting young readers to visualize the world through the eyes of an artist. They can be compared both to Ringgold's performance art of the 1980s, in which the artist's personal struggles were the subject matter, and to her story quilts, in which storytelling is central. Even when it remains largely fictional, the story Ringgold is telling is invariably her own, and her personal link to the histories explored by her work connects her recent pieces, especially *The French Collection,* to earlier quilts like *Change: Faith Ringgold's Over 100 Pounds Weight Loss Performance*

In the 1970's food was a feminist issue and you were a fat feminist. Always looking for a quasi-politically correct reason to eat. And of course you found plenty of them. In the sixties it was being a wife and mother the rejection of being a black artist and other oppressions. In the seventies it was all that and being a woman too.

1970-1970

You didn't have to eat over that. You didn't solve anything by having two dinners at one meal, and don't blame anybody. You used to say Your husband, Burdette, made you eat so that no one else would look at you. And then You didn't look at you either. You used to say you never served leftovers because your family hated them. Your family never saw anything they left over. You'd eat it up while you were washing the dishes. You were so embarassed that day when you entered a mid-town restaurant eating cookies. "I'll be back," the waiter said, "when you finish eating."

Remember the time you showed up at a benefit exhibition for some tight political candidate? You posed with her not realizing you held a greasy bag of nuts. She slapped you on your hand and ordered you to "put that away." At that moment You had the attention of several news media. You could have made the front page and the Nightly News that day "Fat Woman Gors Nuts," but you smiled, wiped your mouth, and put your nuts out of sight. Your clothes were no Longer fashionable or fun, but a cover-up. One day you forgot to cover your knees from the early cold. You had pain in your knees so bad you could hardly walk. The pain travelled to your so that you had to crawl twisted and winding to the doctor's office. "Your weight," he said, "doctors are not at telling you to lose weight and how much to pay the nurse. What they don't tell you is—how?

*Detail from*
*Change: Faith Ringgold's*
*Over 100 Pounds*
*Weight Loss Performance*
*Story Quilt, 1986*

relationship to the work's subject matter keeps shifting. Some of Ringgold's fusions, like *The Sunflowers Quilting Bee at Arles*, seem perfectly whimsical at first glance, until one begins to pick out some of the work's more submerged connections. The first layer, which is not at all hidden, concerns the identity of the eight historically significant women who are "piecing" together the quilt: Sojourner Truth, Madame Walker, Rosa Parks, Mary McLeod Bethune, and others. They have been called together, the narrative tells us, by Aunt Melissa to produce a quilt that will serve as a "symbol of their dedication to change the world." The other, half-concealed purpose for their visit seems to be to boost Willia Marie's own flagging spirits and challenge her to look toward her tradition for support, especially as she lives so far away from home. At one point the discussion turns to quilting, which is described as "what we did after a hard day's work in the fields to keep our sanity and our beds warm and bring beauty into our lives." As we become drawn into an origin myth concerning the work in front of us, Ringgold's powerful argument for tradition resonates with an additional significance: namely, that the American quilt tradition may have played as seminal a role in the growth of a characteristically American late-twentieth-century sensibility as van Gogh's mythic sunflowers within the development of modern European painting.

Behind the apparently triumphalist narrative of *The French Collection* that is its primary source of appeal, several other subtexts appear frequently enough to give us a clear indication that all is not as inspirational as it seems. The symbolic yet passionate rejection of European culture that opens the series—cavorting in front of the Mona Lisa, hurling a traditional wedding bouquet into the Seine—soon collides with another tug-of-war for the artist's conflicting loyalties, from the women's movement *(The Picnic at Giverny)* and the courageous African American women. In this light, as Michele Wallace points out,[10] it is intriguing that the sixth story quilt, *Matisse's Chapel*, in which the sublime beauty of the site cannot be separated from the burden of loss in the narrative, is framed by two quilts in which the ostensible content is the black female body caught within the gaze of the male European artist. That, in Ringgold's version of the story, Willia Marie has posed for Matisse and later Picasso (she is the anonymous African model in *Les Demoiselles d'Avignon*) underlines her growing transformation from a passive object of beauty into a responsive subject with the need to direct the narrative from her own point of view. By flipping the white male gaze back on itself in order to mirror certain implicitly racist assumptions of the modern era, Ringgold accomplishes in a single pictorial glimpse what feminist art historians have struggled to do for a generation, and she prods the Western canon's critical drive into tackling its own history of unacknowledged exploitation and oppression, to see if it can analyze and grow from its previous moral vacuity as profitably as it deconstructs space, form, and color.

The redirection of this deflected male gaze can be traced through the remaining quilts in the series. With *On the Beach at St. Tropez,* the controlling gaze is clearly Willia Marie's, languid but sure as it takes in the skimpily clad male (and occasionally female) bathers showing off in the surf, while Willia Marie relates her need for independence to her son, who has been raised by his great-aunt in Georgia. In *Jo Baker's Birthday*, the power of the gaze belongs once more to the subject, who, although seductively dressed and reclining luxuriously on a divan, makes it clear through her body language that she is in complete control of all she surveys. The organization of the world according to protofeminist principles becomes even more explicit in *Dinner at Gertrude Stein's*, where the presence of expatriate writers conforms to an atmosphere of statelessness in keeping with Stein's and Alice B. Toklas's sense of having been

displaced in the modern world. This movement away from the need to place one's body at the disposal of powerful men's desires and toward the shaping of a world in one's own image parallels the underlying psychological narrative in *The French Collection,* in which the protagonist ends her journey of self-realization by literally becoming her own subject—or, in the example of *Le Cafe des Artistes*, opening a business that offers other artists and writers a refuge from the intolerance of the world outside.

It is telling that *The French Collection* ends and *The American Collection* begins with the same focal point: Africa. Whereas *Moroccan Holiday* caps the theme of European culture's imperialist attitudes toward Africa, *We Came to America*, the first story quilt in *The American Collection*, summarizes in one terrifying image the perils and hardships that most black Americans' ancestors faced just to arrive physically intact on these shores. The painting shows New York harbor with an African Statue of Liberty standing guard over the waters, while hundreds of bodies fight against the treacherous waters and a slave ship burns on the horizon. The overwhelming tragedy of seeing so many struggling figures who have come so far, only to perish at the threshold of a new country, is somewhat mediated by the composition's focus on one young girl who has been swept up in Liberty's arms and saved.

We are now quite far, in terms of narrative direction, from the saga of Willia Marie Simone making her way in Paris. Yet the fact that *The American Collection* was produced after *The French Collection,* while tracing an earlier chronology of historical events, affirms that the lives of Marlena and Willia Marie, however distinct, will mirror each other across parallel chapters in time. The main difference between the two series lies in the way they present the solution to overcoming history's painful legacy. Whereas Willia Marie's world is still circumscribed by events and personalities that belong to the "official" record of modern art, Marlene's variations on the past are charged by a more combustible mixture of social history and artistic legacy— as if she were so deeply involved in creating the paintings that will assure her place in history that she cannot separate her own heritage from the creative rewriting of it that is her particular genius.

By the third story quilt in the series, *Born in a Cotton Field*, it is clear that the edge of historical fantasy has long since been casually breached by the child-storyteller's imagination. In one sense, Ringgold has left the realm of modern art

entirely, relying instead on her particular gift for seeing things from a child's point of view. The dynamic is no less revisionist, however, insofar as the narrative works both to assuage the listener's sorrows—the girl Marlene is telling the quilt's story to soothe her frightened younger brother— and to supplant a known history with an unsuspected version. While the saintly deportment of the figures makes it clear that this is a retelling of the story of Jesus' birth, the presence of innumerable eyes peering out from the leaves places the tale squarely in the midst of the slavery era. The moment shown in the quilt becomes the one hopeful link in a chain of misery, sacrifice, and betrayal. For the second time, a child-messiah survives against extraordinary odds, suggesting that Ringgold sees the artistic vocation in terms of a religious calling, in which the artist's pain and that of others are transformed into a psychic guidebook dedicated to the survival of future generations.

As in *The French Collection,* Ringgold has set out to construct a tale of triumph over adversity, but in exploring the American consciousness she has become increasingly interested in the quality of her heroine's imagination: what kind of work is this artist making and why? A pair of story quilts at the heart of *The American Collection*'s odyssey of artistic reinvention brings us into the near-present by playing off the racial subtext that has often informed the charged relationship between high art and popular culture over the past fifty years. Like female impersonators who know they aren't fooling anyone, *Two Jemimas* and *Bessie's Blues* are based on diametrically opposed twentieth-century female subjects, Aunt Jemima and Bessie Smith, as rendered in formats that are clearly quoting, without attempting to copy, well-known paintings by Willem de Kooning and Andy Warhol.[11]

While Ringgold's use of appropriation may not play as conceptually inventive a role in these two works as it does in *The French Collection,* that is partly because the stakes are considerably different. The impact of slavery and racism permeates *The American Collection* with a quiet persistence that forces us to confront it as directly in its parodic mode as when it is being heroically challenged. The issue is central, for example, to *Wanted: Douglass, Tubman and Truth*, which memorializes a clandestine meeting between the three Underground Railroad leaders, a meeting that almost certainly never took place. In the more parodic *Two Jemimas*, Ringgold puts de Kooning's ingenious formula for pushing the figure into the foreground,

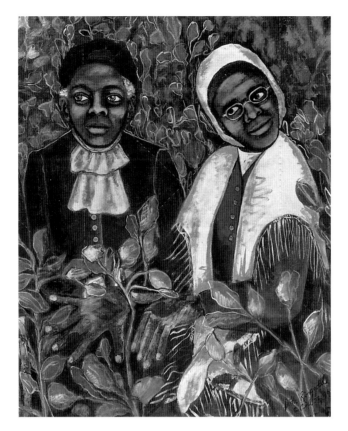

the shifting concerns of authorship and intent. Although both Bessie Smith and Marilyn Monroe died tragically before their time, Smith was a largely unknown talent whose greatness was only recognized posthumously, while Monroe was said to have been driven to suicide partly though the pressures of her fame. In representing Bessie Smith, Ringgold chooses not to duplicate Warhol's signature silkscreen technique; instead, she opts for a stenciled, masklike image with the singer's face in negative, coming closer in feeling to a woodcut than to anything photomechanically reproduced.

This almost ominous folksiness leads us back to Smith's legacy, where we can find iconographic clues to Ringgold's approach. As a blues singer, Bessie Smith drew directly from her own personal suffering to produce an art that has gone on to inspire leagues of musicians, but was largely overlooked by white audiences while she was alive.[12] By referring to Warhol's interpretation of Marilyn as a kind of tragic reflection of American popular culture, *Bessie's Blues* tacitly argues that racism is the key to Smith's tragedy, making her into a historical cipher whose profoundly expressive voice moves all who hear it, but whose face is familiar only to a few. From this perspective, Ringgold's bracketing of Bessie Smith and Aunt Jemima as cultural readymades acknowledges that the choices made by her artist-heroines (and, by implication, herself) are still heavily determined by historical and cultural circumstances out of their control.

Both *The French Collection* and *The American Collection* demonstrate the rich artistic possibilities that occur as forms and issues shift from their theoretical potential to a lived and felt reality. At this moment of American art history, when all established relations between the creative imagination and the weight of tradition are being subjected to an intensive review, Ringgold points to the potential for setting new paradigms for the future to take into account. History, she suggests, will always be with us, but our ability to fashion the past into a usable future is determined by whether we see it as something that has already taken place or as something that we are in the process of making. With her uniquely postmodern twist on history, autobiography, and her commitment to building a new world, Ringgold goes beyond stating that the past is doomed to be repeated by those who do not understand it, to ask: If we cannot position ourselves to see and translate history through our own present-day experience, then how do we envision the future that we are rushing so quickly to embrace?

while cropping it on the top, side, and bottom, to good use. Her crowded composition makes us share the physical discomfort of the two overweight, fully dressed women, who are even more distressed than we are at finding themselves jammed into the picture frame like commuters on a crowded subway car. Ringgold's parodic attack on the Jemima stereotype highlights how even as the image fades into the background of collective memory, it continues to mock the embodied dignity of generations of African American women—*Change: Faith Ringgold's Over 100 Pounds Weight Loss Performance Story Quilt* springs to mind here—and stands as a clear symbol of the racist past that Americans are still struggling to reconcile with their present.

*Bessie's Blues* presents a somewhat more ticklish case, insofar as it stands as the portrait of a musical artist by a visual artist (both nonwhite females), clearly referring to a well-known portrait of an actress by a white male artist. Like *Two Jemimas*, this painting operates in a corrective mode, but less overtly through its subject matter than via

# NOTES

1. From notes taken during a conversation between the author and Faith Ringgold at the artist's studio, San Diego, April 15, 1997.

2. Quoted in Ellen Harkins Wheat, *Jacob Lawrence: American Painter* (Seattle: University of Washington Press, 1986), p. 40.

3. The three-part quilt *The Lover's Trilogy*, which Ringgold completed in 1986, might also qualify, except that it is usually treated as a triptych.

4. Lowery Sims, "Prologue: The Situation at Hand," in *Robert Colescott: A Retrospective* (San Jose: San Jose Museum of Art, 1987), p. 4.

5. Ibid.

6. From notes taken during a phone interview between the author and Lorraine O'Grady, May 29, 1997.

7. As Moira Roth has pointed out elsewhere, the gestation of *The French Collection* began with a series of performances by Ringgold in the early 1980s, in which the persona of Willia Marie Simone was evoked.

8. Faith Ringgold, *We Flew over the Bridge: The Memoirs of Faith Ringgold* (Boston: Little, Brown, 1995), p. 80.

9. The third through the ninth panels contain the essence of Great-Grandma Betsy's story, which begins with a white man asking her mother how she felt as a descendant of slaves, to which her mother retorted by asking him how he felt about being descended from slavers.

10. Michele Wallace, "The French Collection: Who's Looking Now?" in *The French Collection, Part 1* (New York: Being My Own Woman Press, 1992), p. 7.

11. One precedent for *Bessie's Blues* exists in the form of Deborah Kass's appropriation of the composition and technique of Warhol's *Marilyn* series in order to create a portrait of the singer Barbra Streisand. Titled *Jewish Jackie*, the work is a direct comment on the absence of Jewish archetypes of female beauty in both American culture as a whole and in Warhol's work in particular.

12. Robert Santelli, *The Big Book of Blues: A Biographical Encyclopedia* (New York: Penguin Books, 1993), pp. 368–70.

Michele Wallace

## The French Collection

### Momma Jones, Mommy Fay, and Me

WE ALL LOVED French things. In me it has been expressed by my belabored and unrequited affection for the language and its literature, whereas Momma Jones (my mother's mother and my grandmother) delighted in the private showings in Paris of the couturiers. I first realized my attachment during a trip to Europe we all took together in 1961, when I was nine. For Faith (Mommy Fay)[1] and Momma Jones that love was obviously a different thing from mine, but I believe it had much to do with the promise (as opposed to the reality) of freedom to be whatever you might wish to be that Momma Jones saw in her generation of African American expatriates (such as Josephine Baker, Bricktop, and Sidney Bechet) and Faith (my mother) saw in hers (James Baldwin, Chester Himes, and others). Eventually, this love resulted in the series of paintings and story quilts called *The French Collection,* which Faith began in 1990, the as yet most concrete vestige—along with her recent children's book *Bonjour, Lonnie*—of the portion of our legacy that is French.

Like many artists, Faith lives in a rich, complex world almost entirely of her own creation, composed of equal portions of mythic past, present, and future in an idiosyncratic combination of truth, fact, and fantasy. Occasionally, she will allow some input from her much less creative daughters. My sister, Barbara, by this time a divorced mother of three after having completed an M.Phil. in theoretical linguistics in 1981, helped with the historical research and the crafting of the French dialogue in the stories of *The French Collection.* I lent her all my books on Josephine Baker and talked with her frequently about the cultural history of the African American expatriate community.

One of the main points of *The French Collection* for me is precisely its celebration of the fact that Faith Ringgold managed to create her own path with virtually no specific role models. Instead, she drew on a willy-nilly hodgepodge of role models, some of whom certainly didn't deliberately

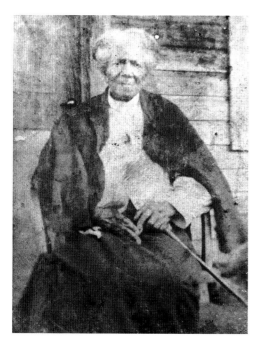

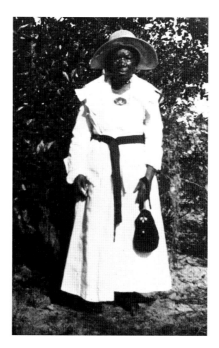

Susie Shannon,
my great-great-great grandmother,
c. 1900

Betsy Bingham,
my great-great grandmother,
c. 1900

choose to be her inspiration (such as Pablo Picasso, Henri Matisse, and Vincent van Gogh); others from black history (such as Sojourner Truth, Harriet Tubman, Mary McLeod Bethune, Fannie Lou Hamer, and Ella Baker) who had no apparent ideas about how to be a visual artist; and still others from her family, in particular her great-great grandmother Susie Shannon and her great-grandmother Betsy Bingham, both of whom were slaves and quilters, and her mother, Momma Jones, who had wanted to be a dancer and who settled for being a Harlem fashion designer— a more practical choice than being an artist, given her historical moment, and not entirely unrelated.[2]

I've been particularly drawn to an analysis of this work not only because I am the daughter of Faith Ringgold, but also because of the manner in which this series of paintings, or story quilts, endeavors to raise a variety of intellectual and cultural concerns that have been central for me as a black feminist writer and cultural critic. These concerns have been (1) the hybridic, symbiotic relationship of African American cultural production to Euro-American culture; (2) the cloaking and embedding of issues of race, gender, and sexuality within the evolutionary framework of European and American modernism; and (3) the means

by which black female subjectivity, creativity, agency, and intellectual life managed to survive the sexual politics of African American modernism. At the same time, this work is about ordinary personal and everyday concerns such as birth, death, love, and marriage, all or any of which can be cataclysmic in a woman's life, particularly in the context of striving for career and vocation.

How can a black woman be an artist at the same time that she makes a life worth living for herself and her family —despite the landmines placed in her path by institutional patriarchy, white supremacy, American provincialism, anti-intellectualism, and xenophobia?

From time to time, I still regret the occasional inconveniences of having been Faith Ringgold's daughter and Momma Jones's granddaughter, namely that I was never the center of their world. But as I become a middle-aged woman, I am beginning to really appreciate their gift to me, the complicated legacy I've inherited. In *The French Collection* in particular there are all sorts of rich lessons concerning the intertwining lives and loves of mothers and daughters.

The twelve panels of *The French Collection* construct an ambitious series, perhaps the most revealingly autobiographical of Ringgold's career. Since it is chock full of historical, philosophical, and aesthetic references, for the purpose of analysis I have chosen to divide *The French Collection,* somewhat arbitrarily, into three categories, each having a different apparent focus. I designate the panels *Dancing at the Louvre, Wedding on the Seine,* and *Matisse's Chapel* as focusing on the family, either Willia Marie's or Faith Ringgold's, or both. The other two categories, which I do not have the space to consider in depth here, focus on (1) a reclining figure, either nude or partially unclothed (*Matisse's Model, Picasso's Studio, On the Beach at St. Tropez,* and *Jo Baker's Birthday*), or (2) a "revolutionary" grouping *(The Picnic at Giverny, The Sunflowers Quilting Bee at Arles, Dinner at Gertrude Stein's, Le Cafe des Artistes,* and *Moroccan Holiday).*

In the early 1990s Faith made frequent trips to France, researching the lives of African American expatriates and visiting celebrated birthplaces of important works of modernism, such as Giverny and Arles, in order to complete her project *The French Collection.* The text is primarily an epistolary narrative, revolving around the episodic adventures of a black American woman named Willia Marie Simone, who goes to live in Paris in the 1920s. She is a woman somewhat like Josephine Baker in that she is an exhibitionist, has a beautiful body, and a tremendous joie de vivre; somewhat like my grandmother (whose first name was

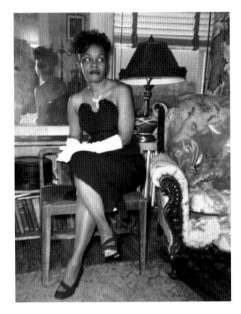

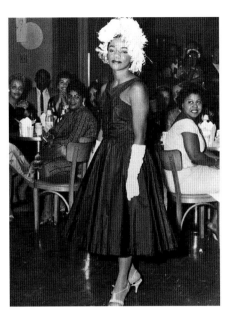

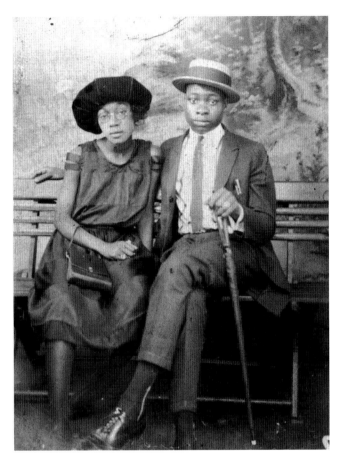

Momma Jones (Mme. Posey)
modeling her own fashions
at 363 Edgecombe Avenue in the 1940s

Photo: Thomas Morrison

Faith in her mid twenties modeling in one of
Momma Jones's fashion shows in the 1950s

Photo: George Hopkins

Momma Jones with
Grandpa Andrew, c. 1920

Photo : De L'Aigle Studio

Willi) in that she is vivacious, well dressed, and gregarious; and somewhat like Faith when she first went to Paris in 1961 in that she wants to be an artist.

Of these three women, Josephine Baker and Faith Ringgold are both better known than Momma Jones, whose professional name was Madame Willi Posey (her maiden surname). Indeed, she returned to her maiden name after her divorce from her husband, Andrew Jones (a good provider thanks to his job driving a truck for the department of sanitation all through the Depression). Her story and her persona provide an essential key to understanding more fully Ringgold's evolution as an artist and, in particular, the genesis of *The French Collection.* An invaluable source in this regard is Faith's autobiography, *We Flew over the Bridge,* which also includes many family pictures.[3]

By the time I was born in 1952, Momma Jones had made a satisfactory living as a seamstress in the garment district and had settled for a modest career as a Harlem fashion designer in an entirely black world of fashion made up of

black designers, black models, and black photographers. She had originally wanted to be a dancer, but it was not considered a respectable or acceptable profession by her parents, who were then schoolteachers in Palatka, Florida. In 1919 she came to New York in one of the early waves of the great migration, following her oldest brother, Cardoza, who had fought in World War I and never returned to live in the South, and her sister Bessie, who was married to a cook on a ship that docked in New York. She in turn was followed by her mother, Ida Mae, who didn't live long.

After graduating from high school, she married Andrew, also from Florida, had four children, and kept house for them in a tenement at 146th Street between Seventh and Eighth Avenues in Harlem until Faith, her youngest, was twelve. Having learned to sew and quilt from her mother, her grandmother, and her great-grandmother, Momma Jones made all her family's clothing. She got her first factory job during World War II sewing Eisenhower jackets, possibly through her best friend, Mrs. Brown, who lived on

Momma T
(Theodora Grant),
c. 1923

147th Street. It was that job which gave her the financial resources to divorce Grandpa Andrew and move to 363 Edgecombe Avenue in 1942. Momma T (Theodora Wallace Grant, my paternal grandmother), who lived at 365 Edgecombe, recollects knowing her from 1942. After the war, she continued to work as a seamstress in the factories making everything from men's shirts to women's ball gowns. Both Aunt Edith and Aunt Bessie, Momma Jones's sisters, also worked in dress factories, as did many of Momma Jones's friends.

During the 1940s sewing in the factories was the only alternative to housework for black women coming to the cities from the South and the West Indies who were not college educated. Before the 1940s they hadn't had even this option. Integration in the workplace was almost as slow in the North as it was in the South. Indeed, Momma T, who had worked in the factories since her arrival in New York in the early 1920s, along with other noteworthy West Indian women, such as Maida Springer-Kemp, had been involved in the struggles to establish the International Ladies' Garment Workers' Union and then to integrate it.[4]

Meanwhile, Momma Jones and her friends, male and female, many of whom were older and more experienced than she, were now in a position to appreciate but not to participate in the American world of fashion. Together, they set up their own organizations, including the National Association of Accessories and Fashion Designers, and began to give their own fashion shows. The first of many shows was held at Abyssinian Baptist Church, to which Faith and her family belonged, under the stewardship of the Reverend Adam Clayton Powell, Jr., in the 1940s. Unfortunately, Momma Jones did not conduct her business in a way that could make money; for instance, she charged people what she thought they could afford to pay and always contributed a hefty portion of the proceeds from the fashion shows to local charities.

When Faith returned home with two small children after separating from her husband (my father) Earl in 1954, when I was two, she became a live-in apprentice in Momma Jones's myriad enterprises, learning how to sew and make clothing, to model, and also gradually to serve as an emcee for some of the shows. The experiences of this young woman, well dressed and articulate, training in the decorative arts under a master, juggling her responsibilities as mother, daughter, and college student (and soon after high school teacher), are an important precedent in the construction of Willia Marie's adventures.

Whereas Faith still had to grapple with Western notions of aesthetic beauty in women and other painterly subjects in the pursuit of her vocation, Momma Jones, who had clearly been forced to practice her craft on the margins of the mainstream, was free in her dealings with her models—young women struggling to find themselves—to nurture, to mother, and to deemphasize the importance of their being picture-perfect beautiful, by anyone's standard but their own. As a particular object lesson, Momma Jones always had one very homely model who was bursting out of the dresses, whom she insisted was as beautiful as all the others. From this I learned, as we all did, that beauty was invisible and spiritual, as well as visible and corporeal. Like almost everybody else who came in contact with her, I adored Momma Jones.

The purpose of Momma Jones's business was the fashion shows, with an emphasis on providing a showcase for her considerable performance talents. There was music and entertainment, usually a full jazz band, a singer named Johnny Rainbow, and a clown. Momma Jones, who was known by her adoring audience as Madame Posey, would sometimes emcee the entire show as a tour de force, accompanied by lots of diva theatrics during the preceding days.

By showtime the collection had to be completed, the hems in, the alterations made, everyone dressed and made up in their appropriate places (including herself, her two daughters, and her granddaughters), the sodas and champagne cold and ready to pop, and the microphones accurately adjusted. During the musical finale she made her most elaborate entrance, wearing a tiara and a full-length silk gown or something short and flouncy with crinoline showing underneath, cut low in back and front over a voluptuous bosom. She would wave her hand in greeting,

lead a string of child models (including Barbara and me), and dance and sing without a trace of self-consciousness for the enjoyment and delight of her enchanted guests.

This bold figure helped inspire the saga of Willia Marie.

Nevertheless, very much to the detriment of her career, Momma Jones, like most black women of her generation, had never failed to put her children and then her grand-children first, although not without a palpable sense of loss. As Momma Jones always told me from the time I was a little girl: Don't ever marry and don't ever have children. She made no secret of the fact that she regretted having done both.

I like to see Willia Marie as representing the creative and symbolic realization of what each of us—Momma Jones, my mother, and myself—might have done had we been free to do so: to go to Paris, or 10th Street, or Mississippi Summer as young women and remain to shine on the center stage of modern cultural history, undefeated and unashamed.

In *Wedding on the Seine*, the second painting in the series, Willia Marie has just married a Frenchman named Pierre. She immediately flees from the wedding party and throws her bridal bouquet into the Seine because she came to Paris, she says, to be an artist, not to marry. "Pierre was a bon mari. But would he leave me alone? Could I do my art?" Included here are all three of the things a woman is supposed to spend her life learning how to juggle: marriage, children, and career. The story concludes with the comment that Pierre died three years later, leaving her with two children and free to pursue her art.

In 1961 Faith traveled with Momma Jones, Barbara, and me to Europe for the summer on the S.S. *Liberté*, which docked in Le Havre. We were guided in our explorations by an elaborate typewritten itinerary, of which Faith was the meticulous author. Itinerary. Because of the subsequent joy of that journey, I savored that sweet word as a child.

Faith's mission was to see as much of the art of Europe as possible in order to determine whether she could finally be an artist. "I don't know why," she said in a recent interview, "I thought that going to the Louvre, the Uffizi in Florence, and looking at European art had anything to do with being an artist, but I wanted to walk down the streets of Paris and see if it was any different, if it would make me feel any different."[5] There was also a young medical student from Guadeloupe whom she dated in Paris and with whom she later corresponded. For a long time after that,

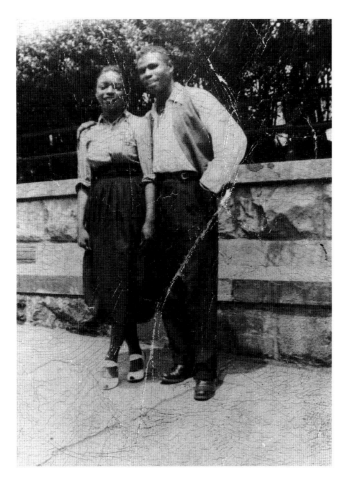

Faith and Earl standing on Edgecombe Avenue, 1946

Increasingly, little Faith gravitated toward friends who lived on the Hill, then epitomized by the residential comforts of Edgecombe Avenue, a street about twenty blocks in length, fronted on one side by Colonial Park, which separated the Hill from the Valley. The developing problems of the Valley at this stage in Harlem's history are eloquently described by James Baldwin in his early essays, *Notes of a Native Son*, and the novels *Go Tell It on the Mountain* and *Another Country*, as well as in Claude Brown's memoir *Manchild in a Promised Land*.

Once she managed to persuade Momma Jones to move into the fourth-floor apartment at 363 Edgecombe Avenue in 1942, Faith soon befriended both of her future husbands. My father, Earl, lived in 365, and his mother was the best cook on Edgecombe Avenue, so much so that Faith and Aunt Barbara would frequently beg him to raid his mother's pots to make sandwiches for them. Faith also knew Burdette, albeit mostly through his sister Gloria's friendship with Aunt Barbara. His family lived down the block in 409, the fanciest building on Edgecombe.

Subject to attack, both from the tough Valley gangs, such as the one Faith's oldest brother, Andrew (nicknamed Baron), belonged to, and from the ruthless Irish and Italian gangs farther west, the Edgecombe boys, none of whom were much into fighting, were forced to form their own gang, called The Frenchmen. Their fighting technique mainly consisted of throwing garbage cans from the roofs down on the heads of their tormentors. In this fiercely urban context, their labeling of themselves as Frenchmen seemed to imply something urbane and out of this world. Actually, "out of this world" was one of Momma Jones's favorite designations for any object—a dress, a room, a pair of shoes, or a hat—that was the most chic she could imagine. She had three heroines I know of: Josephine Baker, Mahalia Jackson, whose music she played constantly, and Chanel, for the spare line of her suit jackets and her gaudy necklaces.

The architectonic approach to the city of Paris displayed in *Wedding on the Seine*, featuring the central landmark of the river, reminds me of the layout of Edgecombe Avenue and the view from our window on Edgecombe of Colonial Park and the Valley. In this view from the face of the Hill, one could see much of Harlem, as well as Yankee Stadium in the Bronx. This aerial perspective, assumed everyday, simply as a function of looking out the window, was somehow characteristic of both the isolationism and the worldliness of the Hill perspective—an environment that, no

she collected brochures from French boarding schools and considered the idea of transporting us all to France, but instead she remained in the United States and married my stepfather, Burdette Ringgold, a childhood friend of both her and my father from Edgecombe Avenue.

Earlier, when Faith had entered adolescence, she had grown impatient with living in what was then called "the Valley." Back in 1919, when sixteen-year-old Momma Jones first came to Harlem in order to keep Bessie company while her seafaring husband was away on long voyages, Lenox, Seventh, and Eighth Avenues were the main thoroughfares for the newly arrived black population of Harlem, the capital of a renaissance in literature, art, theater, and entertainment. But it was the 1940s during Faith's adolescence: blacks were spreading farther and farther up "the Hill," and Edgecombe had become the new haven of the black elite. The quality of life in the Valley was gradually being diminished by its legendary overcrowding, from the continuing influx of immigrants from the South.

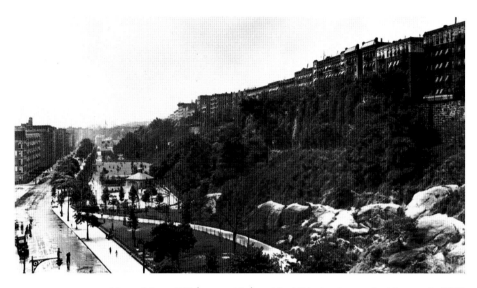

View of Sugar Hill (upper right) and St. Nicholas Avenue looking north, 1938

Collection of Photographs and Prints Division, Schomburg Center for Research in
Black Culture, The New York Public Library, Astor, Lenox, and Tilden Foundations

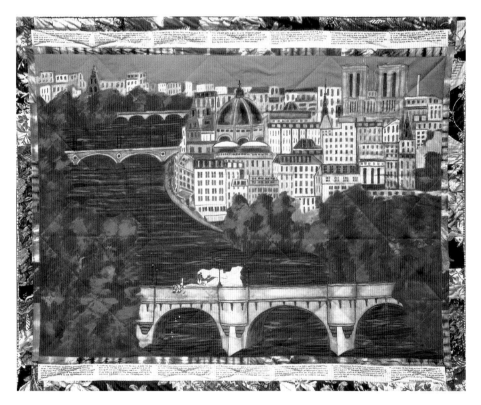

*Wedding on the Seine*
(*The French Collection*, Part I: #2), 1991

Acrylic on canvas, printed and tie-dyed fabric, 74 x 89"
Courtesy of ACA Galleries, New York and Munich
Photo: Gamma One

doubt, helped to produce some of the masters of Harlem culture who lived there: W. E. B. Du Bois, Walter White, Aaron Douglas, Sonny Rollins, Max Roach and Abbie Lincoln, and Duke Ellington.

When we went to Paris in 1961, Faith's divorce was final but she had not yet married Burdette Ringgold, although he had helped to raise the money for the trip and he was very close to my sister and me. He was already a definite candidate for husband and father. Although he was not employed in the "professions," he earned a competitive salary working at General Motors at one of those jobs the United Auto Workers had helped make available to blacks. He made more than Faith, who was then working as a high school teacher.

By now Faith was a young and beautiful woman, thirty-one years old and in her prime. She constantly stopped traffic wherever we went in Paris, Zurich, Monaco, Florence, and Rome. I mean this literally, particularly in Italy, where men would just pull to a screeching halt on their motorbikes or in their little cars to talk flirtatious nonsense to her. She was really very striking with all the correct 1950s attributes: a long neck, a small waistline, and great legs.

She had just completed her M.A. in art two years before at the City College of New York. Barbara and I had watched her march to receive her degree in Lewisohn Stadium, which has since been torn down. But what kind of artist would she be with two kids in tow? Hanging out on 10th Street or in the Village bars, then the fast track to the New York art scene, wasn't an option, as much because of the puritanical strictures of black life on the Hill as because of us. How could she do this extraordinary thing for which there were no role models? All of these themes would be reprised in *The French Collection*.

In *Dancing at the Louvre,* the first panel in the series, Willia Marie is dancing with a friend named Marcia and her three children in the Louvre. The story is told in the form of a letter to Aunt Melissa, who is keeping her children in the United States. Marcia is an old childhood friend who annoys Willia Marie by suggesting that Willia should have her children with her as well. Meanwhile, Marcia's three children are dancing and creating a spectacle in the Louvre and probably only marginally interested in the paintings.

This image always recalls for me our days as a family at the Louvre—Momma Jones, Faith, Barbara, and me, and the Mona Lisa, which would tour the United States the following year. All Faith can remember was our screaming for *glace,* the French ice cream we knew waited for us outside,

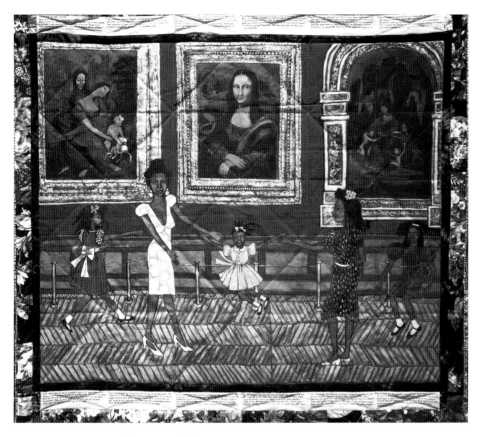

*Dancing at the Louvre*
(*The French Collection*, Part I: #1), 1991

Acrylic on canvas, printed and
tie-dyed fabric, 73½ x 80½"
Collection of Ms. Francie Bishop Good
and Mr. David Horvitz, Ft. Lauderdale
Photo: Gamma One

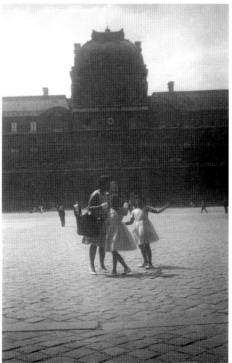

Faith, Barbara, and
Michele in front of
the Louvre, 1961

but what I remember is room after room of beautiful paintings. It was in the Louvre, at the Vatican in Rome, and the Uffizi Galleries in Florence that I fell in love with art.

The three children in *Dancing at the Louvre* are actual portraits of Barbara's children: Baby Faith, Teddy, and Martha, who were often invited to accompany Faith to various social functions during this period and who were always in motion and difficult to contain even on the most formal occasions. For me this panel is about having or not having children in conjunction with being an artist. A deep ambivalence for motherhood is expressed, not only in the conflict between Marcia and Willia Marie, but also in the use of the Mona Lisa and the two other paintings by Leonardo da Vinci, in which the maternal function is idealized. Interestingly, according to the narrative, Marcia has married a Frenchman named Maurice, which is the name of the Guadeloupian medical student my mother dated while she was in Paris.

Momma Jones's father, Bunyon B. Posey, was a teacher and a friend and follower of George Washington Carver, the biologist, and Mary McLeod Bethune, the founder of Bethune-Cookman College. But he died when she was a little girl, destroying forever the possibility of her and her siblings going to college. B.B. Posey and his wife, my great-grandmother, Ida Mae Bingham, were probably born in the 1870s, and, as such, belonged to that first generation after slavery who were eligible for advanced education. Nevertheless, most of the teachers in the South at the turn of the century, when Momma Jones was born, had not had what we today would consider a liberal arts education. According to the dominant pedagogical philosophy of the time, which favored vocational and agricultural education for the children of former slaves, they had no need of one.

Momma Jones explained that her mother, Ida Mae, had a grandmother, Susie Shannon, who lived to be 110, and only died in the early 1930s. Typically in the case of the father, less is known, and there are fewer photos of Bunyon B. Posey's parents and siblings. It was Momma Jones's oldest brother, Uncle Cardoza, whose personal mission it was to spend his vacations from the post office in Mount Vernon tracking down distant Poseys and Binghams.

There was, however, a family Bible kept by the Poseys, in which B.B. Posey's birthplace was recorded as a small town in South Carolina, the only state in which blacks outnumbered whites throughout the antebellum and the early postbellum period. He and Ida traveled from place to place in the Carolinas, Florida, and Georgia, teaching and setting

Michele at her wedding with husband,
Eugene Nesmith, and Barbara's children,
(from the right) Faith, Teddy, and Martha, 1989

Photo: Coreen Simpson

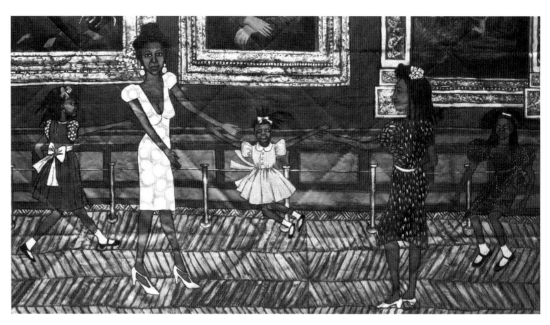

Detail of "Faith, Teddy, and Martha"
from *Dancing at the Louvre*
(*The French Collection*, Part I: #1), 1991

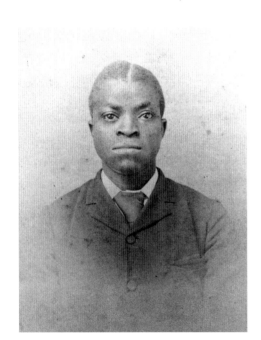

B.B. Posey, c. late 1880s

Photo: Nugent

Detail of B.B. Posey from *Matisse's Chapel*
(*The French Collection*, Part I: #6), 1991

up schools. There was an endless need for schools for blacks in the South at the time, and a constant necessity for urging black farmworkers and domestics, whose labor was quick to embrace their children, to fight for their children's chance to get a rudimentary education. Du Bois and others thoroughly describe the harsh conditions for common folk in the rural South at that time.

An education and a good husband presumably made a difference, yet these were days when housework and child care involved backbreaking labor. Ida Mae bore each child—Cardoza, Inez, Bessie, Edith, Willi, and Hilliard—in a different town, surely no easy ordeal in that time of local midwives and segregated hospitals. Then B.B. Posey died and left Ida alone with the six children. Momma Jones was young enough to remember the dust flying under the horses' hooves as they drew the carriage that brought her oldest siblings home from college. Between the slant of such facts, and the way B.B. Posey looks in his photographs, so black with widespread eyes, nostrils, and mouth, with no trace of Native American or white blood visible, I have always fantasized that he might have been a descendant of slaves brought on one of the late and illegal shipments from Africa, for which South Carolina was known after the importation of slaves had stopped in most of the South.

Not long after Momma Jones moved to New York at age sixteen from Jacksonville, Florida (where she had lived with her grandmother Betsy Bingham), she married and had four children: Uncle Andrew, the oldest; Aunt Barbara; Ralph, who died at two; and Faith, her youngest.

Uncle Cardoza in World
War I soldier's uniform
in France, c. 1919

Detail of Uncle Cardoza
(seated) with his other
siblings, Uncle Hilliard,
Aunt Edith, Aunt Bessie,
as well as Cousin
Mildred, from
*Matisse's Chapel*
(*The French Collection*,
Part I: #6), 1991

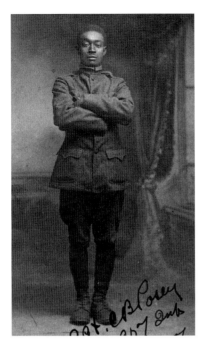

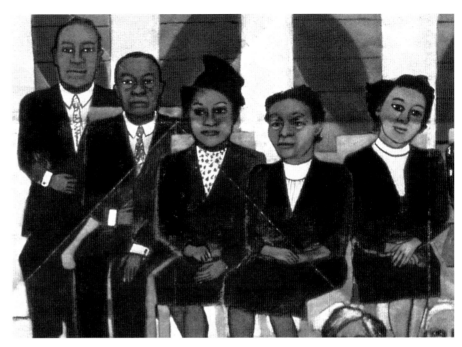

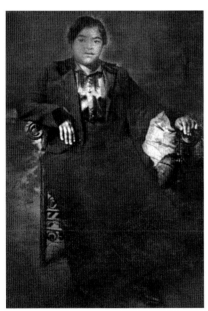

Ida Mae Bingham Posey,
my great-grandmother,
c. 1920

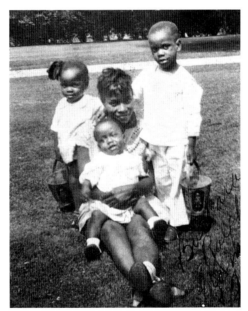

Momma Jones on the grass in
Central Park with Ralph in her lap
and Barbara and Andrew, 1929

All these family members (except Faith) come together
in *Matisse's Chapel.* On the left, in the front row, are
Momma Jones's father and mother, B.B. Posey and Ida
Mae Bingham, on the far left and the far right, respec-
tively. The two women in the middle of the front row are
Betsy Bingham and Susie Shannon. Behind them, sitting
in the second row, are Uncle Peter and Aunt Janie, who
were, I believe, the brother of Betsy Bingham and his wife.
In the back row on the left are all of Momma Jones's sib-
lings—Uncle Hilliard, Uncle Cardoza, Aunt Edith, Aunt
Bessie—as well as Aunt Bessie's daughter Mildred and Ida
Mae, a cousin who remained in the South, who never
married and was a music teacher. On the right side in the
back are the mother and father of Grandpa Andrew: Baby
Doll Hurd—Faith can remember visiting her occasionally
—and Reverend Jones, whom Faith never saw and whose
photo she doesn't possess. This is the one portrait in
*Matisse's Chapel* that she entirely invents.

Down front on the right is for me the most interesting
group of all: In the center is Momma Jones, more or less
the way she looked when I was a little girl, which was in
the late 1950s. In fact, her image is based on a portrait that
Faith did of her during that time. On her right is Aunt
Barbara dressed in the gown, which Momma Jones made,
that she wore at her wedding in 1950. Aunt Barbara, often
called the "Princess" by her family of origin, had the big
wedding, not Faith, who soon after eloped with Earl. On

related as though Faith were Willia Marie. Her brother Ralph, who was born and died before she was born, becomes "l'enfant Jesus" and her brother Andrew is described as "handsome as a Greek God."

The mise-en-scène of Matisse's Chapel in this painting recalls for me the milieu of the church funeral and, in particular, the scene of Momma Jones's funeral at the Abyssinian Baptist Church in Harlem in 1981, although most of the people in this painting were no longer alive and thus unable to attend. At that time I thought I might not survive her death either. How do you survive the death of somebody you really loved? I wondered. I had not intimately known any of the others—Uncle Andrew, Grandpa Andrew, Momma Jones's siblings, my father, and my father's father—not enough to adequately mourn their loss, or even to recognize the need to mourn. In a way, Momma Jones was the first death for me that opened the door to understanding all the other deaths, and finally to the sometimes welcome inevitability of death. For instance, Momma Jones had had a peaceful, quiet passing from a heart ailment at seventy-eight in her own bed.

Now, all these years later in *The French Collection,* everyone on my mother's side has risen and lives again in this painting. The light in this painting reminds me of Marc Chagall's stained-glass windows (as well as Matisse's), and of Easter, which has become today a strange amalgam of Easter rabbits and Christ risen from the dead. *Matisse's Chapel* is quite honestly about mourning and death, at the same time that it is clearly a celebration of a tradition of resistance and a legacy of hope. It recalls Baldwin's statement in *Notes of a Native Son* that he was "a kind of bastard of the West," an interloper, and that his ancestors had played no role in the building of the cathedral at Chartres, to which Faith responds that while the church was the rock upon which Europe's great material triumphs over Africa were built, the African branch of the species, once dragged across the sea to the Americas in chains, was able

the left are Big Andrew and Little Andrew dressed as they were at Aunt Barbara's wedding. In Momma Jones's lap is Ralph at two, his age when he died in 1929 of pneumonia, the year before Faith's birth.

The criterion for being included in this picture is that you are dead. The grouping on the right consists of Faith's entire family of origin—her mother, her father, her two brothers, and her sister, all of whom are dead. Indeed, that summer in 1961 while we were in Rome, Aunt Barbara called to tell us that Andrew had been found dead of a drug overdose in an empty apartment in the Valley and that we must come home as soon as possible. After that it seemed as though somebody in our family died every summer.

But the worst of all the deaths, for all of us, was Momma Jones's, and perhaps this painting, which is all about death, reveals this fact in its imagery. In the story accompanying the painting, Willia Marie writes to Aunt Melissa about a dream in which all the dead members of her family gathered in Henri Matisse's Chapel in Vence. The family tree is

to make of the same text a spiritual triumph and an artistic legacy as well. Who do you suppose was more Christian?

Accompanying the quilt, there is a story within Willia Marie's story in which Betsy Bingham tells how her mother, Susie Shannon, turned a question back on a white man who asked how she felt about being the descendant of slaves. "How do you feel descendant from *slavers*?" she asked him. He told her slavery always made him think of shit because his grandfather had told him that the slave ships smelled like shit.

Oddly, this turns me back to an experience we had that summer in Europe. I was running with Barbara, Faith, and Momma Jones through an Italian train station on our way back to the United States to Uncle Andrew's funeral, when I slipped and fell in a pile of animal shit heaped in the middle of the corridor. I had on my favorite dress of yellow organdy that Momma Jones had made and that had been washed several times and was soft, a little faded and crinkly, just the way I liked it. I can remember Momma Jones taking me into the bathroom, pulling my dress over my head, washing the shit out of the dress, wringing it out, and—since it was so hot—putting the wet dress back on me so that we could continue rushing back home. Although I wore that dress the rest of that day, I remember that I was later forced to throw the dress away, permanently contaminated as it was by the shadow, and perhaps the lingering smell, of having once been stained with shit.

In fact, I remember this trip to Europe as though it were a dream with magical non sequiturs: the fabulous journey on the S.S. *Liberté,* roaming the boat with a band of children searching for Bob Hope, and having a sip of wine with dinner for the first time, the sea all around us; the streets and sights of Paris, the grungy hotel we stayed in on the Left Bank; the white beaches and strawberry ice cream sodas of Monaco; the trip through the mountains and clouds of Switzerland, where I got to practice my Lutheran-school German; the excitement of Italy, both Florence and Rome, where Faith and Momma Jones bargained so aggressively with the dealers in the flea markets that I feared the dealers and their families would starve; the large, shapeless women who pulled heavy carts of food to sell or who toted heavy loads, sometimes on their heads; country people with farm animals in the train stations; the divisions of first-, second-, and third-class coaches; the smiling strangers who always gathered around to touch us and give us presents of food and ice cream because they had never seen black children before.

Barbara and I had always been taught we were special, perhaps to overcompensate for the message of inferiority attached to our race in our native land. Now this trip seemed divine confirmation of that. I can't recall before or since being around so many white people who seemed so happy to see me.

Until the news of Uncle Andrew's death came via telephone. Somehow the Lord delivered out of the ether an angel, a mysterious and wizened elderly matron dressed entirely in black, a Native American expatriate living in Rome, who spoke perfect English, who flawlessly navigated all the suddenly necessary translations, and who stuck to Momma Jones like glue from the moment we heard. After we departed on the train from Rome, I could not help wishing we had been able to take the kind old lady with us. All of Europe seemed transformed into a series of impersonal train stations and borders at midnight, obstacle courses barring our emergency return home.

## NOTES

1. When my sister Barbara and I were little girls, we called Faith by the name Mommy Fay. Her husband Birdie still does.
2. Of course, there were other African American artists who are now rather well known, such as Jacob Lawrence, Romare Bearden, Norman Lewis, Lois Mailou Jones, and Elizabeth Catlett. But in the 1950s, when Faith first decided on her vocation, the only one of these known at all beyond local legend was Jacob Lawrence, and even his work wasn't dis- cussed in the art classes Faith attended at the City College of New York. The two women escaped from the United States: Catlett to Mexico and Jones to France.

3. Faith Ringgold, *We Flew over the Bridge: The Memoirs of Faith Ringgold* (Boston: Little Brown, 1995).

4. Momma T is still alive at 95 and resides in Harlem.

5. "Faith Ringgold: Artist and Author; Interviewer: Moira Roth," *Artist and Influence* 15 (1996): 226.

Patrick Hill

# The Castration of Memphis Cooly

## Race, Gender, and Nationalist Iconography in the Flag Art of Faith Ringgold

THE PAST DECADE has witnessed a revolution in the art world centered on the emergence of the quilt as a fine-art medium articulating a history and social sensitivity that is distinctively female. At the epicenter of this movement, both as one of its chief architects and arguably its most charismatic figure, has been the artist/activist Faith Ringgold. Born Faith Jones in Harlem during the Great Depression and raised in a middle-class African American family with a tradition of fiber art and storytelling, Ringgold has used the quilt and the American flag as logical sites for both her activism and her ongoing effort to celebrate the beauty and humanity of the African American experience. Cultural critic and longtime friend Amiri Baraka once wrote that "Faith's work is not the art of the drawing room. . . . She, when we can get close enough to check what she's about, is carrying news of the Field."[1] While metaphorically seductive and well intended, Baraka's house/field binary fails to appreciate the full scope of Ringgold's critique. Indeed, the artist's commitment to a number of marginalized constituencies has required that her insurgent message not be directed at any single orthodoxy, but at all that seek to advance narrow constructions of gender, race, cultural production, and citizenship.

Faith Ringgold's work with the American flag tells an important story about the ways in which unresolved tensions and ambiguities at the core of the national consciousness get both managed and displaced. In her skillful hands, the national icon is presented as a fetish: an impassioned object designed to gain "symbolic control" over blights at the core of American identity.[2] However, using this insight to interpret Ringgold's flag-based oeuvre as simply a critique of the white cultural nationalism often masked beneath rituals of popular patriotism would diminish the complexity of this modest but important body of work.

I believe that Faith Ringgold's flag aesthetic is centrally concerned with the place of African American women within recent efforts to rearticulate America's national identity. Such an intervention not only places gender alongside race as a key tension animating various nationalist projects during the 1960s, but it also suggests ways in which gender links ideologies of popular patriotism and black radicalism. Moreover, because much of the gender critique in Ringgold's early flag paintings occurs *before* her self-conscious embrace of feminism, these works might be read as fetishes enabling the artist to gain some measure of "symbolic control" over her relationship to popular patriotism, black nationalism, and mainstream feminism as latent gender sensitivities rose ever closer to the surface in her life and work.

The American flag first became a central element in the art and social activism of Faith Ringgold in 1964, when she executed *God Bless America,* the first, and arguably the least successful, of her four major flag paintings.[3] Ringgold's appropriation of the American flag as a vehicle of social protest was part of a widespread movement among artists during the political tumult of the mid-1960s. In the New York scene, artists such as Kate Millett, Carl Andre, Claes Oldenburg, and Jasper Johns were using the national symbol as a fruitful vehicle to critique state-sponsored repression both at home and abroad. Inspired by Johns's "beautiful, but incomplete" 1955 *Flag,* Ringgold's second engagement with the subject came shortly after she joined the Spectrum Gallery.[4] Making use of the spacious facilities made available to her, Ringgold completed the mural-size painting *The Flag Is Bleeding,* as part of her *American People* series in the summer of 1967.

Executed in a style of social realism she has termed "Super Realism," this painting contains many of the formal and iconic elements that have become indicative of Ringgold's aesthetic vocabulary.[5] *The Flag Is Bleeding* features three figures linked arm in arm, two males separated by a female, each presented in full frontal pose and staring expressionlessly at the viewer from behind the stars and stripes of the American flag superimposed over them. While only the physical contours of the three figures are apparent through the flag's translucent red stripes, the faces of the two white figures are pulled forward in space to peer at the viewer from the negative spaces between the red stripes. Conversely, the upper body of the black figure is visually obscured. Further, Ringgold uses sartorial markers to position each figure as a distinct type. The white male's business suit, the trendy chemise of the young white woman, and the bloody black turtleneck of the black male represent carefully considered signifiers that situate the three characters respectively as an agent of white hegemonic power, a bourgeois female interloper/pacifist, and a black nationalist revolutionary.

Standing on the left side of the canvas, the head and upper torso of Ringgold's black male are situated against an ultramarine blue background that closely approximates the color value of the warm browns and blacks Ringgold uses for his face. This blue background area—like the white in the larger, striped portion of the flag—serves as both a positive and negative ground in the painting, providing both a separate spatial background for the African American figure and the field housing the forty-eight white stars representing the states of the union. In contrast to the recessive effect of the white stripes, the white stars seem opaque, pulling forward in space over the dark face and torso of the black figure. Ringgold reinforces the deliberateness of this spatial positioning by juxtaposing against the same blue background half of the face of the modishly attired female, changing her reddish-orange hair to a cadmium yellow at the point it crosses the blue field and, in so doing, heightening the visual contrast that pulls the woman forward in space relative to the black male and situates her only slightly behind the stars of the flag. To the right of the female figure, and similarly situated spatially, is the white male. While this figure stares out toward the viewer with the same expressionless glare as the other two, he assumes an authoritative physical posture, with both hands placed on his hips, palmside down, and feet set wide apart.

The drama of *The Flag Is Bleeding* derives from Ringgold's decision to contrast the calm, carefully composed, and relatively unarticulated expanses of flat color in the flag and

*God Bless America,* 1964

Oil on canvas, 31 x 91"
Courtesy of ACA Galleries, New York and Munich

*The Flag Is Bleeding*, 1967

Oil on canvas, 72 x 96"
Courtesy of ACA Galleries,
New York and Munich
Photo: Malcolm Varon

figures with spontaneous splatters and drips of red pigment, which appear to emanate from the red stripes of the American flag. Her superimposition of fresh blood over an image that might otherwise be read as illustrative of the hope of interracial cooperation (suggested in the linking of arms) is a sardonic twist, which effectively dismisses this reading. A possible explanation for the presence of blood is suggested when we notice that the shadowy black male wields a knife in his left hand. However, when we look at his right hand—placed over his heart as if saluting the flag—we realize that he is the only figure who bleeds, as we see blood flowing through his fingers from a wound in his heart. Though this knife is the only weapon apparent in the scene, Ringgold has stated that the white business-man's hands conceal guns on each hip, which he is "ready to draw, western style."[6]

In superimposing the blood-soaked American flag over an image that may be read as a sign of racial egalitarian-ism, Ringgold presents a powerful visual narrative that not only comments on the volatile state of American social relations during the summer of 1967, but also rejects as illusory any suggestion that the interests of a racially balkanized body politic might be served by simply linking blacks and whites arm in arm. However, Ringgold's cri-tique here should not be interpreted as an outright rejec-tion of the transformative potential of interracial dialogues and coalitions; it is more a reflection of the artist's con-cerns about the state of race relations in the mid- to late 1960s. The "long, hot summer" of 1967 witnessed the eruption of violent and highly publicized battles between Black Panther militants and the police on one side of the country and on the other side a series of fiery race riots in urban centers. One of the most serious of these civil insur-rections (Newark) occurred literally within minutes of the Spectrum Gallery as Ringgold completed *The Flag Is Bleed-ing* in July of 1967.

Faith Ringgold continued to exploit the American flag as a compelling vehicle for her iconoclastic aesthetic when she completed *Flag for the Moon: Die Nigger* in 1969. This smaller, nonfigurative canvas contains many of the same formal elements that marked Ringgold's aesthetic state-ment in *The Flag Is Bleeding*. Superficially, this painting, not unlike Jasper Johns's famous image, appears to be a straightforward representation of the stars and stripes, only this time with all fifty stars as opposed to the forty-eight Ringgold used in *Bleeding*. Upon closer inspection, how-ever, the viewer discerns that along with the fifty stars, the dark blue field of Ringgold's flag design also includes the word *die*, subtly but clearly superimposed in capital sans serif letters. Moreover, like the "white" stripes of her previ-ous flag painting, the stripes of *Flag for the Moon: Die Nigger* serve a double function, spelling with carefully concealed letters the epithet *nigger*.

The audacious nature of the political statement made in this painting is extended through Ringgold's innovative use of color. The stars and stripes in *Flag for the Moon: Die Nig-ger* are clearly not the traditional red, white, and blue; instead, the aesthetic statement in *Moon* turns on the elimi-nation of pure white pigment from Ringgold's palette. As part of her *Black Light* series begun in 1967, this painting initiates Ringgold's radical experimentation with chro-matic structures (and in turn an extension of her critique of ideological, political, and formal structures). Ringgold's embrace of "black light" was by no means an isolated ges-ture, but part of a broader anti-establishment turn among marginalized art communities in the late 1960s. The posit-ing of an alternative chromatic schema both challenged the notion that the Western art canon represented an immu-table aesthetic gospel and exposed the power relations and ideological assumptions concealed by accepted (and highly commodified) aesthetic practices.

*Flag for the Moon:*
*Die Nigger, 1969*

Oil on canvas, 36 x 50"
Courtesy of ACA Galleries,
New York and Munich
Photo: Malcolm Varon

Ringgold's *Black Light* series was also centrally concerned with experimenting with the formal features of African art and in adjusting light in a manner compatible with the shades, forms, and textures of black skin and hair. Ringgold's own words in regard to this aspect of her work are relevant here:

*As an artist and a woman of color . . . I had noticed that black artists tended to use a darker palette. White and light colors are used sparingly and relegated to contrasting color in African-American, South African, and East African art—and used as a "mood" color in African supernatural and death masks. In Western art, however, white and light influence the entire palette, thereby creating a preponderance of white, pastel colors, and light-and-shade, or chiaroscuro. . . . As a young art student, I tried feverishly to paint black portraits using light and shade. I became frustrated because dark-skinned images painted this way lose their luminosity and therefore look better painted in flat color. The South, West, and East Africans knew this and created their paintings accordingly.[7]*

This passage illuminates the introspective dimension of Faith Ringgold's development as an artist, and her written words serve as a fit reminder of another significant innovation in *Flag for the Moon*. This painting introduces written narrative into Ringgold's work. Before, she was content to express her social concerns solely through the vocabulary of social realism and the human figure in particular. But with *Flag for the Moon* Ringgold synthesizes experiments with black light, written narrative, and commentary on black life *sans* the human figure into a radical reappropriation of the American flag and its official meaning(s).

Ringgold's formal experiments in her flag paintings of the mid- to late 1960s were important because they offered novel approaches to making African American experience and knowledge visible in a cultural context (the world of "high" art) where blacks had been rendered largely silent and invisible. In both *The Flag Is Bleeding* and *Flag for the Moon,* Ringgold works to expose and elide binary codes and hierarchies at the base of American power relations by juxtaposing the national symbol with emblems (blood, black light) that effectively transform it into a subversive sign. Not only does Ringgold's clever use of irony allow her to appropriate, for her own purposes, the American flag—a symbol she once called "the only truly subversive and revolutionary abstraction one can paint"[8]—but it also represents a compelling interrogation of power that commits to form the urgent social advocacy so central to other aspects of her life and career. In her words: "I use the flag to force attention to the struggle. That's the symbol that makes you know it's America. So when I say the flag is bleeding, I mean the country is bleeding."[9]

Throughout the twentieth century, public display and use of the American flag have been rigidly restricted by an assortment of federal and state laws.[10] But what made the flag protests of the 1960s so troublesome was that they occurred during a particularly sensitive period. Protracted cold war tensions, along with the ongoing conflict in Vietnam, challenged America's military supremacy. In this politically charged atmosphere Ringgold recognized that her appropriation of the American flag was especially threatening because access to it by a woman artist of color was perceived as an assault on citizenship entitlements defined as the singular province of whites. Ringgold rejected the racial chauvinism encased in mainstream American nationalism outright. According to her, "The flag belongs to us. It belongs to every individual who sees America as home. And if you don't claim it you lose it. When we sit back and allow only people who have on hoods to use it, then it becomes that, it becomes theirs. . . . We must continue to use the flag."[11] But as the harsh response of police authorities to the "People's Flag Show" indicated, the use of the American flag by the marginalized

constituencies to which Ringgold belonged (e.g., artists, liberal intellectuals, women, and blacks) continued to be viewed as an act of sedition.[12]

The racial chauvinism implicit in American patriotism only intensified Ringgold's resolve to channel the isolation and anger she felt as a black female painter into the powerful imagery of the American flag. In each of Ringgold's major flag paintings of the 1960s, the national symbol—whether superimposed over images suggestive of racial violence or recast through a prism where white pigment is absent—ceases to hold its intended meaning. Instead, the American flag is transformed into a visual metaphor for the considerable gap between the state of American race relations and the democratic ideal the flag purportedly represents. By exposing the white cultural nationalism concealed just beneath the surface of popular patriotism, Ringgold's early flag paintings suggest that the national icon masks racist agendas carried out under the guise of democracy. Here the American flag—traditionally a banner that conceals in the name of monocultural consensus—is transformed into a banner that reveals far more complicated social realities.

In these flag paintings Faith Ringgold exposes the duplicity that has always been a byproduct of American democracy where women and African Americans and other people of color are concerned. Chief among the tropes Ringgold uses to expose this duplicity is the mask. While Ringgold situates the entry of masks into her aesthetic repertoire with the *Family of Woman* series and her other performance-oriented work of the early 1970s, a close examination of her portraiture from the mid-1960s suggests an earlier date. In Ringgold's work during this period the human figure is dominated by an oversized head, which is often larger than the body, when the body is not omitted altogether. According to Ringgold, this stylistic feature echoes African art traditions in which "a large head . . . means that the soul or seat of intelligence . . . is more significant than just the mere body."[13] Art historian and critic Lowery Sims has extended this Africanist connection in describing Ringgold's highly stylized frontal portraiture as reminiscent of African masks, particularly the royal portrait masks of the Kuba. This stylistic approach, using organic, curvilinear forms contained within hard outlines, gave Ringgold a way of representing the black portrait that "was neither caricature nor adapted from white standards." Furthermore, while Sims sees both cubism and more direct African resonances in Ringgold's early portraiture, she is

careful to add that it was "neither purely African or merely decorative." This caution is instructive, because although Ringgold's aesthetic draws on Africanisms both consciously and subconsciously, the use of masking in her flag paintings speaks to social realities and experiences that are distinctly American.[14]

In *The Flag Is Bleeding* the oversized, masklike similarity of the three faces, coupled with the linking of arms, is arguably the single most telling feature of the painting. Such a bond—even though the black male's face lies almost completely hidden behind the stars of the flag and the two white figures occupy the space in a way he does not—suggests that despite the turmoil surrounding them, these figures share a strange complicity in this bloody American tableau, one that those absent from this scene can neither participate in nor imagine. From this perspective, the trio's similarly masklike expressions and linked arms might be interpreted not as a hollow exercise in interracial cooperation, but as an unlikely, perhaps dubious, ritual of allegiance among three regimes, which through this violent racial drama have come to share a degree of parity in the construction of the national consciousness. Given this, what does the painting suggest as the source of the complicity among the three figures? What do their masks seek to conceal?

Ringgold makes powerful use of the black vernacular tradition of "Signifyin(g)" to expose the double-voiced quality of this painting.[15] Principal among those absent from *The Flag Is Bleeding* (and in large measure absent from the public debate in 1967) is the black woman. Indeed, given Ringgold's emerging black feminist consciousness at the time of this painting, the black woman is conspicuous in her absence. Yet precisely because of Ringgold's use of masks and the linking of arms to establish a complicity among these three figures, the black woman may not be as absent as we first suspect.

In addressing questions concerning the whereabouts of the black woman in *The Flag Is Bleeding,* Ringgold has recently suggested that "she was reluctantly standing behind her man" while the "daughter of the white power structure" operated as a peacemaker by physically separating the two potentially violent male regimes.[16] The artist's own published exegesis notwithstanding, *Bleeding* and Ringgold's own life experience represent valuable (if leaky) texts suggesting that the black woman not only stands behind her black man, but perhaps just as important, she stands behind each of the other two figures as well. Indeed,

her very invisibility makes her all the more ubiquitous as a presence haunting this dubious assembly. Not only might the black woman provide the source of the unlikely complicity among the three figures, but in important yet distinct ways, each of these three masked archetypes can be read as deriving its identity and legitimacy as a social agent through configuring her as an ontological foil.

The black woman as Other figures prominently in extracting the meaning hidden in the American flag as well. Like the stylized, expressionless glare of the three figures, the American flag, disinterred from its ideological moorings, has been transformed into a mask of sorts. The splatters and drips emanating from its stripes might be read as the product of a crimson ritual in which the national body becomes one with that of the black woman through her blood. Metaphorically speaking, Ringgold's American flag *is* the body of the black woman in *The Flag Is Bleeding,* a body whose symbolic centrality is due to the antipathy for her shared by the three constituencies represented in the painting.

Perhaps it is not the hope of interracial cooperation that is mocked in *The Flag Is Bleeding,* but instead the positing of any allegiance among black male radicals, white bourgeois women (including feminists), and white male-dominated power to construct an America in which the black woman is either subservient, prone, or in some other sense absent from public life. Thus *The Flag Is Bleeding* might be considered less a forecast of violent racial Armageddon (as others have surmised) than a compelling critique of a public dialogue in which the interests of black women are all too often sacrificed at the altar of a tenuous unity among national power regimes mutually interested in her continued silence and invisibility. Indeed, this painting suggests that such an endeavor is not only doomed to failure but is also suicidal precisely because of black women's central place in the national fabric. This argument holds true for the knife-wielding black male figure in particular. Of the three members of this triad, his fate as son, brother, lover/husband, father, and friend is most intimately imbricated with that of the black woman. His failure to embrace her input and, even more, his compliance with an effort to cut her out of public view result in a gradual, suicidal demise, indicated by the knife, the bloody wound in his heart, and his visually obscured presence in the painting.

Faith Ringgold continues to expose the double-voiced character of hegemonic nationalism in *Flag for the Moon: Die Nigger.* This painting, not unlike *Bleeding,* integrates the forms of the flag with signifiers of the not-so-hidden history of America's white racial animus. However, in contrast to the busy, figurative aesthetic in *Bleeding,* the visual statement in this painting is driven by a far more minimalist aesthetic in which the human figure is replaced by written narrative.

Much like Ringgold's conscious interventions with *The Flag Is Bleeding,* her turn toward a minimalist ground in *Flag for the Moon* is a calculated, intentional gesture designed to Signify on the hypocritical reality of American democracy. However, *Flag for the Moon* is both intentionality and Signification with a difference. In contrast to the stark, heavy-handed protest aesthetic of *Bleeding, Moon* signals a shift toward a far more nuanced visual statement. Ringgold's innovative use of "black light" in this painting cannot be described simply as a protest. Instead, her chromatic modernism might more aptly be thought of as an Afrocentric exploration of sight—a formal investigation of radically new possibilities for both seeing and being seen in the late 1960s. Indeed, Ringgold's chromatic explorations in *Moon* were informed by various sources including the "black is beautiful" movement, African art traditions, the black paintings (chromatically speaking) of modernist painters such as Ad Reinhardt and Josef Albers, and the artist's desire to be free of the hegemony of Western color theory—especially its dependence on whiteness to create visual drama.

In *Flag for the Moon,* Ringgold's decision to render the American flag in her new palette of nearly whiteless color combinations, further darkened by the addition of Mars black, results in a visual tableau that requires effort for the Western-trained eye to see. Moreover, in concealing the words *die* and *nigger* within the forms of the flag, Ringgold pushes the problematic visuality of this painting even further on at least three levels. First, *Moon* translates the hard-hitting didacticism of the visually driven *Bleeding* into literate form. Second, it presents a form of Signifyin(g) much more indirect and difficult to decipher (but no less powerful) than the confrontational, but accessible reading in *Bleeding.* Third, *Moon* provides the aesthetic ground for a visual celebration of blackness in keeping with the spirit of the moment. The desired effect of this more nuanced visuality is powerfully articulated in Ringgold's account of her first major sale following the 1970 debut of the *Black Light* series at New York's Spectrum Gallery:

*One outcome [of] the show was that David Rockefeller wrote me about purchasing a painting for the Chase Manhattan Bank art*

*collection. Two representatives from this collection came to make a selection. They almost bought* Flag for the Moon: Die Nigger *since, at first glance, it appeared to be an appropriate one for the collection. Unlike my other paintings, which had obvious political content and titles, this was a simple painting of the American flag. Upon closer scrutiny they discovered the word* die *superimposed on the stars, and the word* nigger *in the stripes. They left in a huff. I coaxed them back to see slides of other paintings. Finally they decided on a painting depicting six faces in varying shades of dark to light skin tones, a subtle statement of black people's multiethnic heritage. Since they didn't know it was titled* Six Shades of Black, *they likened it to the color spectrum of America, and suggested calling it* Untitled. *I renamed it* The American Spectrum *and received $3,000, my first formidable sale.*[17]

This account of Faith Ringgold's first major sale provides some crucially important insights into her work. First, the art buyers' response to Ringgold's work—both in their avoidance of overtly political canvases and in their indignation after "seeing" the politics in *Moon*—suggests that her attempt to use innovations in form to articulate a distinctively black aesthetic within terrain dominated by the core values of highbrow Western art (an aesthetic regime that defines itself as singular) resulted in an epistemological rupture. This point is important, for it was not Ringgold's figurative, overtly political, often didactic visual *content* that was at issue here: as the aforementioned account suggests, the accessible nature of the figurative works permitted Chase Manhattan's art buyers to dismiss them with ease. Instead, far more troubling for these agents of the high art establishment was the recognition that the modernist, apparently innocuous *Flag for the Moon: Die Nigger* had gotten beyond their defenses, seducing them into confronting the same political content they had so easily dismissed in Ringgold's other work. The seductive difference of *Flag for the Moon* was its ability to conceal its confrontational message within the minimalist *form* of Ringgold's black light palette and deliver it to the viewer wrapped in the alluring image of the American flag.

In casting the American flag through the prism of her black light palette toward the end of rendering a novel black visibility, Ringgold both mocks and plays with those binarisms intrinsic to Western racial hierarchies, which define blackness as the negative antithesis of whiteness. But her semiotic inversion is also a highly political act, which effectively eviscerates the national banner of its tra-

ditional patriotic meaning. In Ringgold's hands, the American flag—the national icon in which most citizens (especially whites) have a deep emotional investment—becomes the perfect vehicle to seduce Rockefeller's art buyers into a dialogue with her vision of the African American experience. Her shrewd manipulation of the American flag, the white viewer's gaze, and the patriotic meanings generated at the nexus of the two is perhaps all the more effective because it represents a momentary inversion of power, effectively exposing the art buyers' limited aesthetic vision while stripping away the thin veneer of authority accorded them by the Western art establishment. The tension and frustration the art buyers expressed by leaving "in a huff" after deciphering *Flag for the Moon: Die Nigger* came from recognizing that the gaze they had been so accustomed to directing at others had gazed back and objectified them in a clever game of one-upsmanship. But in this same moment of recognition, the art buyers may not have realized that in her shrewd manipulation Ringgold was effectively drawing on the black vernacular tradition to reclaim the national banner as the symbol of a subaltern American experience, intimately related to the dominant regime yet deriving much of its identity from the violent legacies of American slavery and imperialism.

On another level, the manipulation of the American flag illustrated in Ringgold's account of her first major sale is significant because it relies on well-honed strategies of artifice traditionally employed by subaltern black communities to extract meager victories and petty amounts of capital from a powerful and avaricious labor economy. The black vernacular logic so crucial to Ringgold's aesthetic also manifested itself in this otherwise routine business transaction, eliding clear distinctions between art and the realms of experience, politics, and historical memory. Indeed, in much the same way as we might read the blues and Signifyin(g) as distinct musical and linguistic formations, which double as rich repositories of the black vernacular tradition's theory of itself, a reading of Ringgold's flag paintings that is sensitive to the broader political and social conditions of production yields an appreciation of the visual form as a rich repository of the black vernacular tradition.[18]

In this case, the semiotic play, indirection, and double-voiced nature of *Flag for the Moon*'s minimalist aesthetic are clearly echoed in Ringgold's face-to-face interaction with the powerful art buyers. Even after Rockefeller's representatives decoded the painting, Ringgold used quick wit and

guile to soothe their deflated egos, regaining their confidence enough to achieve yet another deception and secure her first major sale. According to Ringgold, "I knew it was important to get into major collections, but this was also the time to buy some black art, so I knew I had them. The question was, what would I sell them?"[19] Ringgold's acute awareness of the broader political economy that drew Rockefeller's art buyers into her studio and her ability to make instant reads of a sensitive situation were each crucial to the success of this transaction. Indeed, the closing of her first major sale required the improvisational skills and polish of a master trickster in the Black Atlantic tradition. Ringgold's mastery of these skills obliterates the binary logic that usually separates art from other arenas of human activity while placing her squarely in the intellectual tradition so crucial to the identity and survival of Black Atlantic cultures. The chromatic modernism in *Flag for the Moon*, Ringgold's interaction with the art buyers, and the joy with which she recalls outwitting them are all remarkably similar in spirit to tales from black vernacular lore in which trickster figures such as Esu-Elegbara, Papa Labas, and the Signifyin(g) Monkey outwit their more powerful enemies.

*Flag for the Moon: Die Nigger* stands out for yet another reason: it marks the introduction of a complex intentionality into Ringgold's aesthetic repertoire. Much of the significance of *The Flag Is Bleeding* lies at the level of latent, unintended, or otherwise ambiguous meaning(s) attached to the trio of human figures. By eliminating the human figure in *Moon*, Ringgold also eliminates much of the semiotic clutter that prevented her from containing the possible readings of *Bleeding*. But despite Ringgold's careful intentionality in *Flag for the Moon,* this painting retains complex meanings and implications that evade the artist's control, especially as such meanings and implications turn on the issue of gender.

The double-voiced quality in Faith Ringgold's flag art of the 1960s reveals a view of American society that is unique to the experience of African American women, although much of Ringgold's feminist critique is latent during this period. It is in this sense that Ringgold's flag paintings most poignantly embody the double-voiced spirit of Esu-Elegbara and the Signifyin(g) Monkey. Here—unlike the Western tradition—expressive and intellectual devices coexist, exploiting and exposing both the hypocritical nature of American society as well as contradictions in Ringgold's yet evolving gender consciousness. According to Ringgold,

"I think something happens without me meaning to make it happen or controlling it after it happens. Often when I'm painting something, a lot of things come in and I don't know why I do them necessarily. . . . I don't consciously do them and I can't not do them. So I just leave them alone."[20]

Eleanor Flomenhaft, the interviewer to whom Ringgold made this comment, interprets Ringgold's lack of awareness of precisely *how* she creates as evidence of an "expressive thing" devoid of intellect. Yet the consistency with which Ringgold draws on this resource and the consistency with which her art exposes and interrogates the inner workings of both the American social consciousness and her own suggest not a "tension between the intellect and expression" but precisely the opposite.[21] The duality in Ringgold's work makes a strong argument for the presence of *an expressive intellect,* in which the black vernacular tradition operates as a guiding aesthetic/epistemological principle blurring clear distinctions between real and inner worlds.

In the early flag paintings this expressive intellect consistently reveals contradictions masked within the symbolism of the American flag and by the artist's own conscious effort. For instance, although *Flag for the Moon: Die Nigger*'s strident commentary on America's long history of racial hostility and the politics of "spending millions of dollars to send men to the moon while people starve" represents a compelling critique of a social agenda where science is valued more than the lives of the poor, when compared to *Bleeding* it is far less nuanced as a record of Ringgold's personal struggle as an African American woman.[22] Indeed, even though the phrase "Die Nigger" was an evocative marker of a black male martyr complex and an example of the blunt rhetorical style of the black liberation movement of the late 1960s—both of which were dominated by the patriarchal ideology of black nationalism—*Moon* was not intended as a Signification on the gender politics of black nationalism. Instead, as this essay argues, it was intended to Signify on the racial politics of popular patriotism. But given Faith Ringgold's ever-evolving gender consciousness—and indeed her strident feminism of the 1970s—her reluctance to openly address the gender question in her 1960s flag paintings seems rather surprising. The question remains: Why?

The simplest explanation lies perhaps in the difficulty of launching a critique of patriarchy upon an iconic ground as thoroughly saturated with patriarchal meaning as the American flag. Faith Ringgold's initial appropriations of the

American flag as a site of social protest coincided with the period when her art and social activism were centrally concerned with issues of racial inclusion within existing social structures. Despite her disturbing images, the fact that Ringgold's art protested at all testified to a thinly veiled optimism seldom associated with black cultural practices during this tumultuous period.[23] Indeed, both *The Flag Is Bleeding* and *Flag for the Moon: Die Nigger* coincided with the period when a robust economy, the initial legislative and public policy victories of the civil rights era, and the Johnson administration's Great Society programs inspired a sense of optimism among many liberal/left intellectuals that the state and the institutions of the civil society held potential for significant social transformation where issues of racial justice were concerned. Ringgold's central role in the 1968 protest organized by the black art community against the Whitney Museum for failing to include black artists in its exhibition "The 1930s: Painting and Sculpture in America" was motivated not by gender but race-related concerns. The same was true of her efforts (with black sculptor Tom Lloyd and the Art Workers' Coalition) to exert pressure on the Museum of Modern Art to devote a wing to black and Latino art.[24]

Faith Ringgold's advocacy on behalf of racial inclusion within the existing order carried over into her flag paintings of the period. Both *The Flag Is Bleeding* and *Flag for the Moon: Die Nigger* reaffirm a model of social politics in which the image of the martyred black male is a metaphor for a political culture where "an amplified and exaggerated masculinity" functions as a boastful, spectacular centerpiece that "self-consciously salves the misery of the disempowered and subordinated."[25] But this androcentric model of political struggle diminishes the role of women. Consequently, while Ringgold's early flag paintings enabled her to expose the racist discourse just beneath the surface of popular patriotism and in so doing rename the American flag as a counterhegemonic symbol, by mobilizing her critique simply at the level of race she left patriarchal structures responsible for the silence and repression of women untouched.

During this time Ringgold was becoming increasingly aware of her marginalized gender status. This tension initially registered itself in the anger and cynicism clearly expressed in her aesthetic. But Ringgold's anger during this period was not directed solely at white patriarchy. Her memoirs poignantly recall the rejection and humiliation of her initial interactions with the black male-dominated art scene in New York during the 1960s. According to Ring-

gold, "I was not able to talk woman to man with the great black minds of my time. They did not accept me as an equal." Moreover, even as her aesthetic drew on black nationalist motifs, Ringgold remained on the periphery of groups such as Africobra and Harlem's Black Art Theater: "You would have to think very little of yourself to be a member of the black nationalist movement and be a woman . . . black women were not considered *women*."[26]

But the gender bias and isolation Ringgold endured during the late 1960s did not immediately translate into a gender-conscious aesthetic. According to Ringgold, this was a period when "making quilts was the farthest thing from my mind." Neither was she yet prepared to self-consciously "deal with women's issues."[27] Instead, her work during this period emanated primarily from her social location as a middle-class, academically trained African American painter concerned with issues of racial justice and inclusion. In speaking to the absence of a gender dimension in her art and political activism of the late 1960s she recently stated: "Trying to get the black man a place in the white art establishment left me no time to consider women's rights. I had thought that my rights came with that of the black man's. But I was mistaken. Now what was I to do?"[28] One thing she did for certain was continue to paint, but her work of this period reflects an intuitive recognition that the social structures that make racial inclusion possible share at their very base a commitment to patriarchal ideologies. In the 1960s this paradox resulted in a circuitous, double-voiced aesthetic in which Ringgold's still-latent gender sensitivity found expression. But as she sought to self-consciously use her work as a forum to openly address concerns specific to African American women, an iconographic ground less thoroughly imbued with the violent history of American patriarchy became necessary.

In the years between *Flag for the Moon: Die Nigger* and *Flag Story Quilt,* the emergence of Faith Ringgold's self-conscious feminism signaled a radical shift in her thinking about the possibilities for social change. Ringgold's newfound gender consciousness was immediately reflected in her aesthetic. Whereas her flag paintings of the 1960s had assumed a model of social struggle grounded in the transformation of patriarchal structures, by the time she returned to the American flag in 1985, Ringgold had long since abandoned this model of social change for one located in the more female-controlled spheres of the home

and family. This shift in Ringgold's aesthetic reflected a shift not only in the locus of social change but also in the ways in which social power and the possibilities for change based on it are defined. In other words, Ringgold's work of the 1970s shifted from a concern for empowerment in the public sphere to a focus on modes of empowerment located in familial, personal, and even metaphysical realms.

The incorporation of textiles and written narrative into her aesthetic was essential to Ringgold's ability to assume this more enlightened, empowered position. The soft-sculpture dolls, masks, and tankas that populated Ringgold's portfolio in the early 1970s enabled her to break away from an exclusive obeisance to cumbersome wooden frames and stretched canvas. In addition, as collaborative efforts—often done with the assistance of Willi Posey Jones, her fashion designer mother—these works gave her access to forms of praxis and knowing closely linked with a distinctly female, family-oriented cultural legacy.[29] Already in the late 1960s—long before the inclusion of either feminist social theory or the quilt form into her aesthetic repertoire—Ringgold had incorporated writing into works such as *Flag for the Moon: Die Nigger, U.S. Postage Stamp Commemorating the Advent of Black Power,* and the *United States of Attica* poster. However, it was not until after she openly embraced feminism that she began seriously to exploit the possibilities of written narrative as a creative and critical tool, helping her to articulate a distinctly feminist consciousness. According to Ringgold, "The story quilt grew out of my need to tell stories not with pictures or symbols alone, but with words."[30]

In 1985 Ringgold brought her interest in both the quilt and written narrative as distinctly feminist modes of knowing into her work with the American flag. Like her previous flag paintings, *Flag Story Quilt* inverts the meaning of the national banner by integrating its forms with unlikely elements. As

its title implies, both the quilt and the story form are incorporated into Ringgold's ongoing interrogation of the American experience through the image of the national banner. Not unlike the flag, the quilt has a long history as an iconic banner of sorts, but one more closely linked with images of the ideal American home. The symbolism of its patchwork design and its association with domesticity, warmth, and tradition have often been employed within hegemonic discourses to legitimate, maintain, and reproduce both patriotic master narratives and prevailing social hierarchies. But within the African American experience such meanings are far outweighed by the quilt's long and intimate tradition as both a collaborative art form and a key site of memory, especially among women.[31]

*Flag Story Quilt* represents Faith Ringgold's most recent effort to use the American flag to unveil a subaltern experience usually masked by patriotic master narratives but central to the national consciousness nonetheless. Strips of tie-dyed fabric represent both the red stripes of the flag and the blue field containing the stars. The fifty stars are represented by small patches of appliquéd white cloth, each cut into the shape of a human skull in profile. Each skull contains a sequined eye. All these elements have in turn been appliquéd onto a canvas background, which in turn has been attached to the requisite lining and backing of the quilt form.

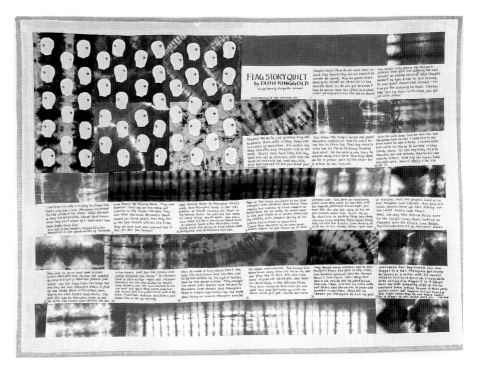

*Flag Story Quilt,* 1985

Appliqué on canvas, 57 x 78"
Collection of Spenser Museum,
Lawrence, Kansas
Photo: Gamma One

In keeping with the radical spirit of Ringgold's earlier flag paintings, *Flag Story Quilt,* by combining the quilt and the short story, is a pastiche that deconstructs modernist categories of high art by eliding clear distinctions between the written and the visual as well as those separating utilitarian, craft-based forms from the so-called high arts. Ringgold's decision to credit Marquetta Johnson (the fiber artist responsible for the tie-dyed fabric) by inscribing her name on the quilt acknowledges that *Flag Story Quilt* is the product of a collaborative effort. Each of these gestures in turn also disturbed traditional notions of connoiseurship. Finally, Ringgold's *Flag Story Quilt,* not unlike her previous flag paintings, continues to draw on the black vernacular tradition to Signify on patriotic master narratives, calling out, if you will, a history of racial repression concealed within the symbolism of the American flag while critiquing both the binary nature of Western logic and modernist constructions of art and culture that reproduce these logics.

But it is also in relation to the black vernacular tradition that *Flag Story Quilt* is perhaps most unlike Faith Ringgold's previous flag paintings. For instance, the inclusion of an openly feminist social and cultural critique into her ongoing critique of racial oppression meant that the double-voiced quality central to her early flag paintings ceased to reveal inner tensions around gender. Moreover, the open embrace of feminism into Ringgold's art also provided her with ideographic tools necessary to dislodge the American flag's singular association with patriarchy and the public sphere. In juxtaposing the American flag with signifiers of a distinctly feminist consciousness (e.g., the quilt, written narrative) in *Flag Story Quilt,* Ringgold extends the doubleness already contained in the flag much further than in her previous work, effectively reclaiming it as a ground for both race- and gender-based critiques. In *Flag Story Quilt,* Ringgold makes use of the dynamic ideographic ground to wage a frontal assault on the phallocentrism of black political culture through the fictional story of Memphis Cooly.

Handwritten within the white stripes of the flag and told in dialect from the perspective of an omniscient black female narrator, the *story* of *Flag Story Quilt* recounts one black man's tragic encounter with the American judicial system. An armless paraplegic disabled during the Vietnam War, Memphis Cooly overcame his physical limitations to become the ghostwriter of several successful romance novels. Despite this momentary triumph over physical injuries caused by America's imperialistic foreign policy, Memphis has become the victim of a far more imperious domestic "policy," in which racial myth and hysteria frequently displace reasoned, dispassioned judgment in matters where race and sex overlap. Memphis Cooly has been convicted and sentenced to death for the unlikeliest of crimes: the rape-murder of a nineteen-year-old white "girl," whose body was never recovered despite witnesses who claim to have seen it dumped into the Harlem River. In commenting on *Flag Story Quilt,* Ringgold stated that the "story is based on the premise that the black man's guilt, whether likely or unlikely, is almost always taken for granted long before it is actually proven." [32]

While the merging of the quilt form with the flag integrates two forms linked in their power to evoke images of a tactile, nurturing, distinctively female Americana, the content of *Flag Story Quilt* marks Ringgold's momentary return to the metaphor of the black male martyr. As in the 1960s flag paintings, Ringgold posits the nation, via the American flag, as the optimal locus for change and the figure of the black male martyr as the metaphoric agent of that change. But instead of invoking a confrontational aesthetic, in *Flag Story Quilt* Ringgold adopts a softer appeal to reason and morality.[33]

This more humanist appeal takes the form of Ringgold's narration of Memphis Cooly as an unlikely rapist caught up in a racist judicial system. But the characterization of Cooly—the innocent boy-next-door *turned* armless, paraplegic Vietnam vet *turned* successful romance novelist—as a virtuous victim caught in the web of an evil judicial system is so overwrought and unrealistic that it appears suspiciously close to a parody of the difficult relations between black males and American jurisprudence. Once again, Ringgold manipulates nationalist cultural sensitivities on both sides of the black/white racial divide to lure the viewer into her sardonic trap.

Ringgold's biting gender commentary in *Flag Story Quilt* is made explicit when she reveals that Memphis Cooly is a eunuch who "never touch[es]" his manipulative wife (a seductress named Verona Valle, whom the narrator accuses of complicity in Memphis's frame-up). In castrating her black male protagonist, Ringgold repudiates the male-centrism of her previous flag paintings while opening a space for the critical (re)examination of the violent racial legacy that is masked under appeals to American patriotism. But Ringgold's representation of an impotent black male martyr/warrior is perhaps most significant because of the challenge it poses to the phallocentric, confrontational

models of social history and struggle so central to African American political culture. In parodying the archetypal male hero figure (as well as her own reliance upon this trope in previous work), Ringgold Signifies on the utility of patriarchal social models in which "an amplified and exaggerated masculinity" functions as the silent center of an authentic black political culture.[34]

Ringgold's return to the American flag after nearly a generation suggests that *Flag Story Quilt* was intended as a transitional work, allowing a momentary return to her prefeminist period for the sake of closure as she set the stage for her next phase of creative exploration. In *Flag Story Quilt* the emasculation of the black male martyr/warrior figure represents an effective, if somewhat shocking, way for Ringgold to mark for herself and her audience the shift in gendered regimes of consciousness in her work. This act of self-affirmation prepares the ground for the black feminist heroines of her later story quilts, who, despite considerable odds, are able, sometimes literally, to fly over the obstacles that confront them.[35]

## NOTES

I would like to express my sincere appreciation to Sharon Patton, Elsa Barkley Brown, Rebecca Zurier, and Romy Berger for their careful readings of earlier drafts of this essay and for their wise counsel and encouragement through the course of its development.

1. Amiri Baraka, "Faith," *Black American Literature Forum* (1986): 12.

2. My effort to situate Ringgold's flags as fetishes is heavily informed by recent work in cultural studies, especially that of Anne McClintock. See Anne McClintock, *Imperial Leather: Race, Gender and Sexuality in the Colonial Context* (New York: Routledge, 1995).

3. In speaking of her first flag painting, *God Bless America*, in a July 28, 1996, interview with the author, Ringgold dismissed its "ridiculous imagery."

4. In her memoirs, Ringgold recalls her desire to "complete" Johns's flag painting by showing "some of the hell that had broken out in the States." See Faith Ringgold, *We Flew over the Bridge: The Memoirs of Faith Ringgold* (Boston: Little, Brown, 1995), p. 158. For a recent, if somewhat overzealous, effort to assess the cultural significance of *Flag,* see Arthur C. Danto, "Jasper Johns," *The Nation* (January 27, 1997): 32–35.

5. Ringgold describes "Super Realism" as a way of rendering the portrait to make "people feel like they were looking at themselves." This approach to the black portrait required that chiaroscuro be abandoned in favor of flat color. Moreover, Ringgold bristles at the notion advanced by some critics that this aesthetic style represents a "naive" approach to the human portrait. See Eleanor Flomenhaft, "Interviewing Faith Ringgold: A Contemporary Heroine," in *Faith Ringgold: A Twenty-five Year Survey,* ed. Eleanor Flomenhaft (Hempstead, N.Y.: Fine Arts Museum of Long Island, 1990), p. 9.

6. Ringgold, *We Flew over the Bridge*, p. 157.

7. Ibid., pp. 162–63.

8. Quoted in Elsa Honig Fine, *The Afro-American Artist: A Search for Identity* (New York: Holt, Rinehart and Winston, 1973), p. 198. See also Lowery S. Sims, "Race Riots. Cocktail Parties. Black Panthers. Moon Shots and Feminists: Faith Ringgold's Observations on the 1960s in America," in *Faith Ringgold: A Twenty-five Year Survey*, p. 17.

9. Ringgold interview, July 28, 1996.

10. Two recent studies of the American flag give at least some attention to its history as a highly charged site of political protest. See Scott M. Guenter, *The American Flag, 1777–1924: Cultural Shifts from Creation to Codification* (Cranbury, N.J.: Associated University Presses, 1990), and Robert Justin Goldstein, *Saving "Old Glory": The History of the American Flag Desecration Controversy* (Boulder: Westview Press, 1995).

11. Ringgold interview, July 28, 1996.

12. The "People's Flag Show" was an exhibit of over two hundred flag paintings held in November 1970 at the Judson Church in Greenwich Village, New York City. The show was organized by an ad hoc committee of independent artists to protest the violation of "free speech" in the 1967 arrest of a New York art dealer accused of showing art made of the American flag. See Ringgold, *We Flew over the Bridge*, pp. 173–216.

13. Quoted in Flomenhaft, "Interviewing Faith Ringgold," p. 10.

14. See Sims, "Race Riots. Cocktail Parties," p. 20. See also Terrie S. Rouse, "Faith Ringgold—A Mirror of Her Community," in *Faith Ringgold: Twenty Years of Painting, Sculpture and Performance, 1963–1983,* ed. Michele Wallace (New York: Studio Museum in Harlem, 1984), p. 9. Also important to the development of Ringgold's aesthetic vocabulary during this period was the influence of Robert Gwathmey, one of Ringgold's art instructors at City College, who is best known for his cubist depictions of rural blacks.

15. According to the literary critic Henry Louis Gates, "Signifyin(g)" is the metaphor for the complex system of double-voiced rhetorical styles peculiar to (but not exclusive to) black vernacular traditions. Rooted in principles of formal language usage and interpretation found in the mythical systems of new world African cultures, black vernacular Signification is formally characterized by the use of indirection, formal revision, repetition, and word play. To Signify is to pun, or less innocuously, to rename; it requires of the "speaker" the ability

to play with, mock, or free-associate with linguistic signifiers thought to be transparent. To distinguish black vernacular Signification from Western models of signification Gates capitalizes the "S" and adds parentheses around "(g)." See Henry Louis Gates, Jr., *The Signifyin(g) Monkey: A Theory of African-American Literary Criticism* (New York: Oxford University Press, 1988).

16. Ringgold, *We Flew over the Bridge,* p. 158.

17. Ibid., p. 174.

18. See Gates, *Signifyin(g) Monkey.* For the blues as a site of African American vernacular's theory of itself, see Houston Baker, Jr., *Blues, Ideology and Afro-American Literature: A Vernacular Theory* (New York: Oxford University Press, 1984).

19. Ringgold interview, July 28, 1996.

20. Quoted in Flomenhaft, "Interviewing Faith Ringgold," p. 10.

21. Quotes from Flomenhaft in ibid.

22. Ringgold interview, July 28, 1996.

23. Ringgold has suggested that her rejection by the black nationalist art community in New York was based not only on gender but on the fact that "they saw me as a protest artist and they didn't believe in protest" (ibid.). However, even black nationalist culture practice contained an optimistic view of the future, even if it assumed highly quixotic, often chauvinistic forms. See Richard J. Powell, *Black Art and Culture in the 20th Century* (London: Thames and Hudson, 1997), pp. 121–60.

24. Ringgold, *We Flew over the Bridge,* pp. 165–72. See also Grace Glueck, "At the Whitney, It's Guerrilla Warfare" *New York Times* (November 1, 1970), sec. 2, p.20; Glueck, "Foes of Biennale Open Show Here," *New York Times* (July 25, 1970), sec. 2, p. 23.

25. Paul Gilroy, *The Black Atlantic: Modernity and Double-Consciousness* (Cambridge: Harvard University Press, 1993), p. 85.

26. Ringgold interview, July 28, 1996; emphasis added. The sarcasm with which Ringgold inflects "women" here was a thinly veiled reference to the manner in which she believes the sexual objectification and conquest of white women in black nationalist circles tainted the treatment accorded all women. For Ringgold's relationship to the black art scene in New York during the 1960s, see Ringgold, *We Flew over the Bridge,* pp. 150–52. Another view into Ringgold's thinking and activity of this period is provided in the recollections of her daughter, the feminist cultural critic Michele Wallace. See Wallace, "A Black Feminist's Search for Sisterhood," in Gloria T. Hull, Patricia Bell Scott, and Barbara Smith, eds., *...But Some of Us Are Brave* (New York: Feminist Press, 1982).

27. See Ringgold, *We Flew over the Bridge,* pp. 164, 161.

28. Ibid., p. 175.

29. Ringgold has commented that her current work with the quilt form merely extends a rich tradition of textiles among the women in her family, beginning with her great-great grandmother Susie Shannon. See Ringgold, *We Flew over the Bridge,* especially pp. 67–80.

30. Quoted in Thalia Gouma-Peterson, "Modern Dilemma Tales: Faith Ringgold's Story Quilts," in *Faith Ringgold: A Twenty-five Year Survey,* p. 23.

31. Recent scholarship across several disciplines has documented the connection between African American women's history and the quilt form. For a sample of this literature see Jacqueline Jones, *Labor of Love, Labor of Sorrow: Black Women, Work and the Family from Slavery to Present* (New York: Basic Books, 1985); Deborah Gray White, *Ar'n't I A Woman? Female Slaves in the Plantation South* (New York: W. W. Norton, 1985); Cuesta Benberry, *Always There: The African-American Presence in American Quilts* (Louisville: Kentucky Quilt Project, 1992); Eli Leon, *Who'd a Thought It: Improvisation in African-American Quilt-making* (San Francisco: San Francisco Craft and Folk Art Museum, 1987); Gladys-Marie Fry, *Stitched from the Soul: Slave Quilts from the Antebellum South* (New York: Dutton Studio Books/Museum of American Folk Art, 1990); Eva Ungar Grudin, *Stitching Memories: African-American Story Quilts* (Williamstown, Mass.: Williams College Museum of Art, 1990); and Maude Southwell Wahlman, *Signs and Symbols: African Images in African-American Quilts* (New York: Studio Books/Museum of American Folk Art, 1993).

32. Ringgold, *We Flew over the Bridge,* p. 255.

33. The body of story quilts Ringgold produced in 1985 merits serious critical discussion in its own right. Along with *Flag Story Quilt*, Ringgold completed *Street Story Quilt* and *No More War Story Quilt*. The narratives of these story quilts mark a significant departure from Ringgold's woman-centered aesthetic by focusing on the tragic black male hero.

34. Gilroy, *The Black Atlantic*, p. 85. My effort to position Ringgold's flag paintings as a black feminist intervention into androcentric narrations of American life and history has been heavily informed by my work with Elsa Barkley Brown. In particular I am referring to an unpublished paper I researched for her entitled "Gender, Nationalism and a Century of Black Studies," delivered at the conference "Black Studies: (Re)Defining a Discipline," held at Ohio State University on June 23–24, 1997. See also E. Francis White, "Africa on My Mind: Gender, Counter Discourse and African-American Nationalism," *Journal of Women's History* 2 (Spring 1990): 73–97; Joyce Hope Scott, "From Foreground to Margin: Female Configurations and Masculine Self Representation in Black Nationalist Fiction," in Andrew Parker et al., eds., *Nationalisms and Sexualities* (New York: Routledge, 1992), pp. 296–312.

35. In 1996 Faith Ringgold planned to return to the American flag with an art quilt she tentatively titled *The Flag Is Bleeding, Part II* (Ringgold interview, July 28, 1996).

Thalia Gouma-Peterson

## Faith Ringgold's Journey

### From Greek Busts to African American Dilemma Tales

*In 1948 I went to City College. There I copied Greek busts and got a sound background in Western Art. Greek sculpture. Compositions after Degas. . . . But I didn't know how to get from Degas and Greek busts . . . to Faith. That would take me considerable time.*

—FAITH RINGGOLD
in Eleanor Munro, *Originals: American Women Artists*

*i*

IN THE COURSE of the lengthy journey that took her from Greek busts back to herself, Faith Ringgold moved from traditional landscapes and cubist-style paintings through her large political canvases of 1963–67, her *Black Light* paintings of 1969, her *Slave Rape* tankas of 1972, and her masks, soft sculptures, and performances of the mid- and late 1970s (*Witch Masks, Family of Woman Masks, Portrait Masks of Harlem*) to reach her quilts of the early 1980s. In this journey her mother, Willi Posey, and her early memories of Harlem played a pivotal role. They made the journey possible.

Born in Harlem in 1930, Ringgold has lived there most of her life and continues to maintain a studio there, even though she now resides in New Jersey and spends half the year in California.[1] Images and memories of Harlem permeate her work, especially the portrait masks and soft sculptures of the 1970s and the quilts of the 1980s. In these works, which are far removed from Greek busts, she combines present realities with childhood memories of Harlem as "a friendly, beautiful place."

Ringgold's mother, a fashion designer and dressmaker, helped in creating the bridge from past to present. Mother and daughter began collaborating in 1972, the year Ringgold became tired of dragging huge stretched canvases up and down narrow stairways. She decided to make soft

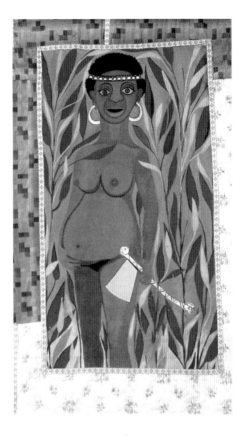

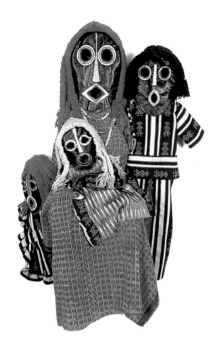

*Mrs. Jones and Family*
*(The Family of Woman Masks* series), 1973

Sewn fabric and embroidery, 60 x 12 x 30"
Collection of the artist; photo: Karen Bell

*Fight to Save Your Life*
*(Slave Rape* series), 1972

Oil on canvas, 87 x 48"
Photo by the artist

and mythic, private and public contexts of the African American woman. In them Ringgold fused new feminist and traditional African forms and used new materials that derive from traditional sources (women's work and traditional African art).[5]

The collaboration with her mother continued until Posey's death in 1981. Significantly, their last joint effort, which Ringgold describes as their "great work together," was for a group show of quilts by women artists done in collaboration with women quilters.[6] Titled *Echoes of Harlem,* the quilt, which combines thirty painted faces within rectangular divisions and traditional quilted strips of multicolored fabric, places the men and women of Harlem in the traditional context of women's lives. It also provides a link with Ringgold's own family tradition, for her mother had been taught how to quilt as a child by her own grandmother "in the old way, boiling flour sacks until they were white for the backing."[7] Moreover, the quilt is part of daily life. Ringgold commented on its purpose as a functional object to be used by people. "It is for a bed, to be laid out flat. . . . It covers people. It has the possibility of being part of someone's life forever."[8]

In 1973, inspired by West African traditional art and ceremonies, Ringgold created several series of masks and portrait masks focusing primarily on women. The raffia, beads, and scraps of fabric she used in these figurative pieces derive both from African art and from Posey's métier. In 1974 she began combining paintings, masks, and soft sculptures in installations such as *Windows of the Wedding.* In 1976 she started using the masks in performances in ways related to West African ritualistic festivals that combine masks and sculptures with costume, music, dance, and drama.[9]

Ringgold's performances are carried out within the setting of her own work, with her paintings and sculptures acting as a background. The culminating work of this period is *The Wake and Resurrection of the Bicentennial Negro* (1976). A performance piece intended for audience participation, it uses masked performers and taped music, but it can also exist as an environment/installation. The heroine and hero of the story are dead: Buba, a junkie who died of an overdose of drugs, and his wife, Bena, who died of grief. The performance combines elements of the black American wake with African beliefs that "hold ancestral deities in a state of limbo until they are released through dance to return to the community in search of new lives."[10] Buba and Bena come back to life through the love of their family, especially their mother, and reform. According to Ringgold,

paintings on lengths of cloth, with frames made of fabric, which could "be rolled up like Tibetan tankas."[2] Willi Posey designed and constructed the fabric frames. This collaboration, with Ringgold painting and Posey cutting and sewing, revived childhood memories of quiet hours spent drawing in bed (as a child she suffered from asthma) while her mother designed and sewed dresses. Ringgold had wanted for a long time to make things with cloth. Her decision to do so coincided with her decision to create paintings that focused on women's experience. The *Slave Rape* series, her most important tanka-framed paintings, deal with the plight of women during the tragedy of the West African slave trade.[3]

In 1973, wanting her art "to have a more human dimension than the flat tankas,"[4] and wanting to create works that had a closer connection with the realities of everyday life, Ringgold embarked on a new project, a series of masks that included portraits of women and children she had known as a child. In these, the collaboration with her mother became more extensive, for Posey designed and sewed the clothes, which Ringgold then molded into the life-size figures. These works concentrated on the historical

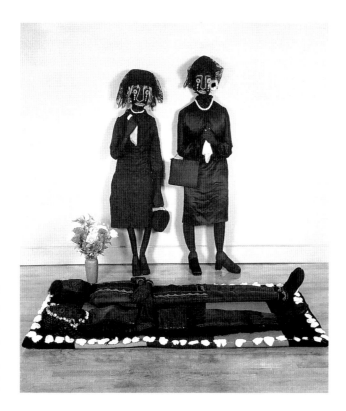

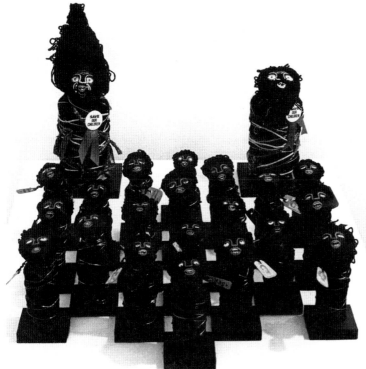

"Buba becomes a new, more sensitive man without dependence on drugs, and Bena becomes a new woman, liberated and aware." Here Ringgold effectively combines African beliefs in the continued life of the spirits of the dead with the realities of twentieth-century life in America.

The four main figures in the piece, Moma, Nana, Bena, and Buba, are life-size soft sculptures. They are combined with five mask figures[11] that hang on the walls (and are worn by the participants during the performance), as well as a number of dance masks. The impact of all these figures, garbed in black, looking at Bena and Buba lying on the floor, is both dramatic and awesome. The story, as conceived by Ringgold for the performance, ends on a hopeful note. But the starkness and sorrow of the wake set the dominant tone in the installation. Its tragedy is gripping and unforgettable.

Faith Ringgold has never shied away from commenting on the tragic aspects of the life of black Americans. She did this most intensely in three 1981 works, the *Atlanta* series, created in response to the senseless killings of black children in Atlanta during that year. The first of these pieces, *Atlanta Children,* consists of twenty small doll-like figures (the number of children killed at the time) wrapped in black satin and tightly bound with wire. They stand together against a white field and look upward. Each has a tag with the name and photograph of one child. In the background stand two adult figures, a man and a woman— also bound, hopelessly watching and screaming "Save our children," as inscribed on the buttons they wear. This is one of Ringgold's most agonized and impassioned pieces. It and the two other related works (*Save Our Children in Atlanta* and *Screaming Woman*) powerfully express her feeling at the time, which she has described as "self-contained rage." She has referred to these 1981 sculptures as "wild art": an art "we do about things we can do nothing about. It is an obsession we cannot escape. So we isolate it, picture it, and then we are free to go on."[12]

Elements of "self-contained rage" were present in Ringgold's political paintings of 1967, the *American People* series. Large mural-size canvases (72 x 96"), harshly painted and somber in mood, these works are about racial tension and the distribution of power in America.[13] In the *Flag Is Bleeding,* two iconic frontal figures of a black man and white man are held together (united?) by a limp, slender, and powerless blonde woman. Over the three figures is superimposed the pattern of a bleeding American flag. *Die,* an angry, blood-stained, and prophetic painting, represents a hypothetical confrontation of blacks and whites in

*U.S. Postage Stamp Commemorating the Advent of Black Power,* 1967

Oil on canvas, 72 x 96"
Courtesy of ACA Galleries,
New York and Munich
Photo: Malcolm Varon

squares, combines narrative text, images, and traditional quilting squares. The story, a contemporary folktale written in traditional black dialect, centers on the popular culture motif of Aunt Jemima, transformed into a successful businesswoman, and the members of her family—parents, husband, children, and grandchildren.

The narrative combines elements of folklore and anecdote with the African and West Indian Dilemma Tale, traditions Ringgold absorbed from her mother's storytelling.[15] It mixes black and white people ("Lil Rufus," Jemima's son, "married a white gal, name a Margo . . . he picked up in Germany, of all places, during that Korean War"). But, unlike traditional folktales, which use stock characters that represent moral absolutes, Ringgold's tale does not make absolute judgments; all blacks are not good, and all whites are not bad (though Margo, "she a scrawny little ole white gal"). Thus it questions our preconceptions. It also does not reach a clear conclusion. Rather, it leaves the audience with a question to puzzle over, as Dilemma Tales do. The heroine and her husband, Big Rufus, die in a fatal car accident "on the way to open they restaurant." Their good son "Lil Rufus brought they bodies back to Harlem, and give 'em an African funeral—Praise God!" But their daughter and her husband, that evil "ole ugly black man Dr. Jones," and "them two worthless chilrun a hers" got Jemima's restaurant. And the story concludes: "Now who's afraid of Aunt Jemima?"

The eloquence of this vital, colorful, and complex quilt completely absorbs the spectator. It crosses two folk forms, the folktale (or family legend) and the quilt, both of which use traditional methods and prefabricated materials (characters, motifs, and structures) inherited from a long tradition—materials they recycle and adapt. The spectator recognizes the visual and literary genre; at the same time, the specificity of the protagonists of this fictitious family legend makes it clear that they are real people whom Faith Ringgold has known. In fact, Jemima Blakey, the beautiful dark-black businesswoman in her colorful dress and elegant hat, appears to be an incarnation of Ringgold's mother, who died shortly after she and her daughter completed their collaborative quilt.

The Aunt Jemima quilt, therefore, is a tribute to Willi Posey. In designing and stitching it, Ringgold worked through her grief and could smile at her mother's gift to her: a tradition of strength, independence, and survival in a less than perfect world. This gift is shared by the series of anonymous black women that frame the main characters. It is solid enough and stable enough to survive some

a suburban riot. And the ironic *U.S. Postage Stamp Commemorating the Advent of Black Power* juxtaposes an ascending ladder of ten masklike black faces (shown only in segments) with ninety white mask segments. Over these masks are superimposed the legends "Black Power" and "White Power" in black and white letters, respectively. "White Power" can be seen only when the painting is turned on its side and is therefore much more obscure than the clearly articulated "Black Power."

In these paintings the "self-contained rage" has been tempered by Ringgold's ironic wit and love of satire. One might describe this wit as her ability to laugh through tears, an ability that becomes a means of survival when the work is not about the other but about the self. The *Atlanta* pieces, as Ringgold has explained, were not "just about the children in Atlanta," they were "about me. The work had become me and my experience."[14]

Clearly, the Greek busts had been left behind forever. But they had not been forgotten; for, after all, they are the standard that those of us educated in the Eurocentric tradition measure ourselves by. They are alluded to in one of Ringgold's wittiest and most intensely personal pieces (1983), her large quilt (90 x 80") dedicated to the black heroine (or antiheroine) Jemima Blakey. Titled *Who's Afraid of Aunt Jemima?*, the quilt, which consists of fifty-six

"worthless" children and grandchildren and even to absorb the Greek bust in the person of "Lil Rufus," Jemima's son, who was "handsome as a Greek God" but "took color after Jemima's side a the family." The quilt, in fact, celebrates the survival of the black family, which Ringgold sees as the best support for political power.[16]

*Who's Afraid of Aunt Jemima?* was a turning point in Ringgold's art. After its completion, she devoted her creative energies exclusively to the making of story quilts with complex narratives, some derived from her own experience, others structured as parables. In either case, they are Ringgold's means of telling her own story. As Kimberle Crenshaw has recently observed, storytelling aims at "challenging versions of reality put forward by the dominant culture."[17] This is precisely what Ringgold has continued to do since 1985. Through storytelling and the manipulation of racial iconography, she has created a narrative that transforms our perceptions of black people.[18] It is the central achievement of her modern Dilemma Tales, which are specifically and exclusively African American.

*Street Story Quilt* of 1985, a narrative triptych of urban American life, is one of Ringgold's most ambitious quilts. Each section corresponds to a part (*The Accident, The Fire, The Homecoming*) of the story that traces the life of A.J. (short for Abraham Lincoln Jones) from childhood through adolescence to adulthood and his final achievement of the American dream.[19] The tale begins with a catastrophe, the death of A.J.'s mother and four brothers in a car accident. The narrator is a woman, a relative of the family, Miss Gracie, who has recently come from the South, and the story is told in black dialect.

During the terrible years of distress after the accident, A.J. and his father, Big Al, begin drinking together: "You ain never seen a big ole 6½ foot man with his little boy, and they both drunk." But A.J. receives support and solace from Ma Teedy, his maternal grandmother, who was "a singing barmaid at the Sky Lark Bar" and whom Big Al called "Old Miss Young," but who, the narrator tells us, "was a real woman." Again, as in the Aunt Jemima quilt, there are some good whites, like the captain of the precinct, without whom "A.J. been in reform school instead of the army." When A.J. returns from Vietnam on crutches and with his spirit broken, Ma Teedy bolsters his spirits: "You do something with you life. Make your gramma proud. Cause I'm tired of cryin at funerals." And the next thing they knew, "A.J. was gone to Paris Lord to be a writer like Big Al neer was." Then A.J. makes it big in Hollywood and returns like a deus ex machina, dressed in white from head to toe, in his white Cadillac limousine, driven by a white chauffeur, to take Ma Teedy out of Harlem as he had promised.

Each of the quilt's three sections is designed as a stylized tenement facade and is divided into five stories with rectangular windows, out of which people look at what is happening on the street below. The text runs in narrow strips above and under the windows, functioning as a running commentary on the images. In each section the main characters and events are easily recognizable. The strips of patterned cloth that frame each section and run vertically between the windows, as pilasters, help to set the general tone, as does the color in the windows. Bright and gay in part one, the colors inside the windows become smoky and indistinct in part two (*The Fire*) and continue to be subdued in part three (*The Homecoming*) with walled-up, boarded-up, and blacked-out windows. Ma Teedy's red hair and A.J.'s white Cadillac and clothes gleam in the general drabness of this last section. Though the folk hero, in his modern fiery chariot, comes to rescue his valiant grandmother, the drabness and desolation of the tenement serve as a sobering reminder of the realities of the lives of those who are not special. As in the other Ringgold quilts, the story leaves us with a predicament to puzzle over.

Ostensibly about a talented, exceptional, and fortunate young man who achieves the American dream, the story

*Street Story Quilt, Parts I–III: The Accident, The Fire, and The Homecoming, 1985*

Dyed, painted and pieced fabric, 90 x 144"
Collection of the Metropolitan Museum of Art, New York
Photo: Gamma One

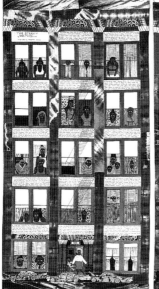

belongs as much to Ma Teedy, the strong, enduring black woman, who provides for A.J. the possibility of living differently, and it is she who is the central agent for change. She is a voice of female authority speaking eloquently at a moment in the story when all seems to have been lost. She shares with Jemima Blakey the gift and power for survival and for effecting change.

The dilemma of survival carries over into Ringgold's own life, as she recorded it in her autobiographical quilt *Change: Faith Ringgold's Over 100 Pounds Weight Loss Performance Story Quilt*, on which she worked during 1985–86. *Change* not only records Ringgold's gain and loss of weight over the last five decades, it also serves as a pictorial transcription of her autobiography, in which she puts the story of her physical changes in the context of psychological and emotional changes in her struggle to be independent. The quilt combines photoetched panels grouping photographs from each decade of her life, starting in the 1930s, with panels of written text. The narrative begins with a photograph of Ringgold at age four and ends with a 1986 photograph of her. Each panel is devoted to one decade, and the viewer follows Ringgold from childhood and adolescence, through her career as a model for her mother, to her life as a grandmother and a political activist. In these panels Ringgold visually records the progressive transformation of

Detail from
*Street Story Quilt, Part I,*
*The Accident,* 1985

Detail from
*Street Story Quilt, Part III,*
*The Homecoming,* 1985

a woman from what she is expected to be to what she wants to be. The weight gain is part of that struggle and a response to the stress and pressures of conflicting demands and expectations. It becomes a protective shield in Ringgold's denial of her stereotyped image as a sex object (the black temptress). Only after she has achieved her professional and artistic independence, in the 1980s, is she able to shed the shield.

In this autobiographical quilt Ringgold most forcefully asserts the subversive "I" as a black woman who refuses to be categorized; her art and life open possibilities for female representation and redefinition, even as her self-image remains fragmented and in a state of flux. Like all the other quilts, *Change* is pieced together from fragments, but the fragmentation is multiplied since each panel is a collage of many photographs/moments in Ringgold's life. Also, the panels are bound together by a fragmented narrative dealing with the process of change. Therefore, her self-image emerges through a triple superimposition of piecing: the photographic collages, the pieced quilt, and the fragmented narrative. It is an extreme example of nonlinear and antilogical construction, dealing with the most illogical subject: weight gain. As in real life and real time, Ringgold's artistic perception of herself is constantly shifting and changing. She has further enhanced this intimate connection between artistic creation and real experience by conceiving of *Change* as an ongoing project, to which she could add sections every year as her weight changed. She also created a complementary performance piece, which involved her physically in her own piece.

During the performance Ringgold, dressed in a quilted jacket identical to the quilt, reenacts her "Over 100 Pounds Weight Loss" by reciting the text of the quilt. She enters the performance area dragging a big, black garbage bag (filled with two-liter plastic bottles of water). It looks like a human body and is equal in weight to what she has lost over the years; she is hardly able to move it. At various points during the performance she returns to the bag and tries to move it, but to no avail. Both at the beginning and at the end, Ringgold intones, "I can do it. I can change, I can

change." Then the audience is invited to join her in dancing to the rhythms of "Only the Strong Survive." This finale is marked by the removal of the quilted jacket and Ringgold's emergence as she is now, as she has re-created herself, as a black activist, feminist, contemporary American artist, whose art speaks with an authoritative female voice.

Performance became an important part of Ringgold's art in the mid-1970s, when she created her major installation and performance piece *The Wake and Resurrection of the Bicentennial Negro*, in which she combines elements of the African American wake with African beliefs that "hold ancestral deities in a state of limbo until they are released through dance to return to the community in search of new lives."[20]

The story of *The Wake*, a modern folktale, set a precedent and model for the tone and themes of Ringgold's subsequent story quilts. It also established the important connections between storytelling, performance, and visual art in Ringgold's work, a connection further exemplified by *The Bitter Nest* series, a sequence of five quilts made in 1988 but whose story Ringgold had created for a performance in 1985. The five-part story, told by the artist as omniscient narrator, is set in Harlem and ranges in time from circa 1915 to the mid-1950s. Like *Who's Afraid of Aunt Jemima?*, it is a family legend and deals with generational relation-

ships. But, unlike *Aunt Jemima*, it is the story of an educated middle-class black family and focuses on the tensions between a mother and a daughter who are profoundly different, both innately and through the circumstances of their upbringing.

Celia Cleopatra Prince, a graduate of Howard University and a doctor, who graduated first in her class, is completely unable to identify with her mother, Cee Cee, who only finished eighth grade and married Celia's father, a dentist, at age fourteen, because she became pregnant. Cee Cee, who "develops a deafness in both ears" after Celia's birth and no longer speaks, is a truly creative spirit, who sews "an endless array of bags," which she uses "as containers for everything." She also performs at the dentist's frequent dinner parties "against an environment of her own colorful bags, coverlets, and wall hangings." Celia dislikes her mother's uniqueness and is disturbed by "her odd looking patterns" because she had learned in drawing to match colors tastefully and harmoniously. She sees her mother as a "tasteless, low class hussy to clutter up the dentist's fine house with all that 'Mammy-made' stuff."

In the concluding part of the story (*Homecoming*) the dentist dies and, again like a deus ex machina, provides for all members of the family by fairly dividing his property among them. But, as is always the case in Ringgold's

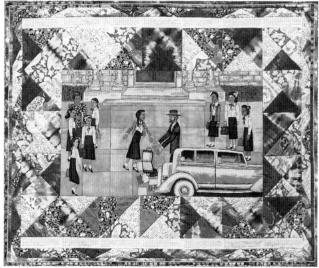

*Love in the Schoolyard (The Bitter Nest, Part 1), 1988*

Acrylic on canvas, printed, tie-dyed, and pieced fabric, 75½ x 92½"
Courtesy of ACA Galleries, New York and Munich
Photo: Gamma One

*Harlem Renaissance Party (The Bitter Nest, Part 2), 1988*

Acrylic on canvas, printed, tie-dyed, and pieced fabric, 94 x 82"
Collection of the National Museum of American Art, Smithsonian Institution, Washington, D.C.; photo: Gamma One

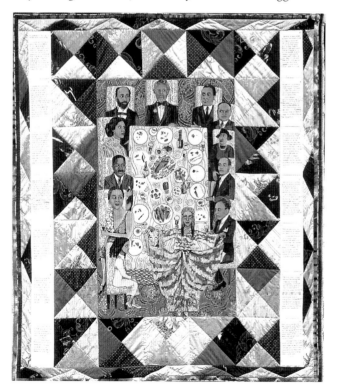

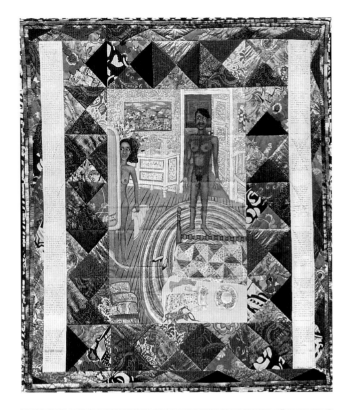

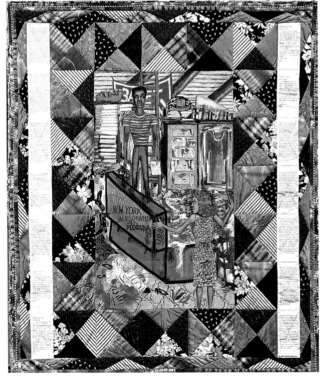

stories, at the end comes the unexpected twist. No longer under her husband's control, Cee Cee takes over the house, makes a studio for herself in her former bedroom, invites family members to move in with her (including her parents, who had moved to Africa years ago), and with the help of her family sets up a shop in the dentist's house, to sell her bags. She even begins to hear and to talk.

*The Bitter Nest* is about being creative and true to one's self. In the end it is Cee Cee, the original creative woman, the artist and nonconformist, who—dancing to music that only she can hear—is the winner. The story and quilt also have autobiographical overtones. In the 1985 performance version, Ringgold, dressed in colorful quilted costumes and wearing masks and headdresses (like Cee Cee at the dinner parties), did a pantomime to the prerecorded sound of her own voice narrating the story. Throughout the performance Ringgold remained silent and the only stage props were ten quilted bags.[21]

Transforming the earlier narrative performance into a quilt series meant identifying moments that would both capture the tone and spirit of the story and illustrate events central to the plot. Part 1: *Love in the Schoolyard* shows the meeting of Cee Cee and her future husband, the dentist. In part 2, *Harlem Renaissance Party*, Cee Cee is dancing in front of illustrious dinner guests.[22] The image of dancing recalls a photograph of Ringgold dancing jubilantly in a long dress included in the autobiographical quilt *Change*. Part 3, *Lovers in Paris* is devoted to the subplot of Celia's happy love affair with Victor in Paris. In part 4, *The Letter,* the progeny of Celia's love affair confronts the woman who raised him and whom he believed to be his mother, with letters he has found in an old steamer trunk written by Celia to his father, Victor. And in part 5, *Homecoming,* the four protagonists and inheritors of the dentist's fortune become reacquainted in Cee Cee's colorful living room, decorated with her quilted wall hangings and coverlets.

The five central tableaux are framed by double-quilted borders between which, on vertical or horizontal strips (depending on the compositional format), is the text. Both images and text are witty and humorous and, in their combination of sparseness and exuberance, reminiscent of folk art. Neither the story, nor the performance, nor the quilted images ever become sentimental or moralizing. The conclusion is open-ended for, even though Cee Cee will thrive and will continue making her bags, the other people, as Ringgold has observed, have their own stories to live through.

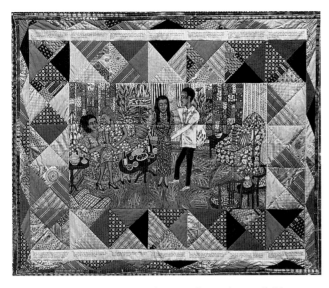

*Homecoming
(The Bitter Nest,
Part 5), 1988*

Acrylic on canvas, printed,
tie-dyed, and pieced
fabric, 76 x 96"
Courtesy of ACA Galleries,
New York and Munich
Photo: Gamma One

The text and images of *The Bitter Nest* show that specificity of time and place became increasingly important in Ringgold's quilts of the mid- and late 1980s. In the text we are informed that Dr. Percel Trombone Prince "was a socially prominent black dentist in the Harlem of the twenties" and that "Celia's family lived in a large townhouse on Harlem's Striver Row . . . famous for its beautiful brownstones owned by the most prominent of Harlem's fashionable 400." In the tableaux the people's dress is used to establish the time and place. This specificity of detail gives the quilts their special character and stresses the fact that these are real people with genuine histories.

The last series of five quilts of the 1980s, the *Woman on a Bridge* series, is a sequence of fantasies that casts women, singly or in groups, in the role of claiming the bridges of New York and San Francisco. In this series Ringgold associates the bridge, "this magnificent masculine structure," with the female quilt. Fascinated by the contrast, she is also intrigued by the intricacy of design of both bridges and quilts. She has described the patterns of bridges as quilts suspended in air, their triangles looking like "little patches of air separated by girders."[23]

The George Washington Bridge, Ringgold's favorite (she has a view of it from her studio window), forms the background for the story and tableau of the opening quilt of this series, *Tar Beach*, set in Harlem in the 1930s. Ringgold remembers how, on hot nights, families moved to the roofs of their brownstones (their tar beaches) to cool off. They brought with them food and bedding and made a picnic out of it. The adults played cards and talked, while the children supposedly slept. Ringgold's happy memories of such nights, "when it was safe to be on the roof top under the open sky," are vivid. There were other families with children on adjoining roofs, and it was like an outdoor party; "you had the sky and it was beautiful."[24]

The memories visually recorded in *Tar Beach* provide the setting in which the eight-year-old heroine and narrator of the story, Cassie Louise Lightfoot, claims the George Washington Bridge "as the stars fell down around me and lifted me up above" the bridge. To claim the bridge all Cassie had to do was to fly over it. Now it is hers forever. Having achieved this feat, Cassie tells us, she will next claim the new union building for her father, a half-breed Indian who has been working on the building but cannot join the union. She will also fly over the ice cream factory and will take her baby brother along. "Anyone can fly," she assures him. "All you need is somewhere to go that you can't get to any other way."

This quilt and the four that followed, as Cassie and Ringgold tell us, are about being free to go wherever one wants. The central message of this wishful fantasy is so clear in the images that Ringgold dispensed with the text in the four subsequent quilts. In *The Winner* a black woman is leading a marathon race of all black men over the Brooklyn Bridge. In *Double Dutch on the Golden Gate*, the quintessential after-school street game of black girls in Harlem has been transferred to the Golden Gate Bridge, over which they levitate, with the facades of the brownstones behind them. In *Woman Painting the Bay Bridge*, a lone nude woman, with wildly windblown hair, flies over the bridge, which she paints in a brilliant red. And, in the concluding quilt of the series, *Dancing on the George Washington Bridge*, fifteen women have invaded the bridge, on which they dance, flying in midair, with all of New York below them.

In each of the last four quilts, a bridge, set against a brilliant blue sky, dominates the composition. Ringgold's major challenge was not to let the figures be dwarfed by the bridge. This she achieved through the use of motion in flight. The mobility and energy of flight and the freedom of placement it allows resolved the formal problem of balancing figures and bridge and clearly restated the series' central theme, about being free and able to claim the untenable as one's own. This energetic, colorful, and witty series of quilts, like most of Ringgold's work, may initially amuse us, but it has a serious message. The emphasis on attaining the impossible reminds us of what African Americans have not been able to attain.

Though very contemporary and untraditional, Faith Ringgold's quilts retain their association with their traditionally female genre. At the same time they are difficult-to-categorize paintings and dramatic narratives. Through her choice of form and content, Ringgold has produced a meaning of her own that subverts hegemonic language and questions male dominance and power. In her highly

individual way, and through her personal strategy (combining the quilt format, narrative, painting, stitchery, and photoetching, and interweaving traditional folktales and contemporary stories), she asserts the black woman's voice. Her heroines and narrators speak with authority both as voices and as dominant images. Men lose their position of centrality and are defined in relation to women (sons, grandsons, lovers, husbands); even fathers are displaced from their position of authority (e.g., Ma Teedy becomes both father and mother to A.J., Cee Cee appropriates the dentist's house, Cassie claims the union building for her father).

With her modern Dilemma Tales, full of detail and irony, Ringgold claims the storyteller's power to run the world, to keep it going by holding things together. By describing and

asserting the full humanity of black people and presenting the complexities of their lives through the double and sometimes triple narrative voice of black women, she has avoided their objectification, their loss of full human identity—a loss W. E. B. Du Bois has described as "the peculiar sensation of always looking at one's self through the eyes of others."[25] Ringgold has successfully resisted this in her modern Dilemma Tales, which place folklore, anecdote, and family legend in a contemporary setting. They do not make moral judgments; instead, they raise questions they do not answer. Framed by the black female voice (the heroine and/or narrator and the strips of traditional quilting), they reflect back on themselves and question the stereotyped and gendered definitions of women and blacks in white hegemonic texts and images.

## NOTES

This essay was originally published in somewhat different and much shorter form in Thalia Gouma-Peterson, *Faith Ringgold: Painting, Sculpture, Performance* (Wooster, Ohio: College of Wooster Art Museum, 1985), pp. 5–7.

1. In 1985 Ringgold was appointed Professor of Art at the University of California in San Diego.

2. Quoted in Eleanor Munro, *Originals: American Women Artists* (New York: Simon and Schuster, 1979), p. 413.

3. Terrie S. Rouse, "Faith Ringgold: A Mirror of Her Community," in *Faith Ringgold: Twenty Years of Painting, Sculpture and Performance (1963–1983),* ed. Michele Wallace (New York: Studio Museum in Harlem, 1984), p. 9.

4. Quoted in Munro, *Originals*, p. 414.

5. On these interconnections see Moira Roth, "Keeping the Feminist Faith," in *Faith Ringgold: Twenty Years*, p. 14.

6. Quoted in *The Artist and the Quilt*, ed. Charlotte Robinson (New York: Knopf, 1983), pp. 103–105.

7. Ibid., p. 104.

8. Interview by author with Faith Ringgold, 1986.

9. Freida High-Wasikhongo, "Afrofemcentric: Twenty Years of Faith Ringgold," in *Faith Ringgold: Twenty Years*, p. 18. When Ringgold first visited Africa, in 1976, she was surprised to find out how many elements from the African tradition she had used in her art.

10. Rouse, "Faith Ringgold: A Mirror of Her Community," p. 10.

11. These figures each consist of a mask with a piece of clothing attached.

12. Faith Ringgold, "The Wild Art Show," *Woman's Art Journal* 2 (1982): 18–19. As a result of her impulses and feelings at that time and the public's reaction to her *Atlanta* pieces, Ringgold proceeded to organize and curate "The Wild Show," for the Women's Caucus for Art, in February 1982, at P.S. 1 in New York City.

13. Roth, "Keeping the Feminist Faith," p. 13.

14. Ringgold, "Wild Art Show," p. 18.

15. I thank Professor Phyllis Gorfain of Oberlin College for helpful comments and insights on folktales, folklore, and folk culture.

16. Quoted in Munro, *Originals*, p. 414. The family has been very important for Ringgold in her own life. She has collaborated on projects with both her mother and her daughters, Michele and Barbara, and since 1982, her first grandchild, Baby Faith, has become an important part of her life and art. See Michele Wallace, "The Dah Principle: To Be Continued," in *Faith Ringgold: Twenty Years*, pp. 25–26.

17. For an overview of recent debates on race theory and storytelling, see Neil A. Lewis, "Black Scholars View Society with Prism of Race," *New York Times* (May 5, 1997): A11.

18. Ibid.

19. For the full text of *Street Story Quilt* see Gouma-Peterson, *Faith Ringgold: Painting, Sculpture, Performance*, pp. 11–14.

20. Rouse, "Faith Ringgold: A Mirror of Her Community," p. 10.

21. *The Bitter Nest* was performed at the College of Wooster in the fall of 1985.

22. Seated around the table, from left to right, are Celia, Florence Mills, Aaron Douglas, Meta Vaux Warrick Fuller, W. E. B. Du Bois, Dr. Prince, Richard Wright, Countee Cullen, Zora Neale Hurston, Alain Locke, Langston Hughes, Cee Cee.

23. Interview with Ringgold, 1986.

24. Ibid.

25. W. E. B. Du Bois, *The Souls of Black Folk* (New York: Blue Heron Press, 1961), p. 187. See also Michelle Cliff, "Object into Subject: Some Thoughts on the Work of Black Women Artists," *Heresies* 15 (1982): 34–35.

Moira Roth

## Of Cotton and
## Sunflower Fields

### The Makings of
### *The French* and
### *The American*
### Collection

*If we—and now I mean the relatively conscious whites and the
relatively conscious blacks, who must, like lovers, insist on, or
create, the consciousness of others—do not falter in our duty now,
we may be able, handful that we are, to end the racial nightmare,
and achieve our country and change the history of the world. If we
do not dare everything, the fulfillment of that prophecy, re-created
from the Bible in song by a slave, is upon us:* God gave Noah
the rainbow sign, No more water, the fire next time!
—JAMES BALDWIN
*The Fire Next Time,* 1963

*I* AM DEEPLY STRUCK by two disparate images
of young black Americans visiting France for the
first time—one of James Baldwin and the other of
Faith Ringgold. Taken shortly after the gay writer,
then in his mid-twenties, had settled in Paris in
1949, the first photograph shows a solitary figure: a three-
quarter view of Baldwin's head and hunched shoulders as
he twists around to look with those remarkable eyes of his
at the photographer.[1] The second photograph (taken by a
professional photographer for the family) could be but one
of a myriad travel images. Yet this photograph is a precious
record of a major event in Ringgold's life as an artist: it
depicts her and Willi Posey, her mother, flanked by Michele
and Barbara Wallace, Ringgold's two young children, pos-
ing formally on the S.S. *Liberté* on their way to France in
1961. The middle-class single mother from Harlem, just
turned thirty, is taking her family on a summer visit to
decide whether she has a future in art.[2] "Somehow I felt
that being in Europe—where Picasso, Matisse, Monet
and other great painters had lived—would lead me to
an answer."[3]

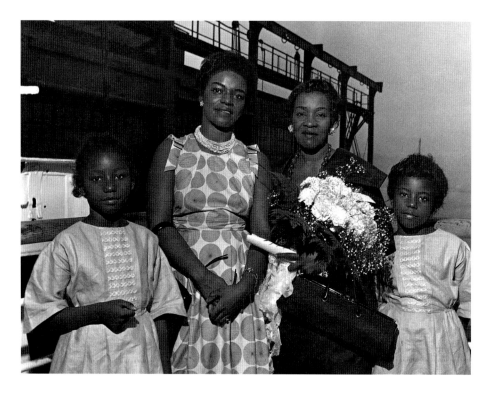

thing James Baldwin had written on relationships between blacks and whites in America. Baldwin understood, I felt, the disparity between black and white people as well as anyone; but I felt I had something to add—the visual depiction of the way we are and look. I wanted my paintings to express this moment I knew was history. I wanted to give my woman's point of view to this period.[6]

In a profound way, Ringgold's politics were decisively shaped by her experiences in the 1960s, as were many of her tastes in art. She came of age politically in the context of the American civil rights movement and plunged vigorously into the women's movement in 1970.[7]

Artistically, however, it was European art, especially French art, that most challenged her at the outset of her career. Later, the lure of Paris, as well as French modernist art, coupled with the desire to give herself and other African Americans a place within that tradition, became a major impetus for *The French Collection*.[8] In this series African Americans make their mark literally and metaphorically on the sacred European sites of art, especially those of modernism, as they dance, quilt, and talk in *Dancing at the Louvre*, *The Sunflowers Quilting Bee at Arles*, and *Matisse's Chapel*; take over the conversation (as does Zora Neale Hurston) in *Dinner at Gertrude Stein's*; and pose, with independence and dignity, in the studios of Picasso and Matisse (as does the heroine of the series).

Equally, Ringgold's decades of multilayered representations of American life and history lead logically to *The American Collection*, which she began in 1996. Many of her 1960s and 1970s paintings and sculptures were devoted to American themes, as were her text-image quilts of the 1980s and 1990s, beginning with her first story quilt in 1983, *Who's Afraid of Aunt Jemima?* In 1988 Ringgold turned to the Harlem Renaissance as a setting for *Harlem Renaissance Party*, part 2 of *The Bitter Nest*, and she chose her favorite New York bridge for *Dancing on the George Washington Bridge* and for *Tar Beach*, the quilt that was the basis of Ringgold's first children's book in 1991.[9]

In the 1990s Ringgold has increasingly addressed children as both audience and subject. Since 1991, she has written five children's books, and she intends to write more. Children are portrayed as central characters in both *The French Collection* and *The American Collection*.[10] Running consistently throughout both series is the choice of whether to be a mother—witness the contrasting decisions of Josephine Baker and Aunt Melissa, Willia Marie and Marlena. In addition, there is a focus on relationships between

The photographs of Ringgold and Baldwin suggest the two dramatically different contexts—psychological, sexual, social, chronological, and geographical—in which Ringgold emerged as an artist and Baldwin as a writer. Between 1961 and 1963 Ringgold struggled with two questions: Was it possible for her, an African American woman with two young children and a recent master of arts degree, to become an ambitious artist? What should the subject matter of such an artist be? She found the answer to the first question in Europe; however, the second question could be resolved only in the United States.

In the summer of 1963, in Oak Bluffs, Massachusetts, two years after her European trip had confirmed her ambitions as an artist, Ringgold located an abiding subject for her art: America.[4] Her first mature work, the *American People* series (1963–67), focuses on contemporary encounters between blacks and whites.[5] Much later, in her 1995 autobiography, she writes about this pivotal year of 1963:

James Baldwin had just published The Fire Next Time, Malcolm X was talking about "loving our black selves," and Martin Luther King Jr. was leading marches and spreading the word. All over this country and the world people were listening to these black men. I felt called upon to create my own vision of the black experience we were witnessing. I read feverishly, especially every-

generations of older and younger women, who literally or symbolically occupy mother and daughter positions.

Significantly, in 1989—just before Ringgold conceived *The French Collection* series—she created *100 Years at Williams College, 1889–1989*, a nearly ten-foot-long work, commissioned in honor of the centennial of the graduation of Williams' first black student, Gaius Charles Bolin.[11] Ringgold drew on her research into the college's hundred-year history of black students and black studies for both the substance of the text and the imagery. Twenty portraits of important alumni frame the central scene of a picnic, which contains forty-nine characters—including many students and administrators, together with people connected with Ringgold. The story quilt's text is in the form of a letter from Francie, a contemporary Williams alumna and black corporate lawyer, to her fiancé, telling him of a dream she has had about this history. (This was the first time Ringgold employed the letter format, although a year earlier in *The Letter,* part 4 of *The Bitter Nest:*, she used a letter within the text, in an exchange between Celia and Victor concerning their love affair in Paris.)

In her dream Francie meets Aunt Haddie, a maid at the college in the nineteenth century. These two black women from different times and classes bond in a basically male world: "At first I was annoyed that everyone thought we were mother and daughter, she a maid and me a corporation counsel. And then I was proud of her as she spoke about her life." The quilt is a revealing prelude to *The French Collection:* combining fiction and extensive historical research, juxtaposing portraits of real people and invented characters, employing the epistolary form—all at the service of reinterpreting African American history and achievements and celebrating the bonds between diverse black women.

Visually the Williams quilt is like a tableau—and its hint of stage managing becomes more obvious in later works. Increasingly, Ringgold's role during the 1990s can be defined in theatrical terms: as set and costume designer and occasional minor actress, but most of all as director and playwright. *The French Collection*'s dramas are full of voiceovers, offstage voices, *sotto voce* asides, and choruses. What we see visually may contrast with what we are told verbally. In *Wedding on the Seine* we are shown what could be a stage backdrop for a beguiling Parisian scene, with a romantic figure wearing a streaming white bridal train poised on the river's bridge. Yet when we read the text, we discover that the new bride is frantically running away, terrified by the confinement of marriage and insidious French racism. The respectable family members in *Matisse's Chapel* face us formally and calmly, as if waiting for a photographer; however, what they are listening to (and we are reading) is a narrative about slavery.

TWO NEW YORK STUDIO VISITS

*February 18, 1992:* Ringgold, her family, and I attend the opening of her second one-woman exhibition at the SoHo gallery of Bernice Steinbaum, then her dealer. It is the initial public presentation of part 1 of *The French Collection,* which consists of the first eight story quilts.

In my essay for the small catalog accompanying the exhibition, I describe the evolution of the series from its conceptual beginnings in the first six months of 1990, in California and New York, to the actual painting of the story quilts, which began in the fall of 1990 when Ringgold visited France for five months (she returned to France for a second visit in the fall of 1991). "I absolutely had to be in France to figure these things out," she told me.[12] By November 1991 part 1 had been almost completed.[13]

During a November 1991 visit with Ringgold in New York, she stated that in the first half of 1990, she knew there would be a series of twelve story quilts. She also

*100 Years at Williams College, 1889–1989, 1989*

Acrylic on canvas, printed and tie-dyed fabric, 86 x 120½" Collection of Williams College Museum of Art, Williamstown, Massachusetts Photo: Gamma One

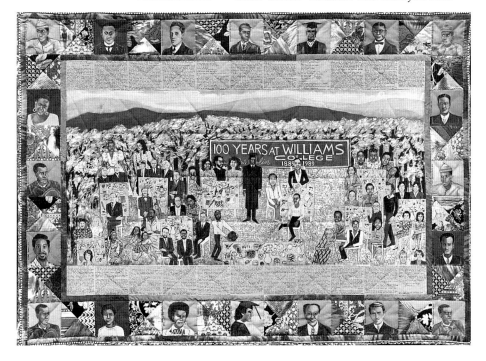

knew their titles, but had not conceived their compositions or evolved the character of Willia Marie. "The last thing to arrive was her name, but I still didn't know her attitudes on anything"—all Ringgold knew was that her heroine arrived in Paris at age sixteen in 1920. In Paris during August and September 1990, Ringgold worked on Willia Marie's character. After this Paris trip (which included visiting Giverny), she went for three months (September 15 to December 15, 1990) to the south of France for an artist's residency in La Napoule, with side trips to Arles, Vence, Antibes, and Nice. While there, she was visited by Linda Freeman, who had come to direct a video (*Faith Ringgold: The Last Story Quilt*).[14] Freeman's video crew recorded Ringgold dramatically blocking out, following an outline already drawn in two small sketches, the overall composition of *The Sunflowers Quilting Bee at Arles* and *Picasso's Studio*.

In the 1992 catalog, I write about seeing the work the previous November in Ringgold's newly rented high-ceilinged midtown studio on 38th Street between Eighth and Ninth Avenues, an area that used to be called Hell's Kitchen and is now officially renamed Clinton:

*Seven of the eight nearly-completed story-quilts of* The French Collection *were hung on Ringgold's studio walls. Draped over a sofa was the Saint Tropez beach scene, whose roughly sketched images and quilting stitches reminded me of both the under-painting of a fresco and layouts in a seamstress' workshop. On the walls, Ringgold had pinned up pencil and watercolor sketches she had made in Paris, Giverny, Vence, Antibes, Arles and Nice, with photographs—some recent, others old—of her relatives. Inter-*

*spersed with these were images of Picasso and Matisse along with their art. Leonardo's paintings in the Louvre, as well as cheap postcards and garish magazine reproductions of famous French tourist sites. Shelves were crammed with books on European art history, biographies of artists, and large numbers of African American history texts.*[15]

*February 19, 1992:* I do a videotape interview with Ringgold in the studio on 38th Street, a now strangely empty space. The interview focuses on *Dinner at Gertrude Stein's,* which Ringgold finished a few weeks before; two sketches for it hang on the studio wall. At one point, we talk about *Moroccan Holiday.* She compares it to *On the Beach of St. Tropez,* in which Willia Marie Simone and her son talk:

*It is the kind of conversation that one day she will have with her daughter. . . . I know that Martin Luther King will be there, and Malcolm X, Marcus Garvey, and Paul Robeson. [I ask if other women will be present.] No, all men, these master-changers, and the daughter and mother. . . . I have an idea about how it is going to go. The mother has the concept that the daughter doesn't understand so the mother is explaining. . . . Of course, it is going to be about women's roles in changing the world. Now why do they have to go to Morocco? Because it is where I want to go and it also seems like a great outpost for discussing, like a summit meeting type of thing. Whether the mother and daughter are actually going to be with these guys, or whether I will allude to them as if they are there, just picture them like they are there—I haven't fully made up my mind.*[16]

## A TRIP TO MOROCCO AND PARIS

*Fall 1992:* On October 26 I fly to Tangiers to meet Ringgold; we intend to spend a week in Morocco and then go to Paris together.[17] In Tangiers we wander around the city; Ringgold is preoccupied with finding an indoor courtyard with balcony and tiles for the site of *Moroccan Holiday.* Among our several excursions to look at indoor courtyards are trips to two family houses of a rug dealer whose shop is opposite our hotel. During the Moroccan stay, we talk daily and at length—in our hotel, on the streets, and in cafes—about Moroccan culture, the country's history of French colonialism, and *The French Collection.* In my diary I record exchanges with Ringgold in which she explains her choice of Morocco for the meeting of Willia Marie and Marlena: it is near Europe and therefore easy to reach, and

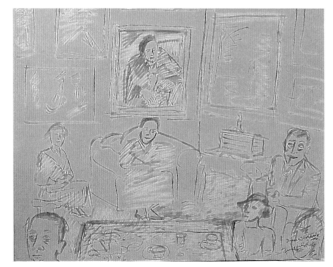

*Sketch of* Dinner Party at Gertrude Stein's *(The French Collection, Part II: #9), 1991*

Green marker on paper, 16 x 20"
Courtesy of ACA Galleries, New York and Munich

Faith Ringgold in a
Paris cafe, 1994

Watching and Waiting
(American People series),
1963

Oil on canvas, 36 x 49"
Courtesy of ACA Galleries,
New York and Munich
Photo: Gamma One

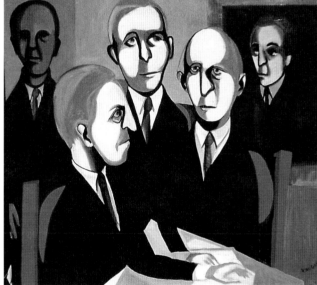

it is "something French people often did." Another main reason is Tangiers' connection with Matisse (whom Ringgold greatly admires): indeed, throughout the week, we try to see the hotel room in which he painted, but the building is closed, and the manager elusive. *Jo Baker's Birthday* is also on Ringgold's mind, and she comments on Baker's obsessive devotion to her adopted children, in contrast to Willia Marie's decision to send her children back to America.

On our last evening in Paris, we attend the Folies Bergère, where Baker once danced. Ringgold has spent much of her time in Paris researching the history of African Americans there between the two great wars[18] and the persecution of French Jews and the Resistance movement in World War II—the context of a future children's book about Lonnie, an American black child who discovers that he is half French and white. By the end of this trip, both the plot of *Bonjour, Lonnie,* and the research on Baker are basically complete. *Moroccan Holiday,* on the other hand, is still unresolved.

*Postscript, May 10, 1997:* I receive a fax from Ringgold of a rough sketch of *Moroccan Holiday* (this is the first time I have seen any hint of the composition), together with the final version of its text.[19] In the rough sketch, mother and daughter are seated opposite each other at a table with portraits behind them—in her accompanying note, Ringgold writes that they depict King, Malcolm X, Garvey, and Frederick Douglass. Why the change, I ask myself, to Douglass from the initially proposed Robeson? Is the work now finished? Is the scene set in a cafe or the artist's studio? As I study the sketch, it remains bafflingly mysterious. I find myself comparing it with a similar composition, *Watching and Waiting,* a 1963 canvas in the *American People* series. Who is now watching and who is waiting in Morocco?

## "WE MUST SPEAK, OR OUR IDEAS AND OURSELVES WILL REMAIN UNHEARD AND UNKNOWN"

Throughout the twelve story quilts of *The French Collection* (1990–97), its heroine, Willia Marie Simone, a fictional expatriate African American artist-model-wife/widow-mother-cafe owner, asks herself: How can I become an artist? Can an artist be a wife and mother, too? How do I justify my life to my children? What shall I paint? How can I find a support system as an artist? Why do I make art ? Who is my audience?

These are questions that Ringgold, too, has pondered since the early 1960s, when she was a young, aspiring artist in Harlem. In the 1990s, now a singularly successful artist in her late sixties who travels back and forth annually between Englewood, New Jersey (her home), and La Jolla on the West Coast (where she teaches at the University of California, San Diego), she has created Willia Marie, a young black woman expatriate in Paris in the 1920s, to answer these

questions. Ringgold provides Willia Marie, however, with a seemingly more benign ambience than Ringgold's own (Europe not America) and with access to historical figures from a time span of more than a hundred years.

In *The French Collection* Ringgold, like an extravagant novelist of a picaresque tale, a cunning sleight-of-hand juggler, and a director-playwright, combines French sites of art and modern European art and artists with the history of American black and white expatriates and invented visits to Europe by black female celebrities, ranging from Sojourner Truth to Zora Neale Hurston. They, together with Ringgold's friends and family, weave their way throughout the narrative and imagery of *The French Collection*.

The series begins in the Louvre (*Dancing at the Louvre*), a Paris cityscape (*Wedding on the Seine*), the nearby gardens of Monet (*The Picnic at Giverny*), and the south of France (*The Sunflowers Quilting Bee at Arles*); later, a family encounter between mother and son plays itself out on a French beach (*On the Beach of St. Tropez*), and Willia Marie addresses an artist audience in her Paris cafe (*Le Cafe des Artistes*). The homes of two expatriate Americans, the black Josephine Baker (*Jo Baker's Birthday*) and the white Gertrude Stein (*Dinner at Gertrude Stein's*), offer further settings. Matisse and his art appear in three of the story quilts (*Matisse's Model*, *Matisse's Chapel*, and *Jo Baker's Birthday*); and Picasso is presented as an artist, accompanied by his art, in two story quilts (*Picasso's Studio* and *Dinner at Gertrude Stein's*) and as a model in *The Picnic at Giverny*. Only the last story quilt (*Moroccan Holiday*) is set outside France, although Morocco has strong French connections (it was once a French protectorate and the site of visits by many French artists, from Delacroix to Matisse).

Over and over again in the series, Willia Marie turns to earlier artists and art to suggest designs and motifs, to offer models for artistic training and studio practice, and most of all to guide her in becoming an artist herself. European and American artists, white and black, and their art play roles in the series: there are Manet references in *The Picnic at Giverny* and *Jo Baker's Birthday;* Leonardo's works are represented in *Dancing at the Louvre;* and van Gogh appears as a troubled minor character in *The Sunflowers Quilting Bee at Arles.* The impressive roster of artists in the audience of *Le Cafe des Artistes* includes white Europeans Paul Gauguin, Henri de Toulouse-Lautrec, Vincent van Gogh, and Maurice Utrillo, and black Americans William H. Johnson, Ed Clark, Sargent Johnson, Romare Bearden, Jacob Lawrence, Aaron Douglas, Henry O. Tanner, Elizabeth Catlett, Augusta Savage, Lois Mailou Jones, Meta Vaux Warrick Fuller, and Edmonia Lewis. Two additional black women artists appear in the cafe: Ringgold listens attentively to Willia Marie as she delivers her "Colored Woman's Manifesto of Art and Politics." As her audience alternately taunts and condescendingly praises her, Willia Marie asserts, "Modern art is not yours, or mine. It is ours," and she tells them that the reason that she became an artist is "freedom."

Women are central to Willia Marie's quest to gain confidence and support if she is to become an artist. They are American, not French, women: "I had to make Willia Marie question fixed notions as to what art is. I couldn't have her trying to be a French woman, so I had to bring all of my women over there."[20] Most of all, Willia Marie turns to Aunt Melissa (who earlier encouraged her to live in Paris and later takes care of Willia Marie's two children).

In *The Sunflowers Quilting Bee at Arles,* Willia Marie meets real African American women activists: Madame C. J. Walker, Sojourner Truth, Ida B. Wells, Fannie Lou Hamer, Harriet Tubman, Rosa Parks, Mary McLeod Bethune, and Ella Baker. When we first see Willia Marie as an artist in *The Picnic at Giverny*, she is surrounded by American women, black and white friends (and supporters

Faith Ringgold in Paris with *Dancing at the Louvre*, 1994

of Ringgold): Ellie Flomenhaft, Lowery Sims, Judith Lieber, Thalia Gouma-Peterson, Emma Amos, Bernice Steinbaum, Michele Wallace, Ofelia Garcia, Johnetta Cole, and myself. And there are yet others, including Betsy Bingham in *Matisse's Chapel*, whose booming voice is heard by Willia Marie in her dream, as her great-grandmother (in reality, Ringgold's) relates the family history: "There was a story my Mama Susie told us young-uns 'bout slavery."

So many voices. So much French and American art history, and American cultural and activist history, and Ringgold's own personal history. Collectively it helps Willia Marie resolve in *Le Cafe des Artistes* what she and other women of color must do: "We must speak, or our ideas and ourselves will remain unheard and unknown."

And there is one final voice that appears only in the last quilt. In *Moroccan Holiday*, which follows *Le Cafe des Artistes*, we both hear and see Willia Marie's daughter for the first time. It is Marlena who ends the story quilt's text by thanking her mother: "You have not only shown me how to be a woman but an artist as well." Yet she rebukes her mother, too: "It is not just Douglass, Garvey, Malcolm and Martin who should be here with us, but Aunt Melissa also. She is our courage too, Mama. She is right up there with you and these men." We are, however, never to encounter Aunt Melissa directly; she remains a pivotal but mediated presence throughout the two series, a surrogate mother for both Willia Marie and Marlena.

In December 1996, while we were together in Paris, Ringgold explained that "the daughter's position as the heroine of *The American Collection* came directly out of *Moroccan Holiday*." This painting represents "the ultimate competition. It is an indoor, ultimate competition between women because women compete with each other."[21] The canvas addresses head-on the relationship between fictional mother and daughter in the Simone family, and surely reflects in part the relationships between Ringgold and her two daughters, Michele and Barbara.[22] The contrast of the lives and artistic careers of Willia Marie and Marlena—which are to be played out in *The American Collection*—can also be read more generally in terms of intergenerational relationships within the women's art movement in this country, and certainly in feminist theory circles, between younger and older feminists. It is no accident, therefore, that this psychologically, theoretically, and politically laden work is the last to be completed by Ringgold in *The French Collection*.

What inspires Marlena Truth Simone, the heroine of *The American Collection*? Ringgold tells us that, in contrast to *The French Collection,* "it is not the artists of the time but issues of race and sex that peak Marlena's interests and provide fuel for her art."[23]

In this new series Ringgold continues the transatlantic saga of the Simone family. She returns the narrative to this country and its history through the career, ambitions, dreams, nightmares, and musings of Marlena (and, though to a far lesser extent, those of her older brother, Pierrot Frederick Douglass Simone). Marlena is born "into affluence" in Paris in 1922, the daughter of Willia Marie and Pierre François Simone, a white Frenchman.[24] Two years later he dies, and Willia Marie takes the children back to America to be brought up by Melissa, their great-aunt. After studying art at Yale, Marlena moves to New York City in the 1940s, where, more influenced by the city's "cultural excitement" than by the abstract expressionists, she becomes a highly successful artist. It is Marlena's own paintings that form the majority of the twelve story quilts' images, whereas in *The French Collection,* only *Matisse's Chapel* and *Jo Baker's Birthday* are by Willia Marie (although her portraits appear in the back of *Moroccan Holiday*).

*The American Collection* revolves around "the African American experience . . . with a definite focus on the African American women's heroic and at the same time invisible presence in America."[25] Central to this history, and to Ringgold's representation of it, is racism and resistance, beginning with slavery and the abolitionist movement [26] and the mixed race of so many blacks. Also central are African American cultural achievements in dance, music, and quiltmaking, with Marlena herself representing African American success in the visual arts through her canvases—together with Ringgold's references to works by black artists.[27]

It is hard to pinpoint a date for the origin of *The American Collection,* but it was around 1992. While Ringgold was finishing *The French Collection*—with the exception of *Jo Baker's Birthday*, *Le Cafe des Artistes*, and *Moroccan Holiday*—she began to take "lots of notes" about a new series.[28] Over the next several years I heard periodically about its progress. In 1995 the ideas crystallized, and in 1996 Ringgold started to paint the series.

In August 1995 Ringgold told me on the telephone that she knew definitely: "There are going to be twelve story quilts, just like *The French Collection,* to be done between 1995 and the year 2000." Two months later, she stressed: "The main thrust is Marlena trying to achieve success as an artist. I want to examine the problem of racism that she has to go through and how she deals with it, and I would like to create an analysis of racism not only from the point of view of being black, but also of being white. I want to prepare a questionnaire for whites. I can't rewrite history without understanding racism."[29]

In her New York studio in the summer of 1996, Ringgold began to work on the series' prepared canvases. In an August phone conversation with me, Ringgold described how *The American Collection* was proving to be innately more difficult than *The French Collection.* First, there was the question of the narrative: she knew that she did not want to do more handwritten texts on the canvases themselves—eliminating them, she stressed, would give her "more freedom." But how could she present a short but necessary narrative for the viewer? Second, she stated, American art has always been "less interesting and compelling" for her than French art, and also (because she knows less about French history and culture) it has been easier to focus on the art she loves, that of French modernism. Because she is an American, however, her sense of this country is more complex, having more to do with history and culture than art. Increasingly, she realized, *The American Collection* conceptually was becoming as much a continuation of the 1960s *American People* series as a continuation of *The French Collection.*

In Paris in December 1996, at the end of a long taped discussion about *The French Collection,* Ringgold emphasized again: "*The American Collection* is less about art and more about America than *The French Collection* was. That is as it has to be. It's a different experience. That's one of the reasons why people went to France, to get away from the problems there. They come here [to Paris] and they don't have to think about that."[30] A month later, when we were planning a presentation in New York, which was to focus on *The American Collection,* she announced even more tersely: "*The American Collection* and all things American in America are about race."[31]

*A La Jolla Studio Visit, April 29–30, 1997:* Ringgold's University of California studio is housed in a gray building that contains the other art faculty and graduate studios on this southern California campus. It is a stern edifice with massive gates and barren indoor courtyards—Grace Welty (Ringgold's main assistant) tells me that it is often called "The Prison." On the second floor in Room 554, a space bursting with color and energy, Ringgold is working intensely on the remaining *American Collection* story quilts.[32] She usually works on two (occasionally four) simultaneously, and she paints them mostly on weekends because, as Welty explains, "She's very social so she gets much more done when no one's around. During the weekdays, when Faith's thinking of stories, she tries them out on us."[33]

In the huge, high-ceilinged studio, lit by a wall of windows and fluorescent lights, I find three women at a table—two professional local quilters and a graduate student—talking and listening to the radio as they sew "a top," a blank canvas and its quilted border. They are preparing *Jo Baker's Bananas,* which is held together with big safety pins to keep the surface flat; one of them is creating the "quilting" lines with a large darning needle and fishing tackle thread. At present this story quilt is covered with only a gray paint base, the first of many thin layers and glazes that create the series' subtle surfaces. These base monochrome colors of the twelve story quilts are selected from the three colors of the American flag, with gray standing in for the original white.[34]

Welty is perched on a ladder pinning the quilted edge around the almost finished *Picnic on the Grass.* On the opposite wall are two signed and dated works: *Wanted: Douglass, Tubman and Truth* and the multi-imaged *Bessie's Blues,* a stencil for which is still propped up on an easel. In *Wanted,* a composition and subject that invoke Jacob Lawrence's *Toussaint L'Ouverture* series,[35] the three nineteenth-century black abolitionist leaders—fictionally brought together by Ringgold—are dressed soberly in black and white and surrounded by dense, rich green-blue foliage. In her notes on the series, Ringgold speculates: "Did they ever have a meeting in a secret place, as conductors on the Underground Railroad making escape plans? They should have."[36] Ringgold began to paint *Wanted* in March, and Welty remembers: "The three people came fast. She is so familiar with them."[37] Looking at the painting's date, I realize that it was finished just two days ago.

At first *The American Collection* seems strangely silent and sparse in narrative guidance. No longer are there handwritten texts above and below the images to enrich one's reading of it (although Ringgold plans to use her short descriptions of each "story" as wall texts and perhaps

include them in an audio tour). The removal of the texts radically changes the size and shape of the image within its quilted frame. One is told less verbally and accordingly must imagine more. But, equally, I find myself *looking* more. I am struck, for example, as I wander around the studio by the series' focus on the American landscape—skies, cottonfields, woods, and water make up the settings of over half the series.[38]

The more time I spend in Ringgold's studio, the more I find my head spinning with notions about modernism and the avant-garde, and about postmodernism, appropriation, and representation.[39] But also I keep asking myself questions about didacticism and inspiration, singularly unlikely components in standard postmodernist discourse, but the key to reading Ringgold's conscious intents and explaining her appeal—both conscious and unconscious—to many diverse audiences. A postmodernist bravado may characterize the liberties that she takes in intermingling diverse high and low art, media and autobiographical sources, and fiction and fact in her chronologies and biographies. Feminist and postcolonial theory, too, are important lenses through which to read Ringgold's exploration of gender and race, of sexism and racism. But these theoretical frameworks seem to provide only partial interpretations. It may be inevitable that Ringgold lives in a geographically and historically fragmented postmodern world, but unlike so many artists and writers committed consciously to postmodernist thinking, Ringgold surely has something else in mind. And that is what makes her strikingly interesting *and* different.

As I look at the works in the studio, I speculate about their future audiences. Among them will be artists, critics, curators, historians, and theorists—many of whom are fascinated by current theoretical discourse and what Ringgold has to contribute to this. But her exhibitions also draw huge crowds of adults who otherwise might not enter an art gallery or museum. Yet further audiences purchase the large color posters of her work for their homes and offices. And Ringgold has an additional audience—young children around the country who avidly read her popular children's books and older high school students who enthusiastically attend class outings to view her art. Her work uncannily cuts across normal boundaries of ethnicity, class, age, artistic education, and political ideologies. In short, Ringgold is highly unusual among major contemporary American artists both in her publicly reiterated desire to make art for an audience ("As an artist I need my audience like I need

food")[40] and in her success in speaking of concerns, visual and conceptual, political and psychological, dear to the hearts of her very different audiences.

I turn back increasingly to a central question, posed even more in the new series than in *The French Collection*: How does one make visible and eloquently re-present black history, especially black women, in the medium of painting? According to Ringgold, "*Bessie's Blues* is designed to bring attention to the great blues singer Bessie Smith in the same manner that Warhol used to focus attention on such women as Marilyn Monroe, Jackie Kennedy, and Elizabeth Taylor."[41] Later in the day, Welty puts up *The Two Jemimas* (a work that refers to de Kooning's *Two Women in the Country*) for me to study. Again, I resort to Ringgold's notes: "By the 1960s, Marlena, like other black artists, began to incorporate racially demeaning language and black face stereotypes such as the Aunt Jemima pancake box and the words 'black' and 'nigger' in their art as liberating antidote."[42] Like ferocious twins, the two "Jemimas" strut forward out of their flowery-meadowed background—their sturdy bodies, pressed together, are so near to the canvas's surface that they seem about to burst out into the studio space.

Certainly American painting is one important source for Ringgold, but alone it is insufficient—be it by black or white artists. Where else does Ringgold turn in *The American Collection* for guidance and information in her desire to teach and inspire?

I study Ringgold's massive research for the series—drawings, photocopied images and articles, and newspaper cuttings—which are variously piled up on tables and separated according to quilt. There are photos of the Apollo Theater, Tina Turner, and Lena Horne for *Stompin at the Savoy*; a James Van Der Zee photo and a copy of a Florine Stettheimer family portrait for *Family Portrait*; and photographs of Harriet Powers's quilts and of slave quarters for *Cottonfields, Sunflowers, Blackbirds and Quilting Bees*. Other material includes newspaper photographs of black male athletes and packages of postcards of the Great Smoky Mountains National Park. Ringgold's ability and desire to draw on such a conglomeration of sources are partially responsible for the uneasy and unexpected visual tensions within *We Came to America* and *Born in a Cotton Field*, such tensions that earlier on in *The French Collection* were created by the more simple contrast of image with text.

And then there are the references to Africa, and to religion.

*That's exactly the diasporic experience, far enough away to experience the sense of exile and loss, close enough to understand the enigma of the always-postponed "arrival." . . . Since migration has turned out to be the world-historical event of late modernity, the classic postmodern experience turns out to be the diasporic experience.* —Stuart Hall[43]

Immersed in frothing red-white-and-blue waters are masses of figures, open-mouthed with raised arms, like some ecstatic black choir singing "Hallelujah." On the horizon, next to a rainbow-haloed sun, is a ship on fire. In front, a dreadlocked Statue of Liberty holds a naked child in one arm and a torch in the other. Ringgold explains that in *We Came to America*, while her light-skinned brother is wining and dining a white socialite, Marlena dreams that she is on a slave ship. In "this hellified dream" she joins the other slaves who revolt and leap overboard; "the slave ship then bursts into flames as the human cargo is guided to shore by the eternal light of a black Statue of Liberty."[44] Visually, the scene blends exhortation, jubilation, and an almost biblical promise of deliverance.

This juxtaposition of slavery and its triumphant down-

William H. Johnson,
*Mount Calvary*, c. 1944

Oil on paperboard,
27⅛ x 33⅜"
National Museum of
American Art, Smithsonian
Institution, gift of the
Harmon Foundation

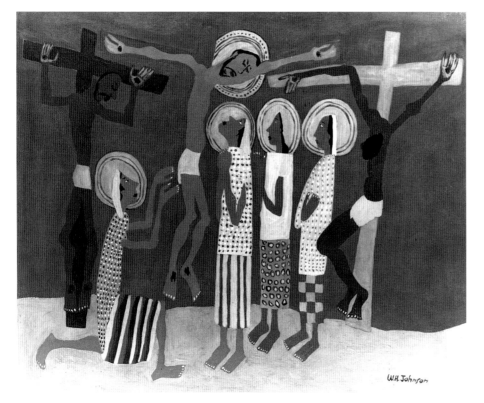

fall, with a pivotal role for a child, appears again in *Born in a Cotton Field*, a fairy story created by Marlena "as a tribute to her slave ancestors": it is about a slave child in Africa, who, if successfully hidden, will eventually lead the other slaves to freedom. Ringgold depicts the child with her parents (their faces illuminated by the child's halo) as a black Holy Family, a scene witnessed by villagers hidden amid the cotton, while above the Prince of Night—so dramatically foreshortened that it is hard to read whether he is hovering or kneeling—presides protectively over them.

What inspired Ringgold to invent such a striking and original figure as the Prince of Night?

While browsing through the piles of source material for *The American Collection,* I find photographs of black athletes —sources, Welty remembers, that Ringgold would seek out when "looking for a strong, positive image; that's an easy place to find it." Another inspiration for *Born in a Cotton Field,* credited by Ringgold, is the black artist William H. Johnson—specifically his *Lamentation (Descent from the Cross)* and *Mount Calvary*, the latter a striking canvas with its dangling, painfully awkward bodies and their extended arms on the crosses.[45] (Ringgold has collected, too, nineteenth-century photographs and etchings of slaves in cottonfields that play an obvious role in the ambience of this quilt, as well as *Cottonfields, Sunflowers, Blackbirds and Quilting Bees*.)

*We Came to America* also has an astonishing admixture of sources—again athletes, but this time combined with Frédéric Auguste Bartholdi's Statue of Liberty, a work with a fascinating Franco-American Egyptian history, and photographs from *The Black Book*.[46] In his introduction to *The Black Book,* a medley of images and texts (songs, stories, patents, letters, newspaper articles, charms, and poems), Bill Cosby writes that it suggests the scrapbook and memories of "a three-hundred-year-old black man" and constitutes "a folk journey of Black America."[47] The initial images and texts in *The Black Book* are about Africa. On the first page there is an African woman—only her head, shoulders, and bare breasts are shown—with a caption that reads: "I was there when the Angel / drove out the Ancestor / I was there when the waters / consumed the mountains / —Bernard Dadie."[48] A few pages later we see an African man, spear held high above his head, his back turned to the viewer: "And they sold us like beasts, and they counted our teeth. . . . and they felt our testicles and they tested the lustre or dullness of our skins—Césaire."[49] I find photocopies of these pages, plus another titled

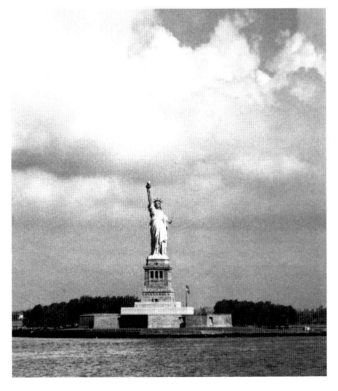

"Thomas Jefferson's Slave," in the envelope of sources for the story quilt, along with photographs of black and Russian athletes and of the Statue of Liberty and Bartholdi's early terra-cotta versions of it.

## "WE CAN MAKE IT COME TRUE. OR LOOK TRUE."

To aim deliberately to inspire political and social change these days might be viewed by many postmodernists as naive and impossible aspirations for art. But inspiration, combined with rage and a belief in the possibilities of change, were what kept a lot of us going in the 1960s, and Ringgold is most definitely a product of that decade. In her 1960s *American People* series, she depicted contemporary race relationships in the United States. In the 1990s, in *The French Collection* and *The American Collection,* she moves back and forth in time, from past to future, from fact to fiction, in order to redress history, both political and artistic, and to create a more prominent place in this new history for African American women.

In the last section of the children's story *Tar Beach,* the eight-year-old heroine, Cassie Louise Lightfoot, flies with Be Be in the sky, explaining to him: "All you need is somewhere to go that you can't get to any other way. The next thing you know, you're flying among the stars."[50] For her adult audiences, Ringgold provides more questions and fewer answers. In *Listen to the Trees,* she portrays Marlena as an artist "who meditates on her African and European ancestors and questions certain family stories and values shared by both sides of her family as she ponders the questions: Who am I and why am I here?"[51]

The saga of Marlena that begins in the waters of the Atlantic ends in a wooded grove, a serene, albeit solitary ending. In *Picnic on the Grass,* the finale of the twenty-four story quilts, Marlena, in a red-and-white dress and red earrings, sits cross-legged on a white tablecloth, complete with picnic basket, fruits, a ribboned hat, a mint julep in one hand and a diamond ring in the other; behind her is a distant mountain range. "Since Marlena has success, money, beauty, and fame, but neither husband nor children, she finds herself searching for a real relationship. . . . She prepares a sumptuous picnic lunch for an enchanting afternoon date in the park, only to be stood up at the last minute. Yet she goes anyway, and experiences a feeling of power, having conquered the greatest fear of all . . . being alone."[52]

Gallery installation
of Faith Ringgold's
*Who's Afraid of
Aunt Jemima?*
Mills Art Gallery,
Oakland, 1992

Photo: Hannah Tandeta

For her audiences of both children and adults, Ringgold sees a certain role for herself as an African American woman artist. As she once said when discussing her intent in *Dinner at Gertrude Stein's*: "My process is designed to give us 'colored folk' and women a taste of the American dream straight up. Since the facts don't do that too often, I decided to make it up. It is important, when redressing history as I am doing here, not to be too literal or historical. It will spoil the magic. . . . That is the real power of being an artist. We can make it come true. Or look true." [53]

## NOTES

I am, as always, deeply grateful to Faith Ringgold for her art and her friendship. I also want to thank Maria denBoer for her most intelligent, meticulous reading of the manuscript; Melanie Franklin, at the New Museum, for her enthusiasm and alacrity of response to my many inquiries; Tim Yohn and Sue Heinemann for their skillful editing; Cheryl Leonard for her unflagging energy and care; and Grace Welty, Ringgold's assistant, for her illuminating conversations as well as her copious practical help. Finally, I want to acknowledge the amazing work of the students in my College 10EE, a course I taught on Ringgold at Mills College in the spring of 1996. This essay is dedicated to them.

1. The photograph was taken by Gidske Anderson, a Norwegian journalist and Paris neighbor, who "became [Baldwin's] best friend in the quarter. They shared a concern about sexual ambivalence, and often spent long evenings together, exploring each other's souls" (David Leeming, *James Baldwin: A Biography* [New York: Alfred A Knopf, 1994; Owl Books, 1994], p. 58).

2. In 1961 Ringgold was a single mother, having left Earl Wallace, her first husband, for good in 1954 (in 1962, she remarried, to Burdette Ringgold). Until her mother's death in 1981, mother and daughter were deeply devoted to each other; indeed, Willi Posey contributed directly to Ringgold's art in the 1970s, and Ringgold has described *The French Collection* as "the most ambitious of all my tributes to Mother" (Faith Ringgold, *We Flew over the Bridge: The Memoirs of Faith Ringgold* [Boston: Little, Brown, 1995],p. 79).

3. Ibid., p. 131. In the text of *Change: Faith Ringgold's Over 100 Pounds Weight Loss Performance Story Quilt* (1986), in the section on 1960 to 1969, written humorously and in the third person, Ringgold describes another cultural impact of this French visit: "In 1961 you discovered French bread & cheese, and wine-with-your-meals in Europe though you were brought up to believe that people who drank wine were winos."

4. Ringgold briefly attempted to make "French" art, and in her autobiography she describes flowers, landscapes, and trees

"painted in the French Impressionist manner" and her failed attempt around 1963 to place these in an East 57th Street gallery, which displayed such work. Ringgold's canvases were turned down by Ruth White: "'You,' she said, placing stress on *you,* 'cannot do this.'" See the account in Ringgold, *We Flew over the Bridge,* pp. 143–44.

5. The initial 1963 canvases of the *American People* series are *Between Friends* (a depiction of an uneasy encounter between a black woman and a white woman), *For Members Only, Neighbors, Watching and Waiting,* and *The Civil Rights Triangle.* The series culminates in 1967 with large canvases revealingly titled *Die, The Flag Is Bleeding,* and *U.S. Postage Stamp Commemorating the Advent of Black Power.*

6. Ringgold, *We Flew over the Bridge,* p. 146.

7. Ringgold writes that in 1970, "I became a feminist because I wanted to help my daughters, other women, and myself aspire to something more than a place behind a good man." Yet she goes on to point out that, painfully, "in the 1970s, being black and a feminist was equivalent to being a traitor to the cause of black people" (ibid., p. 175). In 1971, she was commissioned to paint *For the Women's House,* a mural for the Women's House of Detention on Riker's Island in New York; it was "the first painting in which I portrayed a large number of women" (ibid. p. 190). An interesting exchange on this work ends with Ringgold telling her daughter Michele Wallace: "This mural is just part of a series called America's Women. I want to do more with women, dealing with their ages, races and classes because no matter how old you are or what color you are, or how much money you have, you're still a 'girl'" (Faith Ringgold and Michele Wallace, "For the Women's House," *Feminist Art Journal* [April 1972]: 27; reprinted in Michele Wallace, *Invisibility Blues: From Pop to Theory* [New York: Verso, 1990]).

8. A significant moment in the history of *The French Collection* was Ringgold's slide presentation of it on a panel with Martin Puryear and Ray Saunders at a major conference, "A Visual Arts Encounter: African Americans in Europe," held at the Palais du Luxembourg, February 2–4, 1994. There she talked about her encounters with European culture and life, from her 1961 visit on, including her trip to documenta in Kassel, Germany, in 1972, where she unofficially distributed her posters: "I put myself where I thought I should be." She described *The French Collection,* telling her responsive audience of mainly American artists and historians: "What I am doing here is rewriting history. It's too bleak as it is." (*Dinner at Gertrude Stein's* was exhibited at the same time in a Paris gallery.)

9. Ringgold's five children's books are *Tar Beach, Aunt Harriet's Underground Railroad in the Sky, Dinner at Aunt Connie's House, My Dream of Martin Luther King,* and *Bonjour, Lonnie.* Among the people and topics she explores in them are Harriet Tubman, Martin Luther King Jr., and many nineteenth- and twentieth-century black women activists (represented by speaking portraits found in an attic). *Bonjour, Lonnie,* which is about a child of mixed race, incorporates the story of African Americans in World War I—the 369th Regiment, the Harlem Hell Fighters—and the French Jews in World War II. Clearly there are major research topics for future scholars in the comparison of texts and images in these children's books with the texts and images of Ringgold's works for adults in the 1990s.

10. Children are a focus of *Dancing at the Louvre* and *Born in a Cotton Field;* a child is at the symbolic center of *We Came to America;* and Marlena and Pierrot, as the adult children of Willia Marie, partially occupy center stage in the St. Tropez and Moroccan family exchanges.

11. On February 23, 1990, I videotaped Ringgold reading the *100 Years at Williams College, 1889–1989* text. She spoke of the inevitable challenge, trying to please so many people in such a commission, and the demands of its research: "I read everything I could get my hands on and interviewed students and alumnae and professors. It was a huge project. Now I'm really into other things. I'm thinking about the stories [for *The French Collection*] I'm going to be doing in France. I'm very much involved with all this. Right now the backings are already made and on the walls of my studio, and they are so beautiful. I won't take them to France, but I will take the borders with me so that I can benefit from their colors when I start to paint. I like to paint with my borders in place." For a discussion of the Williams quilt, see Eva Ungar Grudin, *Stitching Memories: African-American Story Quilts* (Williamstown, Mass.: Williams College Museum of Art, 1990), pp. 50–55. Also see my essay, "A Trojan Horse," in Eleanor Flomenhaft, ed., *Faith Ringgold: A Twenty-five Year Survey* (Hempstead, N.Y.: Fine Arts Museum of Long Island, 1990), pp. 53–54.

12. Quoted in Moira Roth, "Upsetting Artistic Apple Carts: The French Collection," in Michele Wallace, Moira Roth, and Faith Ringgold, *The French Collection, Part 1* (New York: Being My Own Woman Press, 1992), p. 9.

13. *Dinner at Gertrude Stein's* was also finished in 1991 and at the beginning of 1992 was shipped off for its first showing in "Paris Connections: African Artists in Paris" (January 14–February 29, 1992), curated by Raymond Saunders, at the Bomani Gallery in San Francisco. During a November 8, 1991, conversation with Ringgold, she told me that she was planning to paint both *Le Cafe des Artistes* and *Jo Baker's Birthday* in Atlanta during a six-week workshop there in March–April 1992. (*Jo Baker's Birthday* was finally completed in 1993 and *Le Cafe des Artistes* in 1994.)

14. Freeman's video contains a small selection of this footage, but there is also much more unedited footage. In the La Napoule studio, Freeman also saw *The Picnic at Giverny,* which Ringgold had already started to paint (phone conversations by author with Linda Freeman, May 13–14, 1997).

15. Roth, "Upsetting Artistic Apple Carts," p. 9. During the November 1991 visit, I videotaped Ringgold's studio, which was filled with *The French Collection* and sketches and photocopied image sources for it.

16. Interview by author with Faith Ringgold, February 19, 1992. Other parts of this interview appear in Moira Roth, "Dinner at Gertrude Stein's, A Conversation with Faith Ringgold," *Artweek* (February 13, 1992): 10–12.

17. Ringgold and I had received a travel grant from the National Endowment of the Arts for this trip.

18. For an excellent study of black Americans in Paris from World War I until the present, see Tyler Stovall, *Paris Noir, African Americans in Paris* (New York: Houghton Mifflin, 1996).

19. Ringgold gave me a version of the *Moroccan Holiday* text in mid-1995, and, in comparing that to the 1997 finished version, I find she made very few changes.

20. Phone conversation by author with Faith Ringgold, April 9, 1995.

21. Interview by author with Faith Ringgold, Paris, December 17, 1996.

22. Ringgold has two highly gifted daughters, Barbara Wallace and Michele Wallace, both born in 1952 and thus now in their forties. (Barbara has three children, Michele has none.) Over the years Barbara, a brilliant linguist, has assisted Ringgold in her research, and the relationship between Ringgold and Michele, a leading black feminist, has been extremely rich in its exchanges and mutual influences. There is a fascinating history to be untangled of the presence and influence of Michele Wallace's ideas, research, and writing in the work of Ringgold, which includes texts for Ringgold's 1972 *Political Landscape* series and the story quilt *Dream 2: King and the Sisterhood* (1988).

23. In 1996 Ringgold wrote a short, unpublished text on *The American Collection,* which includes descriptions of each work, and she slightly revised it in 1997. From here on, it is referred to as Ringgold, *"The American Collection Introduction."*

24. In *"The American Collection Introduction,"* Ringgold writes that "Pierrot looks white, like his father, and Marlena looks black, like their mother." Willia Marie's husband was born in New York City and brought up in a Fifth Avenue townhouse with a black nursemaid, yet "his family has been in Paris for three generations. He is practically French." (See the text of *Wedding on the Seine,* reprinted in this catalog.)

25. Ringgold, *"The American Collection Introduction."* The works in *The American Collection* are (1) *We Came to America,* (2) *A Family Portrait,* (3) *Born in a Cotton Field,* (4) *Cottonfields, Sunflowers, Blackbirds and Quilting Bees,* (5) *Bessie's Blues,* (6) *The Two Jemimas,* (7) *Stompin at the Savoy,* (8) *Jo Baker's Bananas,* (9) *The Flag Is Bleeding, Part 2,* (10) *Wanted: Douglass, Tubman and Truth,* (11) *Listen to the Trees,* and (12) *Picnic on the Grass.*

26. Ringgold's choice of middle names for the Simone siblings places them squarely in this history: Marlena's refers to Sojourner Truth, and that of her brother, Pierrot, to Frederick Douglass.

27. In an unpublished 1996 list of "influences" on *The American Collection,* Ringgold cites the following works by black male artists: William H. Johnson's *Lamentation (Descent from the Cross)* and *Mount Calvary* (for *Born in a Cotton Field*), Sargent Johnson's *Forever Free* (for *The Flag Is Bleeding, Part 2*), Jacob Lawrence's *Toussaint L'Ouverture* series (for *Wanted: Douglass, Tubman and Truth*), and Aaron Douglas's study for *Aspects of Negro Life from Slavery through Reconstruction* (for *Listen to the Trees*). In addition, there is the complex issue of Ringgold's

self-referencing in her titles for *The American Collection*: for example, to *The Flag Is Bleeding* (1967) and *Who's Afraid of Aunt Jemima?* (1983), as well as to such works from *The French Collection* as *The Sunflowers Quilting Bee at Arles* and *The Picnic at Giverny.*

28. Interview with Ringgold, Paris, December 1996. Ringgold stated: "I wanted to do another series. I like these long series, and I figured out that it should be about Marlena Simone." Taking "a lot of notes" is a favored mode of hers.

29. From notes taken by author on October 8, 1995, Englewood, New Jersey. At this time, Ringgold showed me a little book with a blue cover, which she took with her on her travels, containing ideas for *The American Collection.* In this she listed issues and events as they occurred to her, wrote down questions about artists and places, and made small pen-and-pencil sketches. She told me, "I don't know if I'll give Marlena a husband. I don't know if I'll let her have children." She saw the new series as her "first novel, with the paintings as illustrations." Later in the month, Ringgold composed a questionnaire that began, "Imagine waking up being black in America," which she started to distribute in 1996 to whites who attended her lectures and exhibitions.

30. Interview with Ringgold, Paris, December 1996.

31. Ringgold, faxed message to author, February 8, 1997, regarding our preparations for a College Art Association conference on February 13. She also wrote: "I would like to talk about race but I don't want a one-sided conversation. I don't have the answers to a situation that I'm not central to. I actually think it would be great to discuss race since *The American Collection* and all things American in America are about race. I can distribute my racial questions and discuss *The American Collection* but you may be timid on the subject. Think about it."

32. During this visit, I am shown five story quilts, signed and dated: *Bessie's Blues* (1/19/97), *Two Jemimas* (2/9/97), and three just completed (4/27/97)—*We Came to America, Born in a Cotton Field,* and *Wanted.* Another three are almost finished: *Listen to the Trees, Picnic on the Grass,* and *Cottonfields, Sunflowers, Blackbirds and Quilting Bees.* The remaining four story quilts are "blank," waiting for Ringgold to paint them; they were prepared the previous summer with a base monochrome color, and Ringgold's assistants are currently sewing their quilted borders.

33. Interview by author with Grace Welty, La Jolla, April 29–30, 1997.

34. Red for *We Came to America, The Two Jemimas, Stompin at the Savoy,* and *The Flag Is Bleeding, Part 2;* gray for *A Family Portrait, Cottonfields, Sunflowers, Blackberries and Quilting Bees, Jo Baker's Bananas,* and *Picnic on the Grass;* and blue for *Born in a Cotton Field, Bessie's Blues, Wanted: Douglas, Tubman and Truth,* and *Listen to the Trees.*

35. For two reproductions of Lawrence's *Toussaint L'Ouverture* series, see Ellen Harkins Wheat, *Jacob Lawrence: American Painter* (Seattle: University of Washington Press and Seattle Art Museum, 1986), p. 53. Harkins describes Toussaint L'Ouverture as "a Haitian slave who, in the late eighteenth and early

nineteenth centuries led his country to freedom from French rule and founded the Republic of Haiti, the first black Western republic" (p. 39).

36. Ringgold, "*The American Collection* Introduction."

37. Interview with Welty.

38. Ringgold's focus on nature is drawn both from art and advertisements (ranging from Winslow Homer's cottonfield paintings to travel brochures and postcards) and from direct experience. Welty emphasizes how increasingly responsive Ringgold has been to La Jolla's natural beauty. Significantly, last year Ringgold wrote "The Five Queens," a mythical tale of strife among three generations of women rulers of the earth. One day, "barely in their teens," the five Daughter Queens ask their respective mothers: Who is the more powerful advocate for peace? The Five Queens and their Husbands argue vehemently over this, and a battle ensues. Following a punishment of fierce winds, storms, ice, and frost, the Supreme Powers of Nature insist that the mothers step down and be succeeded by their daughters, whose powers are later challenged by their own daughters. The tale ends with the five Daughter Queens telling both their mothers and daughters: "None of us is more powerful than the unity of our combined resources" (Faith Ringgold, "Five Queens," unpublished manuscript, 1996).

39. See Ann Gibson's essay "Faith Ringgold's *Picasso's Studio*" (in this catalog). She makes *Picasso's Studio* the pivotal "text" for a discussion of the term *avant-garde,* positions Ringgold in relation to avant-garde, anti-avant-garde, and postmodern tendencies.

40. Quoted in *The French Collection, Part 1,* p. 37, and drawn from Ringgold's introduction to *Change 3,* the third quilt in a series concerning her weight loss and body image. The story quilt's image is of multiple selves, fat and thin, and the second line of its text reads: "It has been a long time since I learned anything new about myself. I talk to myself and I understand and accept my point of view. But I want to know, who am I talking to?" (ibid., p. 38). It is, I think, significant, that here the notion of "change" is literally appended to *The French Collection* and that a light-hearted, semifictional, semiautobiographical text immediately follows the intricacies of the semifictional, semiautobiographical narrative of part 1 of *The French Collection.*

41. Ringgold, "*The American Collection* Introduction."

42. Ibid.

43. In Kuan-Hsing Chen, "The Formation of a Diasporic Intellectual: An Interview with Stuart Hall," in *Stuart Hall: Critical Dialogues in Cultural Studies*, ed. David Morley and Kuan-Hsing Chen (New York: Routledge, 1996), p. 490.

44. Ringgold, "*The American Collection* Introduction." The quotation in the next paragraph is also drawn from this unpublished manuscript.

45. For a discussion of these paintings, see Rick Powell,

*Homecoming: The Art and Life of William H. Johnson* (Washington, D.C., and New York: National Museum of American Art and W. W. Norton, 1991), pp. 182–88. Powell comments that "as in all of Johnson's black interpretations of Christian themes, the raised arms and genuflecting postures of his figures reenact an eloquent, spiritual gesture closely identified with black religious expression" (p. 183). As an example of this, he reproduces a 1940s photograph of a Chicago Pentecostal church (a photograph that, incidentally, is illuminating when looking at the gestures of the figures in the water in *We Came to America*).

46. The title of *We Came to America* was slow in coming. A 1995–96 sketch was titled "Come Back Home" (it shows the Statue of Liberty holding a tablet-book). A little later Ringgold tried out "They Came to America," and in Paris in late 1996, I remember Ringgold speculating on a walk by the Seine, "Perhaps I should call it 'The American Dream.'" Ringgold did considerable research on the history of the Statue of Liberty and spent time in Paris looking for French publications on Bartholdi. Financed by the Franco-American Union, the Statue of Liberty was to celebrate the first hundred years of America's "liberty," and it was completed and officially presented to the United States in Paris in 1884. A pedestal was built for it on Bedloe's Island, and the work was finally dedicated there in 1886. Its origins are connected with a proposal of Bartholdi for a colossal figure at the entrance of the Suez Canal to symbolize Egypt carrying the Light to Asia. See Marina Warner, *Monuments and Maidens: The Allegory of the Female Form* (New York: Atheneum, 1985), p. 8.

47. Bill Cosby, "Introduction," in Middleton Harris, assisted by Morris Levitt, Roger Furman, and Ernest Smith, *The Black Book* (New York: Random House, 1974).

48. Ibid., p. 1.

49. Ibid., p. 7.

50. Ringgold, *Tar Beach* (New York: Crown Publishers, 1991), unpaginated.

51. Ringgold, "*The American Collection* Introduction." In *Listen to the Trees*, Marlena, wearing a white-and-green dress, holds a bouquet of flowers, paint brushes, and a painting. Earlier this canvas, which rests against Marlena's body, depicted Willia Marie's head, but later Ringgold substituted a reclining nude. Welty remembers Ringgold telling her that "the mother's portrait competed too much" in the composition (interview with Welty).

52. Ringgold, "*The American Collection* Introduction." In a July 8, 1997, phone conversation Ringgold told me that she had decided to create a part 2 of *The American Collection:* "I don't have anything else that is embracing me like *The American Collection* is doing. I have so much more to say that I don't want to leave it right now."

53. Roth, "Dinner at Gertrude Stein's," p. 11.

Ann Gibson

## Faith Ringgold's
### *Picasso's Studio*

HAT DOES IT MEAN to be avant-
garde? What does it mean to be post-
modern? Both terms have been used as
terms of approbation, signaling in their popular implica-
tions the conviction that whatever is being discussed is
"advanced," in the case of the term *avant-garde,* or "insight-
fully retro" in the case of the term *postmodern.* Both terms
carry with them significant status. Artists not considered
avant garde before the 1970s and postmodern since then
have commanded less attention, less press, and fewer sales
than those who were. Are there important distinctions
between these tendencies? Some would say "yes!" and
others "no!" Faith Ringgold's *Picasso's Studio* (1991) from
her *French Collection* series is particularly instructive in this
regard because its subject, style, and the very material of
which it is made refuse to settle easily into either of these
categories. Since it exemplifies avant-garde as well as what
have been called "postmodern," "anti-avant-garde,"[1] or
"anti-aesthetic"[2] tendencies, *Picasso's Studio* would seem to
support the argument that there is a continuum between
these two positions. To settle for this, however, is to miss
Ringgold's criticisms of both positions. What is it in Ring-
gold's work that places her both inside and outside each of
these categories? Looking at the categories themselves
with Ringgold's *Picasso's Studio* in mind tells us not only a
good bit about Ringgold's quilt paintings, but also about
the categories themselves.

This quilt painting, in fact the whole *French Collection*
series, displays the intellectual iconoclasm and playfulness
usually associated with the anarchic spirit of the avant-
garde, for instance, but not its characteristic sense of "uni-
versal and hysterical negation."[3] Like avant-garde works
are said to be, *Picasso's Studio* is self-reflexive: it is *about* the
definition and the centrality of the avant-garde in the his-
tory of modern art. It thus extends the premises of the
avant-garde into the late twentieth century by affirming

What is it about this work that lends itself to these contradictory readings? *Picasso's Studio* is painted on pieced, quilted, and stuffed fabric. The artist has relegated Picasso nearly to the margin, crowded between a border of decoratively pieced flowered material, overlapping patterns of painted fabric, a bored but alert model, and his famous *Demoiselles d'Avignon* of 1907. At one side of the painting are numerous sketches of the abstracted female figure. Brush poised, Picasso—perhaps the twentieth century's most famous embodiment of the avant-garde—stands before a blank canvas. His model, an imaginary alter-ego invented by Ringgold, represents what members of the avant-garde like Picasso were *not:* females of non-European descent who were more often, in Meyer Schapiro's words, art's "object-matter" than its makers.[4] As an antipatriarchal parody, one that aims to "transgress the ideology of the transgressive (avantgardism),"[5] it tells us about the avant-garde by "what [it] talk[s] about," that is, through its "*substantive* revision of, rather than [its] apparent *formal* allegiance to, the European avant-garde."[6]

But art-lovers may still feel indignation at seeing Picasso, the epitome of the heroic avant-garde, marginalized in terms of his model, and, what's more, in a

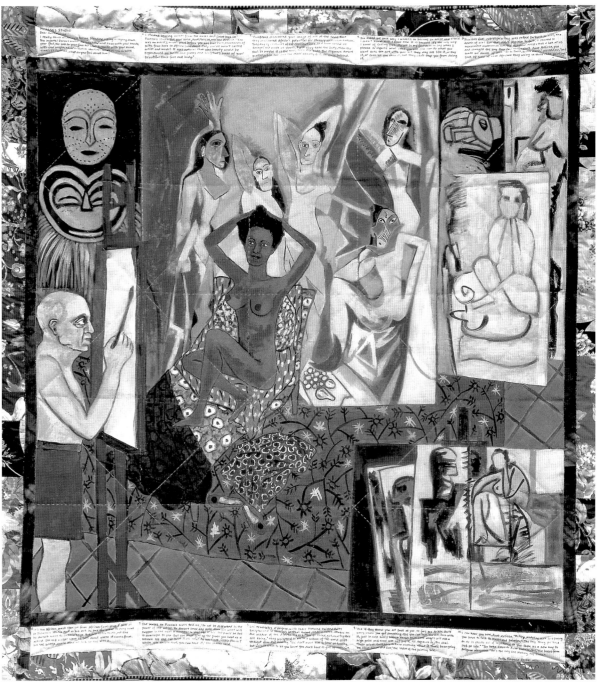

*Picasso's Studio*
*(The French Collection,*
*Part I: #7), 1991,*

Acrylic on canvas, printed
and tie–dyed fabric, 73 x 68"
Courtesy of ACA Galleries,
New York and Munich
Photo: Gamma One

some of its characteristics while critiquing others. But disturbingly, for those who would argue against a distinction between postmodernism and the avant-garde, as an allegory of avant-garde production Ringgold reuses avant-garde strategies for "anti-avant-garde" ends, and so offers an opportunity to explore both.

work whose narrative naturalism he played a part in discrediting. Naturalism was characterized by artists and critics like Baudelaire, Maeterlinck, and Mallarmé as well as later writers such as Ortega y Gasset as falsely and superficially totalizing because it employed the surface likeness of mimesis, of the copy, instead of exploring the "deeper" similarities available to metaphor. The continuing vitality

of this response to naturalistic representation is instructive because it represents as avant-garde an optimistic traditionalism, to which some would deny the title "avant-garde" altogether, calling this aspect of the avant-garde "modernism." Members of the avant-garde who worked in this modernist vein often sought a way to accept the flux of modernity with its ruptures and fragmentations. This is a part of the modernist criteria by which Picasso's abstractions—along with those of Manet, Cézanne, Proust, Torres-García, Pound, Kandinsky, Joyce, Benn, Mondrian, Eliot, Pollock, Stella, and other artists and writers from the Enlightenment until at least the 1960s—remain of critical interest. They have held out the hope that the disruption caused by modern progress in the arts and sciences will result in the end not only in the control of nature to humanity's benefit, but will also promote universal justice, moral progress, and happiness.[7]

On the other hand, reactions of dismay to *Picasso's Studio* may also be caused by the absence in it of the "universal and hysterical negation" of that other anarchic and even nihilistic wing of the avant-garde rooted in elements of Dada and surrealism typified in the readymades of Duchamp, Man Ray, and seen in the work of others such as Tzara, Brecht, and Warhol.[8] However, the 1970s saw a revival of interest in the "*notion of avant-garde*."[9] One of the earliest signs of this revival was Robert Venturi's anti-avant-garde manifesto, *Complexity and Contradiction in Architecture*. "I prefer 'both-and' to 'either-or,' black and white, and sometimes gray, to black or white," he wrote.[10] The critical revival that this kind of thinking sparked, in terms of the outlines broadly and effectively suggested by Ringgold, is the springboard of this essay.

Using *Picasso's Studio* as its center locates the vantage point of this discussion firmly in the late twentieth century. In doing so it echoes what is perhaps the major surviving manifestation of the politics of what Peter Bürger has called the "historical avant-garde," evident in the tendency of some contemporary art and criticism "to name an identity and mechanism of oppression that structures it." This tendency, analyzed by Christopher Reed and demonstrated in the arguments mounted in two panels published in *October* magazine in 1993 and 1994 on "The Politics of the Signifier," characterizes the current anti-avant-garde's rejection of purity as it extends and focuses earlier postmodernism's noncommittal play of recognizable and often socially significant images.[11]

In the United States, postmodern estimations of the nature and value of the avant-garde have frequently been funneled back through the conflicting claims of studies such as Renato Poggioli's *The Theory of the Avant-Garde*, published in Italian in 1962 and in English in 1968 (though conceived in the late 1940s),[12] and *Theory of the Avant Garde*, an amalgam of Peter Bürger's writings published in German in 1974 and 1979, brought together in English in 1984. As they apply to Ringgold, more current understandings of the avant-garde and its projects by theoreticians like Nicos Hadjinicolaou, Susan Rubin Suleiman, Carol Duncan, Daniel Herwitz, Rosalind Krauss, Richard Shiff, and Andreas Huyssen are usefully seen against Bürger's and Poggioli's influential claims.

Poggioli and Bürger did agree that the term *avant-garde* was originally used to designate the conjunction of revolutionary sociopolitical tendencies and artistic goals. They saw the avant-garde as had Walter Benjamin, attempting "to wrest tradition away from a conformism that is about to overpower it,"[13] interrupting the sense of continuous development in the arts by its transgressions against anything established as a given. They differed, though, in their estimates of what counts as exemplary avant-garde art, and therefore, in their descriptions of both its history and its legacy.

For Poggioli, the alliance of what he called "the two avant-gardes," one cultural-artistic and one sociopolitical, survived in France only until about 1880. What is commonly understood as "avant-garde art," he wrote, concentrated after the third quarter of the nineteenth century on formal creativity, rejecting conventional habits and incorporating "the cult of novelty and even of the strange" (poet Ezra Pound, Russian formalists such as Victor Shklovsky, and critic Harold Rosenberg have all commented on this aspect of the avant-garde). But Poggioli claimed that his autonomous, cultural-artistic avant-garde did not leave behind its social task when it was no longer specifically critical of society. Unlike Mondrian, whose utopian goals for neoplasticism he saw as "antiseptic,"[14] and also unlike Breton's surrealism, whose insistence on the "omnipotence of the dream" Poggioli believed could produce only a "quasi-mechanical product, a passive reflection,"[15] Poggioli held that the most effective avant-gardes reformed society by functioning as cathartic therapy for a language of art, music, and literature that had degenerated through thoughtless and habitual formulas. "It is absolutely indispensable to

distinguish the spurious from the genuine avant-gardism which results in art," he wrote. The need for value judgments, he believed, however, must not be obviated by "nonaesthetic considerations."[16] Poggioli is thus allied with Theodor Adorno in his belief that art should be autonomous (i.e., that artworks should "point to a practice from which they abstain: the creation of a just life"). For Adorno (as for Poggioli), "every commitment to the world must be abandoned to satisfy the ideal of the committed work of art." Adorno supported this claim with the observation that apparently apolitical art (he used the examples of Kafka's novels and Beckett's plays) "have an effect by comparison with which officially committed [i.e., politically aligned] works look like pantomime."[17]

Bürger, on the other hand, saw Poggioli's definition of the avant-garde as too elastic. Bürger felt that Poggioli, by permitting avant-garde autonomy to be identified as far back as the eighteenth century, allowed the avant-garde to separate itself from "real" life and social issues. He preferred to understand art not as single works produced by individuals but, following Walter Benjamin, as entities within an institutional framework that includes artists, dealers, critics, museums, collectors, etc.[18] This framework, he insisted, determines what art is supposed to be and do. Thus for Bürger, the avant-garde cannot be separated from society, but is inescapably implicated in it. For Bürger, the radical shift occurred at the beginning of the twentieth century, when aestheticism gave way to a historical avant-garde that attacked art as an institution.

Bürger's historical avant-garde (those instrumental in contesting the deadening effects of art's institutionalization) included Italian futurism and German expressionism to a limited extent, cubist collage, and especially movements of the 1920s, including Dadaism, the Russian avant-garde after the October Revolution, and particularly surrealism.[19] In the radical break that produced this historical avant-garde, he posited, collage and montage techniques were crucial, since they broke not only with the idea that perspective was equivalent to representation, but also with the idea that to be art, a work must be an organic whole. While Bürger contested the validity of autonomous art supported by Adorno and Poggioli, he nevertheless found certain of Adorno's arguments useful. Citing Adorno's caveat that nonorganic structure may offer escape from a system whose preference for the organic has congealed and ossi-

fied it, Bürger embraced elements of the concept of allegory advanced by Walter Benjamin, who wrote that the allegorist extracts elements from life or art, isolating them from their function there, and then combines them into a new work of art. Allegory's artificiality provided an example of just the kind of anti-organicism that Bürger saw in the historical avant-garde.[20] Although Bürger and Poggioli disagreed about surrealism's status as a model avant-garde (given their disagreements on art's autonomy, it was predictable that Bürger liked surrealism, and Poggioli didn't), they agreed, as Poggioli put it, that "when a specific avant-garde that has had its day, insists on repeating the promises it cannot now keep, it transforms itself without further ado into its own opposite."[21]

Poggioli's views were conceived before the ideas encapsulated in the term *postmodern* had achieved currency.[22] He did not relate his definitions of the avant-garde to such issues as appropriation, meaning as audience reception rather than artistic intention, representation as the construction rather than the mirror of reality, originality as function rather than fact, or issues of gender or race. Peter Bürger, writing a generation later, found himself at the beginning of the widespread currency of these issues, but gave short shrift to what he called "post avant-garde art." He was unable to accept postmodern art's politicism, its pluralism, its reenshrinement of narrative and mimeticism, and its insistence on the importance of the difference of artists who worked unrecognized, even when their anti-institutional strategies paralleled those of the anti-institutional avant-garde he affirmed.

Bürger noted that Herbert Marcuse's essay "The Affirmative Character of Culture" led him to model his focus on the avant-garde's anti-institutional strategies as opposed to the merits of individual works. But he was also much influenced by Marcuse's claim that while the idealistic, transcendent art favored by bourgeois society showed "forgotten truths," it also served to detach those truths from any influence they might have in real life. Art, wrote Marcuse, bestowed on its audience "a beautiful moment in a chain of misfortune," thus offering them "the illusion of a resolution of the contradiction between a bad material existence and the need for happiness." It could present this illusion better than religion or philosophy because, unlike these disciplines, art could offer satisfaction in the here-and-now.[23] Although Bürger found Marcuse wanting in both theoretical and material sophistication, he nevertheless

extrapolated from his definition of "affirmative culture" as autonomous art in which "freedom of the soul was used to excuse poverty, martyrdom, and bondage of the body."[24]

Referring to Jürgen Habermas as well, Bürger argued that the historical avant-garde (in such manifestations as Duchamp's *Fountain*) negated the preconditions for "affirmative," autonomous art by its disjunction of art and life, disavowal of the significance of individual production, and disinterest in individual reception.[25] But even the avant-garde art's anti-institutional character could be destroyed by its incorporation in institutions such as museums and academia.[26] Bürger believed that reusing avant-garde strategies only confirmed their institutionalization.[27] In this he followed Poggioli but focused Poggioli's complaint on art's institutional frame, elevating the "historical avant-garde" to the highest pinnacle of ethical worthiness. This permitted Bürger to see later art that attempted to repeat the manifestations of the historical avant-garde as merely derivative, and later art that departed from this model, no matter what *its* historical motivations, as regressive. He was thus unable to come to a positive assessment of the "post avant-garde," or the "anti-avant-garde" of postmodernism.

More recent investigators of avant-garde practices have criticized Bürger for his repression of the heterogeneity of the avant-garde's response to modern, popular, and industrialized culture, a response that included, but was not limited to, the goal of Berlin Dada.[28] As Maud Lavin has pointed out, that goal *was* to protest the institutionalization of art in order to reengage it with life—but in conjunction with, not in opposition to, its embrace of "affirmative" popular culture. After 1922 Berlin modernism was not concerned primarily with rebellion, but with "how to respond to commerce, politics, and new forms of mass communication, and with which appropriately modern styles." However, meshing art with technology, mass culture, and popular entertainment seldom included an imperative to engage (as Ringgold does) the politics of race and gender. Even Berliner Hannah Höch, who in her collages displayed an exceptional concern for the objectified position of women, seems now to us less critical than we might wish her to have been of her society's derogatory attitude toward ethnographic others.[29]

Thus Faith Ringgold may be seen as continuing and sharpening Höch's project. Like Höch's collages, Ringgold's quilt affirms qualities once considered the province of the avant-garde: its central plane of fabrics on which the model poses, for instance, which in traditional perspective would appear to be horizontal, and therefore perpendicular to the picture plane, is tipped up, à la Degas and so many other modernists, to coincide with the picture plane instead. It meets Poggioli's demand that the avant-garde be formally transgressive. But in doing so with methods already established as elements in the tool kit of an earlier generation, it also performs both Poggioli's and Bürger's recipe for the avant-garde's opposite: by conforming to what is now expected of the avant-garde it thus adapts to the "theory-death" of its institutionalization.[30]

*Picasso's Studio*, like *Demoiselles*, is a one-of-a kind production, too, an object made by a nameable person—an "individual"—who has set herself both with and against a number of now-institutional conventions. One of these is the art market; since Ringgold's quilts have readily entered a number of collections, both private and public, she has aligned herself in this regard with the autonomous avant-garde. For Bürger, such an adaptation to the market accounts for the "arts and crafts impression that works of the avant-garde not infrequently convey."[31] One must recall that not all avant-gardes were obsessed with modern technology. The hand-making traditions emphasized by the British Arts and Crafts movement and Jugendstil were extended by the avant-garde arts and crafts workshops of Bloomsbury, De Stijl, the Bauhaus, Black Mountain College, and El Taller Torres-García. In deliberately making reference to "craft" (*Picasso's Studio* really *is* a quilt, complete with decorative stitching, printed, pieced fabric, and scrap-cloth batting), Ringgold ratcheted up the pejorative ante with which the avant-gardes Bürger promoted viewed "craft," by making it synonymous with the ground whose materiality that same avant-garde championed. Rather than being—as it is in Matisse—merely a represented element, or as it often is in Picasso, Braque, and Schwitters, only an element that brings reality into the picture metonymically rather than mimetically or metaphorically, Ringgold's crafty ground of printed fabrics forms a part of the very base on which her figures are painted. It not only refers to, but is, the material from which quilts are traditionally made. So, while she throws into question one aspect of the avant-garde's continuation of traditional art's separation of art and craft, she tacitly extends another.

Ringgold's painted story quilt also displays cubism's abstracted forms, juxtaposing them with their so-called "primitive" inspirations—the masks on the upper left, and

their human source: the model. By collaging together not only Picasso's cubist transcriptions of African masks and feminine form, but also simplified naturalistic representations of the masks and of a live model, along with the transgressive elements of "craft" processes and the actual narrative text in bars at the top and bottom of the quilt, Ringgold meets and, in fact, exceeds the revolutionary quality—the breaking of the illusion of organic unity—that Bürger ascribed to the admission of actual fragments of empirical reality when they were incorporated into artworks.[32] Not only does her collapse of the "decorative," supposedly superficial aspect of craft into the tipped-up plane of modernist painting exceed the imperatives of both Poggioli's autonomous avant-garde and the economic definitions of the institutions resisted by Bürger's historical avant-garde, but her placement of an actual narrative on the quilt's surface catches all the elements on display in a net of specificity that reestablishes the organic congruence of the parts and the meaning of the whole that collage technique was supposed to destroy.

Ringgold's painting technique in *Picasso's Studio* throws into question a primary route through which the avant-garde has manifested its desire to produce works whose procedures and appearance place them outside of "art" conventions: primitivism. Her representation is constructed not only through crafts techniques and collage, but also acrylic paint, with which she renders figures, furniture, fabric. Naturalistic but not academic, Ringgold's techniques are somewhat reminiscent of artists such as Horace Pippin, whose untutored style was sometimes called "primitive." Ringgold, however, is not untutored. She is a professional who took her M.A. in art in 1961 from City College in New York. "I'm using whatever method I need to use," she has commented. "It's not that I don't know how to do it another way."[33] Her "neo-primitive" style, then, might be more appropriately likened to that of other trained artists such as William H. Johnson, whose *choice* of an untutored technique has prompted critics to use this designation, or, more pointedly for the purposes of this essay, Picasso or Matisse (who, with his painting *La Danse* and his model, the same Willia Marie Simone, is the subject of another quilt in *The French Collection* series). Significantly, Picasso and Matisse, both of whom attempted to escape Europe's academic beaux-arts heritage via alliances with colonialized nations' art and what were prevalently understood as its "natural" art techniques, have not been seen as "neo-

primitives," but as "avant-garde." In choosing this style, Ringgold might be seen as following them; but as Poggioli remarked, avant-gardists are opposed "to the principle of spiritual and cultural inheritance," and their favorite myth is "the annihilation of all the past, precedent and tradition."[34]

So, does this mean that Ringgold's quilt is an example of failed avant-gardism? I think not, since Ringgold's purpose in selecting a neoprimitivizing rhetoric is in an important way exactly opposite to that of most members of the avant-garde. Jürgen Habermas's observation on the avant-garde's use of the so-called "primitive" is instructive in this regard: it exhibited, he wrote, an "anarchistic intention of blowing up the continuum of history," often by replacing historical memory with "the heroic affinity of . . . a sense of time wherein decadence immediately recognizes itself in the barbaric, the wild and the primitive."[35] Thus it could annex the stereotyped "wildness" of both internally and externally colonialized peoples without eliciting charges of plagiarism or political insensitivity. By painting in one nonacademic style to question the ascendancy of what has become another one, Ringgold raises questions that strike at the heart of this aspect of the avant-garde enterprise: "In the attempt to break away from the status quo, whose reversals are acceptable?" "who benefits?" and "who decides?"

Equally disconcerting is Ringgold's dislocation of what Rosalind Krauss has called "the originality of the avant-garde," and what Richard Shiff has termed "the technique of originality." Both Poggioli and Bürger remarked briefly on the importance of novelty to the avant-garde enterprise, although to different ends: Poggioli notes its usefulness in creating unpopularity and Bürger (following Benjamin in "The Work of Art in the Age of Mechanical Reproduction") its support of the aura, the mystique of art's ritual status as an irreplaceable product of an individual genius.[36] But for Krauss and Shiff, the demystification of the avant-garde's claim to originality was a crucial postmodern task. When the double, the copy, is seen *with* the original, Krauss has written, the double destroys the pure singularity of the original.[37] As both Krauss and Richard Shiff have remarked, originality, that prime directive of the avant-garde whose sign is spontaneity, or self-expression, is a quality that, paradoxically, is rather laboriously produced by copying.[38] Following Derrida, however, Shiff identifies a yet more radical political potential of the copy. Observing that doubling merely reverses the avant-garde's priorities in the opposition

original/copy, he concludes that the anti-avant-garde has not finished its work until the toppling of the myth of the original has been followed by the displacement of the entire system of which that myth was a support.[39]

In *Picasso's Studio*, Ringgold does go further than the mere doubling of Picasso's painting. She presents a copy of the *Demoiselles* accompanied not only by cubistic drawings—traditionally preparations for painting—but also by representations of two kinds of "originals" for the mask-faced nudes in the historic avant-garde painting: African masks and the slim figure of Simone, Ringgold's stand-in. Ringgold's repetitions accomplish several things: they push Picasso's "masterpiece" into the background, obscuring it with the sketches, the "star" of the painting, Simone, and the masks hovering hieratically in the background; and they deny Picasso's "masterpiece" its spontaneity and thus the originary genius of its maker by showing its sources and the preliminary kinds of labor needed to produce it. Ringgold questions not only the status that Picasso's presumed originality granted to him as representative of the avant-garde, but also the supporting role the art of colonialized nations and its primitivized feminine objects played in the avant-garde's modernist enterprise.

Following the insistence of theorists such as Susan Rubin Suleiman, it is important to note that a worthwhile theory of the avant-garde must include a poetics of gender.[40] Ringgold, however, makes it equally necessary to add to that a poetics of colonial and postcolonial experiences. Ringgold uses her invented alter-ego, Willia Marie Simone, to de-mythify and historicize the nature of the split between the representor and the represented—often a gendered as well as a racializing separation—that characterized the historical avant-garde as much as it had traditional art. In Ringgold's rendition, Simone, Picasso's "object-matter," speaks, thus taking charge of the narrative. She thus refuses to accept the hierarchy of status that places those who represent in charge of those who have historically *been* represented.

Some avant-gardists have echoed this hierarchy in their assumption that high art's methods—metaphor, spontaneity, and abstraction—were superior to low, or popular, art's narrative, "craft," and naturalism. Often they gendered and raced this hierarchy in precisely the terms of Ringgold's drama. "The virulence of kitsch, this irresistible attractiveness," Clement Greenberg had worried, was "crowding out and defacing native cultures in one colonial country after another."[41] The implication was that popular, that is, non-

avant-garde culture, was somehow seductive and diseased (the image of a prostitute leaps to mind), and what is more, that this feminized populism (as opposed to the "real" art of the colonizers) would dilute and displace "pure" native cultures. The presupposition was that excellence was European and male, and as Andrew Ross has argued, that a "native culture" that responded to the Western images it received (as we in the West had, of course, responded to theirs) was both diseased and feminized.[42]

As Carol Duncan (and, more recently, Griselda Pollock) have pointed out, the avant-garde (or vanguard) artist had been universalized as male well before "Avant-Garde and Kitsch" was published in 1939, a status confirmed by opposing his active, heterosexual, masculine agency to the passive, feminized, and objectified status of his art and the females it so often represented. From the late nineteenth century on, for avant-garde artists like Paul Gauguin and Edvard Munch through Picasso and Matisse, including fauves like André Derain and Maurice Vlaminck, Brücke artists Ernst Kirchner and Erich Heckel, Dadas and surrealists like Marcel Duchamp, Kurt Schwitters, Max Ernst, and Alberto Giacometti, to abstract expressionists Jackson Pollock and Willem de Kooning, women were the vehicle, not the drivers, of art that examined what were understood as the central problems of existence in terms of middle-class European or European American males' struggles against the economic and psychological structures of modern bourgeois society. Even Duchamp's *Fountain* is a male fixture (though not unambiguously so) and his *Nude Descending a Staircase* is riven, like the architecture surrounding her, by a dynamized cubism, rather than being the agent of her own activity.

Michele Wallace has extended Duncan, arguing that the anti-avant-garde's deconstruction of the modernist avant-garde's primitivizing really echoes, rather than rejects, primitivism's xenophobia. Wallace, however, is interested also in another aspect of the avant-garde's apartheid, its exclusion of artists of color as the *makers* of important art because it understood the arts and artists of Africa and elsewhere in the Third World as worthwhile primarily as inspiration for the European avant-garde. The understanding of African and Oceanic art as productions whose worth is dependent on European validation is repeated, Wallace claims, by most postmodernists' inability to grant influential creative significance to anything but the production of

European-descended artists and critics. Thus, she concluded, both the masculinity and the whiteness of the historic avant-garde were continued by the anti-avant-garde, the postmodern generation.[43]

It is just this situation that is countered by the narrative told in the borders of Ringgold's quilt painting in the voice of Simone, an artist herself, but also Picasso's model. In opposition to the usual silence of the one who is painted, Simone recalls her responses to her Aunt Melissa's advice, to the whispered observations she ascribes to the masks of her ancestors on Picasso's wall, and to the prostitutes in his painting. "My art is my freedom to say what I please," asserted Simone in response. "N'importe what color you are, you can do what you want avec ton art."[44] The format and narrative style of the quilt itself represents Ringgold's position in the art world, since quilts, as Patricia Mainardi has noted, "have been underrated precisely for the same reasons that jazz, the great American music, was also for so long underrated—because the 'wrong' people were making it, and because these people, for sexist and racist reasons, have not been allowed to represent or define American culture."[45] Like jazz, the tradition of narrative quilts is strong in African American communities, although its preeminence there is still undetermined.[46]

Ringgold maintains a subjectivity that combines artistic identity with a compound of retrieved African heritage and a feminine sexuality—a gesture that runs contrary to the merely metaphoric or metonymic (even when sympathetic) meshing of these terms by the creative roster of both the avant-garde and the anti-avant-garde. Her position as a subject is, however, situated in the idea that art offers an arena of individualistic freedom, a standard claim of one of Poggioli's two avant-gardes, the cultural-artistic one. This anomaly reveals the paradox at the heart of the avant-garde's claim to universal relevance: its freedom is circumscribed; its universality partial.[47] As Daniel Herwitz has suggested, perhaps "the tendency of contemporary art and theory to treat theorizing about art and culture as if it is the one remaining avant-garde activity on the face of the earth" is the proper continuation of earlier avant-gardes.[48]

Following Herwitz's observation, one could say that Ringgold not only reveals the paradoxes at the heart of the avant-garde, she participates in them. As noted, members of various manifestations of the avant-garde, especially at their most revolutionary moments, have been dissatisfied with art's commodity status in capitalist society and with the traditional hierarchy of media. Avant-garde status, however, is defined in relation to a society's traditions, and to achieve recognition or even embodiment must take advantage of some of its resources. Clement Greenberg commented that culture cannot develop without economic support, and that the avant-garde, despite its assumption that it was cut off from the elite ruling class, was actually "attached by an umbilical cord of gold."[49] Historically, the avant-garde has negotiated this realization with a variety of more or less adaptive strategies. Nicos Hadjinicolaou and Peter Wollen, following Poggioli's formulation of "the two avant-gardes," observed that the twentieth century has seen the formation of a "progressive," left-wing, and a "conservative," right-wing, avant-gardism. The stereotype that a political and revolutionary left-wing tended to privilege realism, illusionism, and literature, while an apolitical or counterrevolutionary right-wing favored abstractionism, self-reflexiveness, and a Greenbergian modernism, however, is frequently contradicted in practice. Artists like filmmakers Sergei Eisenstein and even Jean-Luc Godard, as well as Picasso in *Les Demoiselles*, for instance, notes Wollen, display a startling loosening of conventional connections between form and meaning, but without permitting their concerns with abstract and experimental form to force them to abandon either realistic or expressionistic treatment of their subject matter.[50] Unlike the avant-garde productions most preferred by Bürger, such as futurist and Dada performances, and the least salable of surrealist constructions, Ringgold's quilts seem to affirm not only their status as a commodity by appearing in galleries as luxury objects for sale but also to assert the hegemony of painting, since its appearance on what is a nominally usable object (i.e., "craft") promotes her quilts to the status of "fine" art.

However, there are two relevant points to be made here. The first is that there is a difference between rejecting something one may reasonably hope to attain and something that has historically been unavailable. Ringgold represents a constituency—women of color—who, as a theme that runs through *The French Collection* series, were rarely considered eligible to be members of the avant-garde. Her identity marked her as one like those who had been considered by the dominant society, including the avant-garde, to be much more likely to produce "craft" than fine art. For an artist in Ringgold's position to *refuse* to accept the roles assigned to her by the traditional avant-

garde, by elevating quilting to painting's status and then by selling it at painting's prices, was to put herself outside of some definitions of the avant-garde, but to remain inside others (as Hadjinicolaou notes, the "right-wing" current of avant-gardism has since the beginning been the most powerful).[51] *Picasso's Studio* places both definitions in question. But on another level, to break a cultural apartheid enforced by conventions that still, early in her career, were so deeply embedded in both avant-gardes (as well as in the burgeoning anti-avant-garde in ascendancy when this piece was done) that most institutions denied their existence,[52] is to participate in what many commentators identify as the overriding key to the most common definition of the term *avant-garde*: to be inventive. It also—and not incidentally—reflects a sociological understanding of avant-gardism, one that sees it as opposing not only obsolete norms but also voids in social memory where past artistic developments (like African art and women's art) have been repressed.[53]

The second point regards originality. Despite her use of and reference to avant-garde characteristics, Ringgold appears here to have set herself against at least three aspects of avant-garde production: its frequent (though not unexceptional) prejudice against "craft," its refusal of narrative, and, perhaps most significant, its outlawing of the copy in the name of originality. It might seem as if Ringgold were really attempting to annihilate the avant-garde. After all, the allegorical mode she employs in *Picasso's Studio* empties its objects, including the idea of the avant-garde itself, of any claim to immanent meaning by reanimating them with her concerns. But, as Paul Mann has noted, even to talk about the death of the avant-garde is to recuperate it, and recuperation is (also) the spectacle of the internalization of the margins of cultural discourse that appears to be peculiar to the late-capitalist culture that produced the avant-garde in the first place.[54] It is more accurate, I think, to admit Ringgold's participation in the contemporary fracturing of the avant-garde "into a number of related shards, each of which retains one or more avant-garde features—political, stylistic, theoretical, rhetorical, obnoxious, and so forth."[55] This permits us to ascribe to *Picasso's Studio* a "triple-voicedness" (adapting a conclusion of Susan Rubin Suleiman's), and a "complexity and contradiction" (echoing Robert Venturi), composed of Ringgold's allegiances to the formal experiments and some of the cultural aspirations of the historical avant-garde. But through her feminist critique of the dominant culture and her postcolonial deconstruction of the racializing practices of the European and American avant-gardes, Ringgold moves beyond their limits.

## NOTES

Originally published as "Avant-Garde" in *Critical Terms in Art History*, ed. Robert Nelson and Richard Shiff (Chicago: University of Chicago Press, 1996), pp. 156–69.

1. "David Harvey, *The Condition of Postmodernity: An Inquiry into the Conditions of Cultural Change* (Oxford: Basil Blackwell, 1989), p. 59.

2. Hal Foster, "Postmodernism: A Preface," in *The Anti-Aesthetic: Essays on Postmodern Culture*, ed. Hal Foster (Port Townsend, Wash.: Bay Press, 1983), p. xv.

3. Andreas Huyssen, "The Search for Tradition: Avant-Garde and Postmodernism in the 1970s," *New German Critique* 22 (Winter 1981): 30. See also Matei Calinescu, *Five Faces of Modernity: Modernism, Avant-Garde, Decadence, Kitsch, Postmodernism* (Durham, N.C.: Duke University Press, 1987), pp. 125, 140.

4. Moira Roth, "Upsetting Artistic Apple Carts: The French Collection," in Faith Ringgold, *The French Collection, Part 1* (New York: Being My Own Woman Press, 1992), p. 8. See also Meyer Schapiro, "The Liberating Quality of Avant-Garde Art," *Art News* 56 (Summer 1957): 38.

5. Foster, "Postmodernism," p. ix.

6. Susan Rubin Suleiman, *Subversive Intent: Gender, Politics, and the Avant-Garde* (Cambridge: Harvard University Press, 1990), p. 162. She is quoting Gayatri Spivak, "French Feminism in an International Frame," *Yale French Studies* 62 (1981): 167.

7. Jürgen Habermas, "Modernity—an Incomplete Project," in *The Anti-Aesthetic,* ed. Foster, p. 9. See also Huyssen, "Search for Tradition," pp. 26–27; Calinescu, *Five Faces of Modernity*, pp. 96–97; and Juan Fló, "Torres-García in (and from) Montevideo," in *El Taller Torres-García: The School of the South and Its Legacy*, ed. Mari Carmen Ramírez (Austin: University of Texas Press, 1992), pp. 25–43.

8. Calinescu, *Five Faces of Modernity*, pp. 140–41.

9. Nicos Hadjinicolaou, "On the Ideology of Avant-Gardism," trans. Diane Belle James, *Praxis* 6 (1982): 39. See also Huyssen, "Search for Tradition," p. 25.

10. Robert Venturi, *Complexity and Contradiction in Architecture* (New York: Museum of Modern Art, 1966), p. 16.

11. Christopher Reed, "Postmodernism and the Art of Identity," *Concepts of Modern Art*, ed. Richard Stangos (London: Thames and Hudson, 1994), p. 281. See also Hal Foster, Rosalind Krauss, Sylvia Kolbowski, Miwon Kwon, and Benjamin Buchloh, "The Politics of the Signifier: A Conversation on the

Whitney Biennial," *October* 66 (Fall 1993): 3–27; and Hal Foster, Benjamin Buchloh, Rosalind Krauss, Yves-Alain Bois, Denis Hollier, and Helen Molesworth, "The Politics of the Signifier II: A Conversation on the *Informe* and the Abject," *October* 67 (Winter 1994): 3–21.

12. Calinescu, *Five Faces of Modernity*, p. 113.

13. Walter Benjamin, "Theses on the Philosophy of History," in *Illuminations*, ed. Hannah Arendt (New York: Harcourt, Brace and World, 1968), p. 255.

14. Renato Poggioli, *The Theory of the Avant-Garde*, trans. Gerald Fitzgerald (Cambridge: Harvard University Press [1962], 1968), p. 203.

15. Ibid., p. 205.

16. Ibid., pp. 164–65.

17. Theodor Adorno, "Commitment," in *The Essential Frankfurt School Reader*, ed. Andrew Arato and Eike Gebhardt (New York: Continuum, 1993), pp. 314, 317.

18. Peter Bürger, *Theory of the Avant Garde*, trans. Michael Shaw (Minneapolis: University of Minnesota Press, 1984), pp. 83–92.

19. Ibid., p. 109, n. 4.

20. Ibid., pp. 68–73, 90–91. See also Theodor Adorno, *Aesthetic Theory*, ed. Gretl Adorno and Rolf Tiedman, trans. C. Lenhardt (London and Boston: Routledge and Kegan Paul, 1984), pp. 242, 266–68.

21. Poggioli, *The Theory of the Avant-Garde*, p. 223.

22. Calinescu, *Five Faces of Modernity*, p. 113

23. Herbert Marcuse, "The Affirmative Character of Culture," in *Negations: Essays in Critical Theory*, trans. Jeremy J. Shapiro (Boston: Beacon Press, 1968), pp. 94–96, 99, 102, 117–20.

24. Ibid., p. 109. See also Bürger, *Theory of the Avant Garde*, pp. 12–14.

25. Bürger, *Theory of the Avant Garde*, pp. 25, 50–53.

26. Ibid., pp. 27, 89.

27. Ibid., pp. 57–59.

28. David Bathrick and Andreas Huyssen, "Modernism and the Experience of Modernity," in *Modernity and the Text: Revisions of German Modernism*, ed. David Bathrick and Andreas Huyssen (New York: Columbia University Press, 1989), p. 8.

29. Maud Lavin, *Cut with the Kitchen Knife: The Weimar Photomontages of Hannah Höch* (New Haven: Yale University Press, 1993), pp. 50, 17–19, 160.

30. Paul Mann, *The Theory-Death of the Avant-Garde* (Bloomington: Indiana University Press, 1991).

31. Bürger, *Theory of the Avant Garde*, p. 53.

32. Ibid., p. 78.

33. Faith Ringgold with Eleanor Flomenhaft, "Interviewing Faith Ringgold: A Contemporary Heroine," in *Faith Ringgold, A Twenty-five Year Survey* (Hempstead, N.Y.: Fine Arts Museum of Long Island, 1990), p. 7.

34. Poggioli, *The Theory of the Avant-Garde*, p. 47.

35. Habermas, "Modernity," p. 5.

36. Poggioli, *The Theory of the Avant-Garde*, p. 50. See also Bürger, *Theory of the Avant Garde*, p. 28.

37. Rosalind Krauss, *The Originality of the Avant-Garde and Other Modernist Myths* (Cambridge: MIT Press, 1986), p. 109.

38. Ibid., p. 162; Richard Shiff, "Mastercopy," *Iris* 1 (1983): 119.

39. Jacques Derrida, "Signature Event Context," *Glyph* 1 (1977): 195; Shiff, "Mastercopy," p. 118.

40. Suleiman, *Subversive Intent*, p. 84.

41. Clement Greenberg, "Avant-Garde and Kitsch," in *Perceptions and Judgments, 1939–1944*, ed. John O'Brian (Chicago: University of Chicago Press, 1986), p. 14.

42. Andrew Ross, *No Respect: Intellectuals and Popular Culture* (New York and London: Routledge, 1989), pp. 43–47.

43. Michele Wallace, "Modernism, Postmodernism and the Problem of the Visual in Afro-American Culture," in *Out There: Marginalization and Contemporary Culture,* ed. Russell Ferguson, Martha Gever, Trinh T. Minh-ha, and Cornel West (New York and Cambridge: The New Museum of Contemporary Art and MIT Press, 1990), pp. 39–50.

44. Ringgold with Flomenhaft, "Interviewing Faith Ringgold: A Contemporary Heroine," p. 33.

45. Patricia Mainardi, "Quilts: The Great American Art," in *Feminism and Art History*, ed. Norma Broude and Mary D. Garrard (New York: Harper and Row, 1982), p. 344.

46. Eva Ungar Grudin. "Essay," in *Stitching Memories: African-American Story Quilts* (Williamstown, Mass.: Williams College Museum of Art, 1990), pp. 13–17.

47. Huyssen, "The Search for Tradition: Avant-Garde and Postmodernism in the 1970s," p. 38; Reed, "Postmodernism and the Art of Identity," p. 273.

48. Daniel Herwitz, *Making Theory/Constructing Art: On the Authority of the Avant-Garde* (Chicago: University of Chicago Press, 1993), pp. 272–73.

49. Greenberg, "Avant-Garde and Kitsch," pp. 10–11.

50. Peter Wollen, "The Two Avant-Gardes," in *Readings and Writings: Semiotic Counter-Strategies* (London: Verso, 1982), pp. 98–101. See also Hadjinicolaou, "On the Ideology of Avant-Gardism," pp. 44–46.

51. Hadjinicolaou, "On the Ideology of Avant-Gardism," p. 45.

52. Howardena Pindell, *The Heart of the Question: The Writings and Paintings of Howardena Pindell* (New York: Midmarch Arts Press, 1997), pp. 3–48.

53. Hadjinicolaou, "On the Ideology of Avant-Gardism," pp. 40, 48.

54. Mann, *The Theory-Death of the Avant-Garde*, pp. 14–15.

55. Herwitz, *Making Theory/Constructing Art*, p. 273.

Selected Works by Faith Ringgold

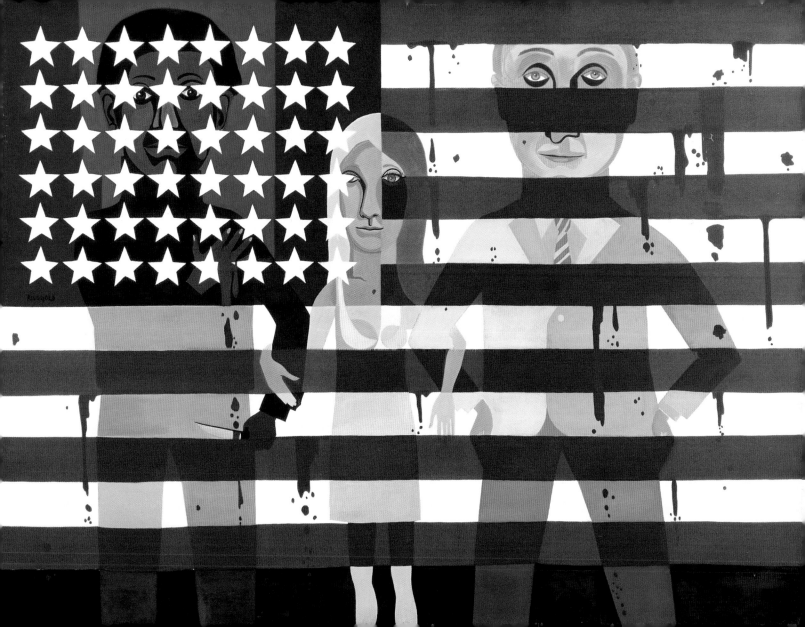

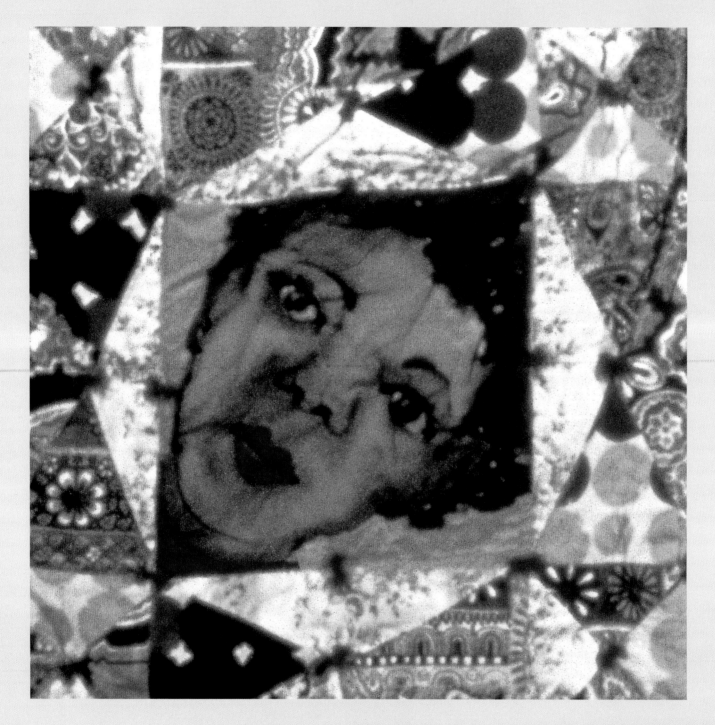

## *Echoes of Harlem*
### 1980

Acrylic on canvas, dyed,
painted and pieced
fabric, 96 x 84"
Collaboration
with Willi Posey

Collection of
Philip Morris
Companies, Inc.

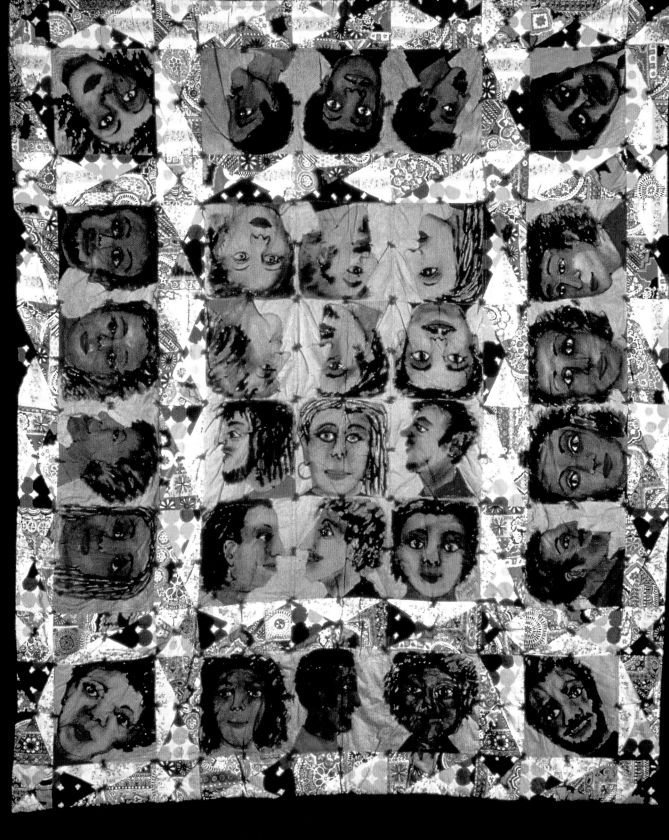

*Who's Afraid of
Aunt Jemima?*
1983

Acrylic on canvas, dyed, painted
and pieced fabric, 90 x 80"

Collection of Frederick N. Collins, Esq., Brooklyn
Photo: Studio Museum in Harlem, New York

Fig O    ANNABELLE

**5**
Now 'Lil Rufus, Jemima's baby, handsome as a Greek God, took color after Jemima's side a the family. Jemima likena died when he married a white gal, name a Margo (Fig) he picked up in Germany, of all places, during that Korean war. Brought her home too, to live in Jemima's house in Harlem. They had three girls. Jemmie, (Fig J) Jo Ann, (Fig K) and Julia (Fig L). They look just like Jemima. They ain look nothin like they ma, Margo, she a scrawny little ole white gal. Love the ground 'Lil Rufus walk on.

Fig E   OLE MAN PROPHET

**1**
Jemima Blakey (Fig) didn't come from no ordinary people. Her Granma and Granpa bought they freedom out a Slavery in New Orleans. Gramma Jemima Blakey- they called her Aunt Jemima too- made cakes and catered fine parties for them plantation owners in Louisiana. And Granpa Blakey was a first class tailor too. From memory he could make a suit of clothes fit like a glove. They was sure smart people, them Blakeys. And Jemima was just like 'em, hard working, and God-fearing till the day she died.

OLE LADY PROPHET

**6**
Georgia, Jemima's daughter, was high yallah likena her pa, Big Rufus, and had green eyes and long straight hair she could sit on. Only thing she took after Jemima was her shape. Georgia was real big up top and had skinny legs and big feet. Jemima'd blow up like a balloon when folks say'd she was Georgia's maid. Georgia'd laugh and call her Aunt Jemima. Jemima'd take that piss tail gal over her knee and whoop her till she quit. "You ain nothin but your ma, Jemima'd tell her, and Georgia'd screw up her li'l horse face and holler. Jemima was some proud a Georgia's wedding to Dr. Jones (Fig M) But Ma Tillie said " Jemima, thats a evil ole ugly black man, you'll see.

Fig   PA BLAKEY    Fig B   MA TILLIE

**2**
Jemima could do any thing she set her mind to. When Ma Tillie (Fig) and Pa Blakey (Fig), Jemima's Ma and Pa, forbid her to marry Big Rufus Cook (Fig) on account a they wanted her to marry a preacher, Jemima up and married Big Rufus anyway, and they run off to Tampa, Florida to work for Ole Mom and Ole Lady Prophet (Fig Lt) cookin, cleanin and takin care a they chirun, same thin Jemima ain never had to do livin in her Ma and Pa's comfortable home in New Orleans.

Fig N   PETER

WHO'S AFRAID OF AUNT JEMIMA? QUILT & BOOK BY FAITH RINGGOLD

Fig M   Dr. JONES

Ole Man Prophet used to joke that Jemima was his heir. "Jemima keep my house and family like they hers. I reckon I'll leave em to her when I die," he used to tell Ole Lady Prophet. "Over my dead body." She used to say. Well as God would have it, lightening struck they house one night whilst the servants was away and burnt it to the ground. Ain nar' one of them Prophets survive. And she met Jemima was in Ole Man Prophet's will as the last to survive. And, praise God, she was.

**7**
Tillie Blakey, Jemima's Ma was half Indian. A real beauty in her youth, she was coal black with long braids and keen features. They say she ran a bad house for white men in New Orleans. Anyway I know she was a good church going woman owned a fine house and left plenty money to the church when she died. Pa Blakey called it penance money from the devil. He swore he'd never touch it. Much as he loved Georgia an her struggling doctor husband, and they two chirun Peter (Fig) and Annabelle (Fig) he never give em a cent of Ma Tillie's money.

Fig D   BIG RUFUS    Fig A   AUNT JEMIMA    Fig G   GEORGIA

Fig J   JEMMIE

**9 THE END**
That same morning Jemima and Big Rufus had a fatal car accident on the way to open they restaurant. Word reached they souls. Lil Rufus brought they bodies back to Harlem, and give 'em an African funeral. Praise God! Dressed Jemima in an African gown and braided her hair with cowry shells. Put Big Rufus in a gold dashiki. They looked nice though, peaceful, like they was home. Georgia, her Doctor husband and them two worthless chilrun a hers get Jemima's restaurant business and Ma Tillie's fine house in New Orleans. Now who's afraid of Aunt Jemima?

Fig L   JULIA    Fig I   MARGO

**8**
After Pa Blakey died, Jemima an Big Rufus one up they restaurant business in Harlem. Lil Rufus and his German wife, Margo and moved to New Orleans. There they opened another restaurant near Georgia's house. But Jemima ain never see her grandchirun, Peter and Annabelle. "My pa don't want you in our house," they told her one day. And then Peter kicked Jemima in the bad knee and he and Annabelle ran off. The next day before Dr. Jones could leave for his office, Lil Rufus was there, and he was mad as hell. When Dr. Jones saw him, he jumped in the pool fully dressed, Dr. Jones an all.

Fig K   JO ANN    Fig H   LIL RUFUS

**4**
Jemima and Big Rufus was rich now. They come to New York with they two chirun, Georgia (Fig) and Lil Rufus (Fig) and opened a restaurant and catering business in Harlem. Big Rufus was a fine chef too, and could tailor clothes out this world just like Granpa Blakey. He looked like white, and couldn't see nobody but Jemima, black as she was. No- never died. "Where you get that fine color, my man?" from Jemima? folks used to ask. "Where I get you from asking me that question?" she'd say, laughing.

# The Wedding

## The Lovers Trilogy: #1, 1986

Acrylic on canvas, printed,
tie-dyed, and pieced
fabric, 77½ x 58"

Collection of
Ms. Marilyn Lanfear,
San Antonio
Photo: Gamma One

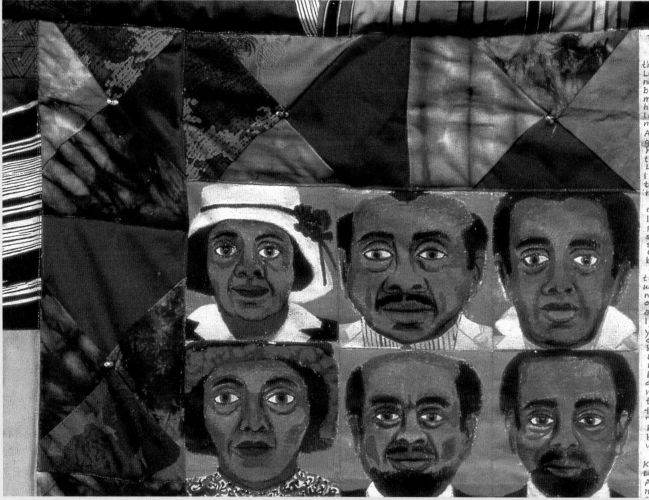

THE WEDDING: LOVER'S QUILT #1

Not a day passes that I don't
think about the day I married
Luther. What would I give to have
not opened the door when Luther's
brother, Larry came over that
morning. He said Luther sent
him to tell me something. When
I opened the door he said, "Give
me something." I believed him.
And stood there in my night
gown with my eyes shut and my
hands behind my back like he
told me to do. And then I felt
Larry's hot breath on my breasts.
I stayed there frozen while he
took off my gown and unzipped
his pants.
    We made love right there on
the floor. My mother, father, my
little brother and sister, anyone
passing my bedroom could have
seen us or heard us. Did they?
Since then Larry has had that
effect on me. I don't love him
but I can't resist him.
    Larry is such a rat. All the
time we were on the floor he
was saying, "You think I would
make love to my brother's girl
on her wedding day? You have
a morbid sense of humor Addy.
I just came over here to give
you something. 'Something
old, something new, something
borrowed, something blue.' It
was really Martha who sent
me. So you don't have to tell
her I came." I never could un-
derstand Larry but that's the
way he is. He always denies
that we are making love. All
these years he has denied it.
"So how could the twins be
his?" He says. "You were a virgin
before Luther. You're still a
virgin. Remember that Addy!"
    I often wonder if Martha
knows about me and Larry. She
looks at me like she knows.
At the wedding she cried so
much she got sick. It was like
she was at a funeral. The nurse

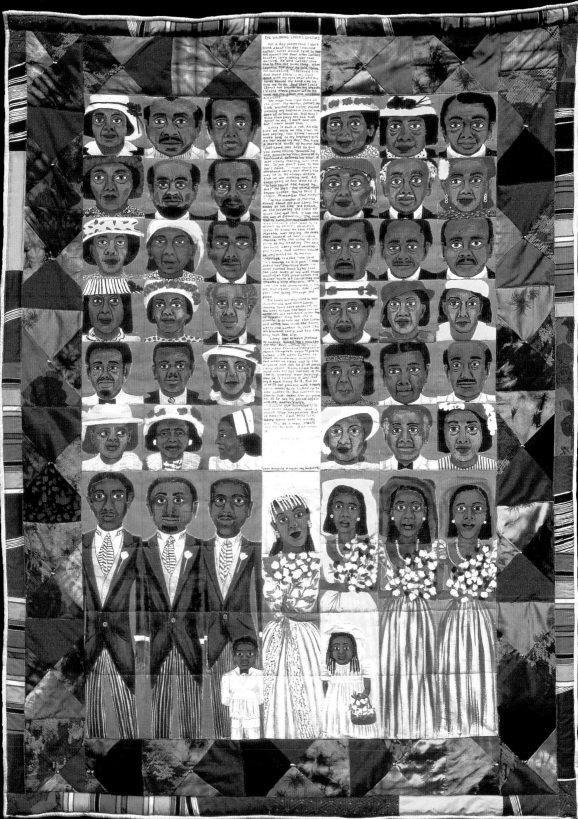

*Change:*
*Faith Ringgold's*
*Over 100 Pounds*
*Weight Loss*
*Performance*
*Story Quilt*
1986

Photoetching on silk
and cotton, 57 x 70"

Courtesy of ACA Galleries,
New York and Munich
Photo: Gamma One

CHANGE: FAITH RINGGOLD'S OVER 100 POUNDS WEIGHT LOSS STORY QUILT

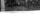

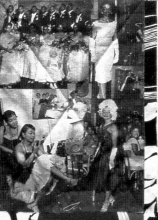
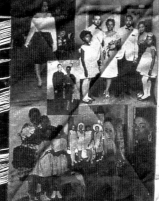

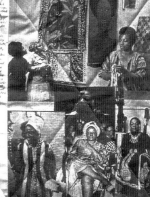

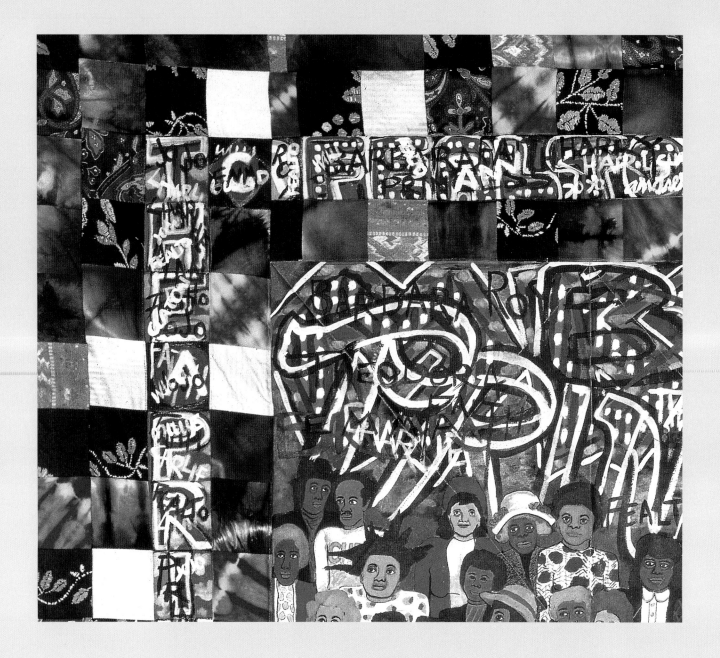

*Subway*
*Graffiti,*
*#3*
1987

Acrylic on canvas and
pieced fabric, 60 x 84"

Courtesy of ACA Galleries,
New York and Munich
Photo: Gamma One

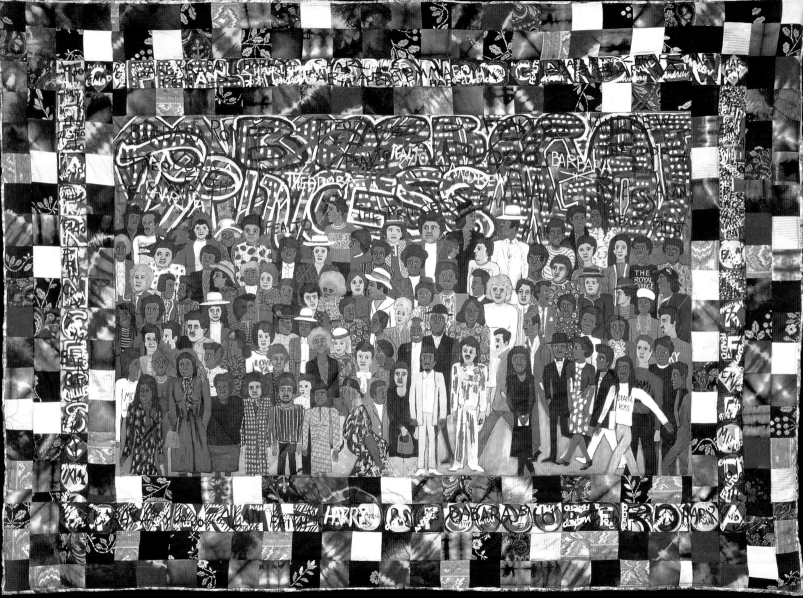

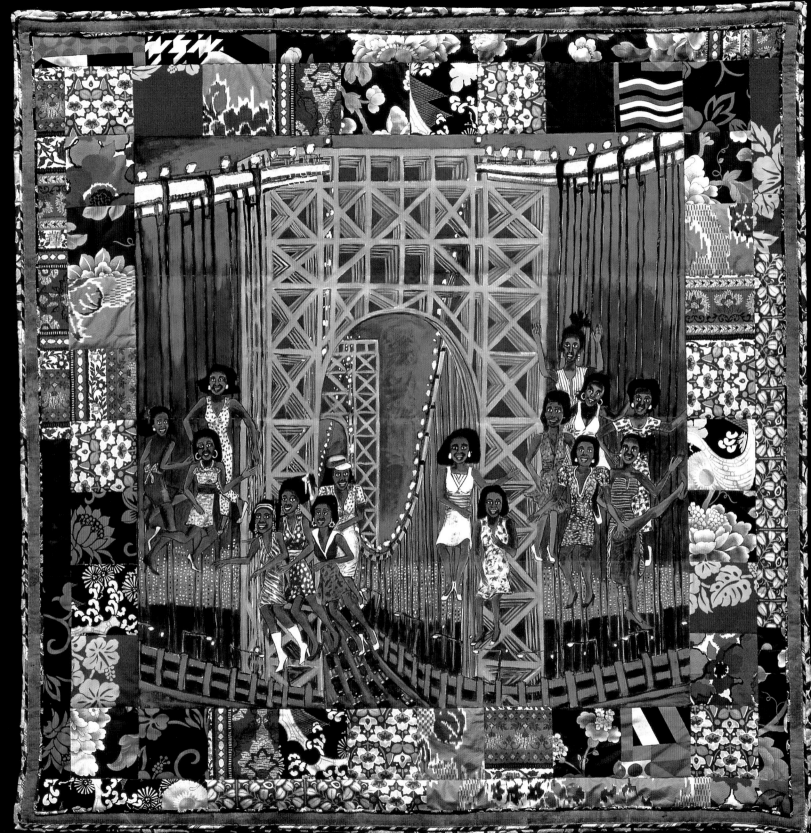

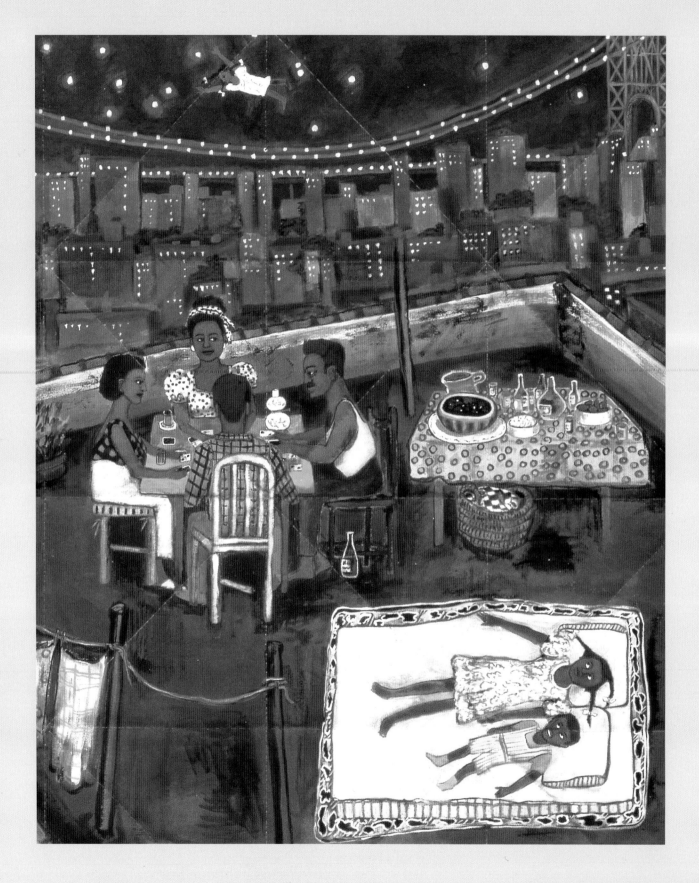

## Tar Beach

### 1988

Acrylic on canvas, printed and tie-dyed fabric, 74 x 69"

Collection of the
Solomon R. Guggenheim
Museum, New York,
Gift, Mr. and Mrs. Gus and
Judith Lieber, 1988
Photo: Gamma One

Tar Beach: Woman On A Bridge Series - Part I
by Faith Ringgold © 1988

I will always remember when the stars fell down around me and lifted me up above the George Washington Bridge.

I could see our living room top with Mommy and Daddy and Mr. and Mrs. Honey, our next door neighbors, still playing cards as if nothing was going on, and Be Be my baby brother, laying real still on our mattress, just like I told him to, his eyes like huge floodlights tracking me through the sky.

Sleeping on Tar Beach was magical. Laying on the roof in the night with stars and skyscraper buildings all around me made me feel rich, like I owned all that I could see. The bridge was my most prized possession.

Daddy said the George Washington Bridge was the longest and most beautiful bridge in the world and that it opened in 1931 on the very day I was born. Daddy worked on the bridge hoisting cables. Since then I've wanted that bridge to be mine.

Now I have claimed it. All I had to do was fly over it for it to be mine forever. I can wear it like a giant diamond necklace, or just fly above it and marvel at its sparkling beauty. I can fly; yes, fly me, Cassie Louise Lightfoot, only eight years old and in the third grade and I can fly.

That means I am free to go wherever I want for the rest of my life.

Daddy took me to see the new union building he is working on. He can walk on steel girders high up in the sky and not fall. They call him The Cat.

But still he can't join the union because Grandpa wasn't a member. Well, Daddy is going to own that building cause I'm gonna fly over it and give it to him. Then a union membership card is not in their old union or whatever he's colored or a half breed Indian like they say.

He'll be rich and won't have to stand on line in the unemployment or join the union and Mommy won't cry all winter when Daddy goes to look for work and doesn't come home. And Mommy can laugh and sleep late like Mrs. Honey and we can have ice cream every night for dessert.

Next I'm going to fly over the ice cream factory just to make sure we do.

Tonight we're going to Tar Beach. Mommy is roasting peanuts and frying chicken and Daddy will bring home a watermelon. Mr. and Mrs. Honey will bring the beer and wine and green card table and even the stars will fall down around me and I will claim the night sky all as mine.

It'll be mine me. She threatened to tell Mommy and Daddy if I leave him behind.

I told him all it's very easy, anyone can fly. All you need is somewhere to go that you can't get to any other way. The next thing you know you're just flying among the stars.

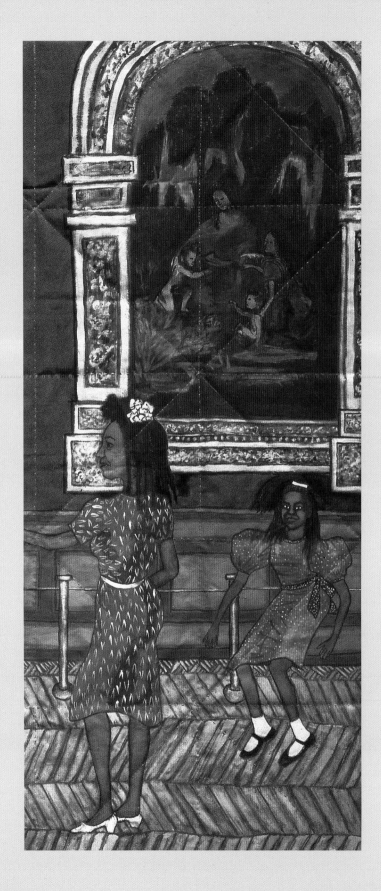

Dancing
at the
Louvre

*The French Collection*
Part I: #1, 1991

Acrylic on canvas,
printed and tie-dyed
fabric; 73½ x 80½"

Collection of
Ms. Francie Bishop Good
and Mr. David Horvitz,
Ft. Lauderdale
Photo: Gamma One

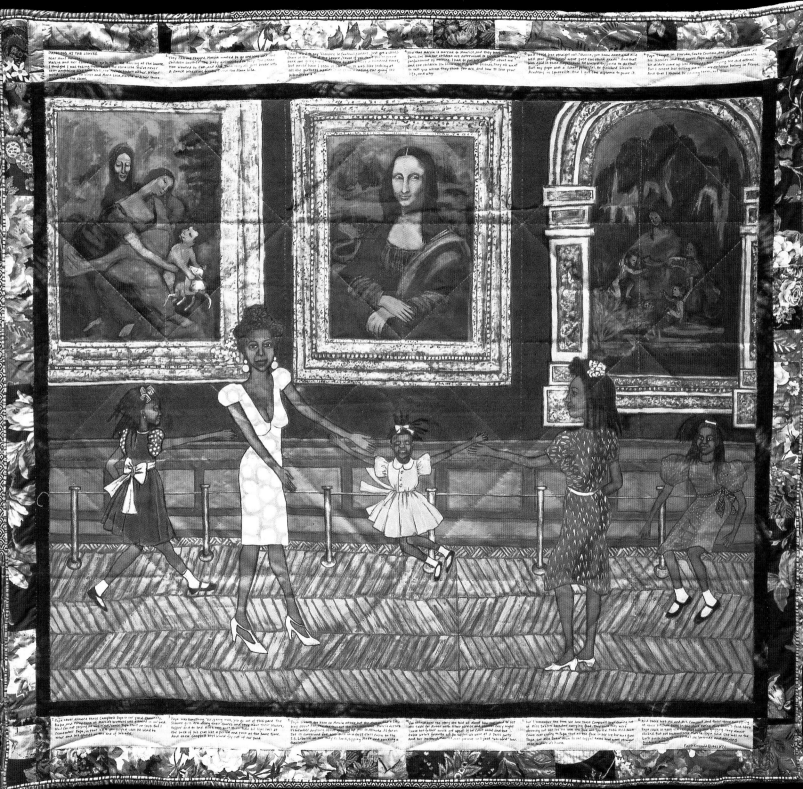

## The Picnic at Giverny

*The French Collection,*
Part I: #3, 1991

Acrylic on canvas, printed
and tie-dyed fabric, 73½ x 90½"

Collection of
Mrs. Barbara and Mr. Eric Dobkin,
Pound Ridge
Photo: Gamma One

Front row, left to right: Picasso,
Moira Roth, Ellie Flomenhaft,
Lowery Sims, Judith Lieber,
Thalia Gouma-Peterson, Emma Amos,
Bernice Steinbaum, Michele Wallace,
Willia Marie Simone
Back row, left to right: Ofelia Garcia,
Johnetta Cole

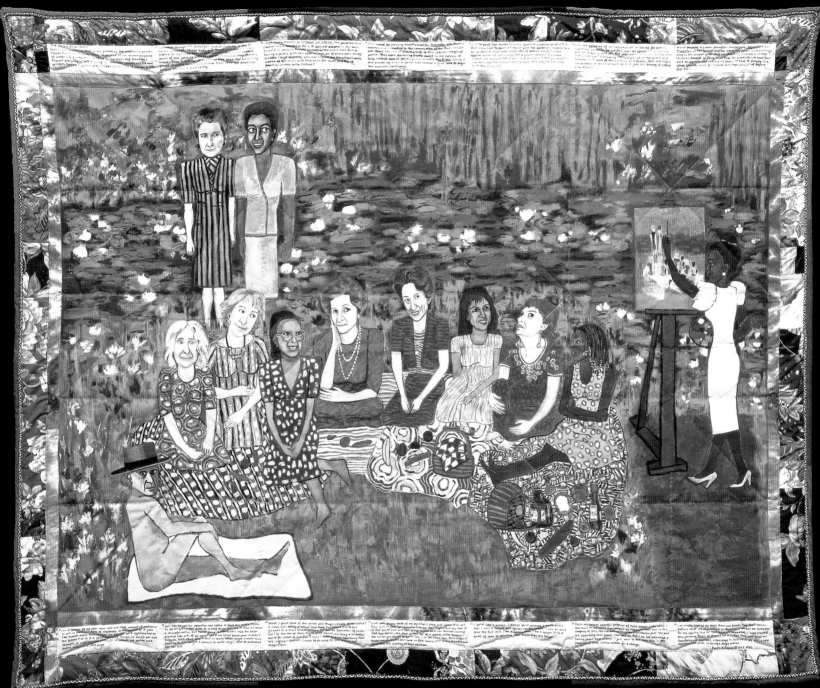

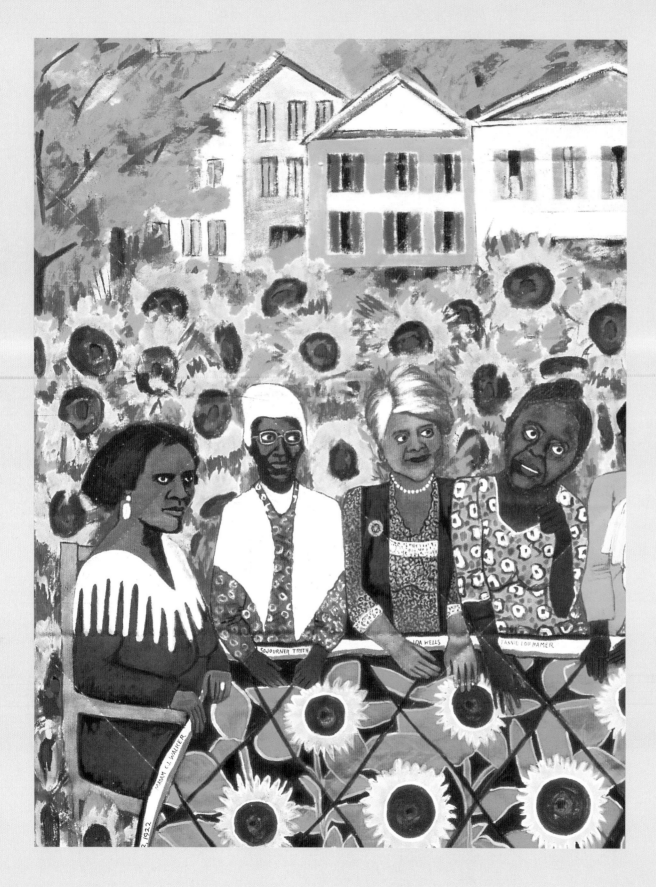

## The Sunflowers Quilting Bee at Arles

*The French Collection, Part I: #4, 1991*

Acrylic on canvas, printed and tie-dyed fabric, 74 x 80"

Private collection
Photo: Gamma One

Left to right: Madame C.J. Walker, Sojourner Truth, Ida B. Wells, Fannie Lou Hamer, Harriet Tubman, Rosa Parks, Mary McLeod Bethune, Ella Baker, Vincent van Gogh

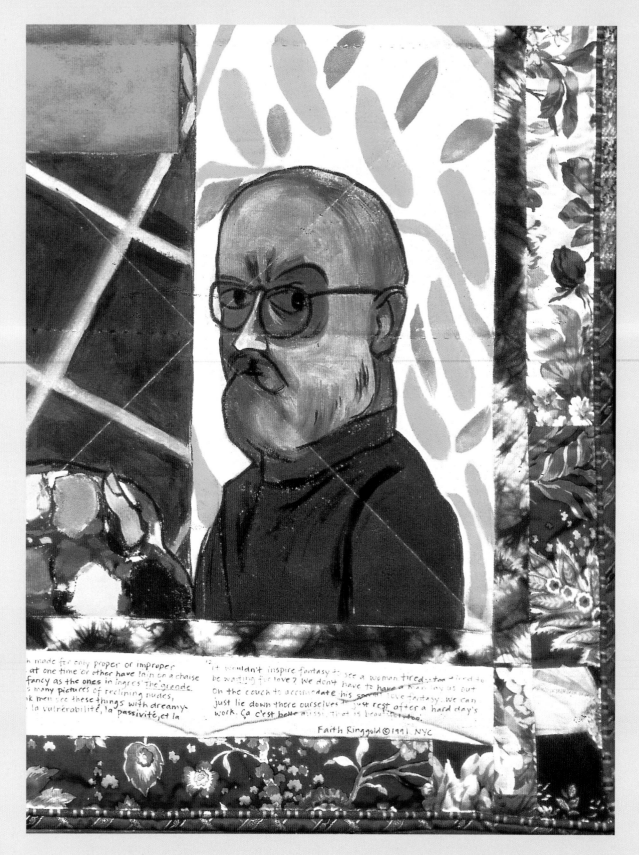

# Matisse's Model

*The French Collection,*
*Part I: #5, 1991*

Acrylic on canvas, printed and
tie-dyed fabric, 73 x 79½"

Courtesy of ACA Galleries,
New York and Munich
Photo: Gamma One

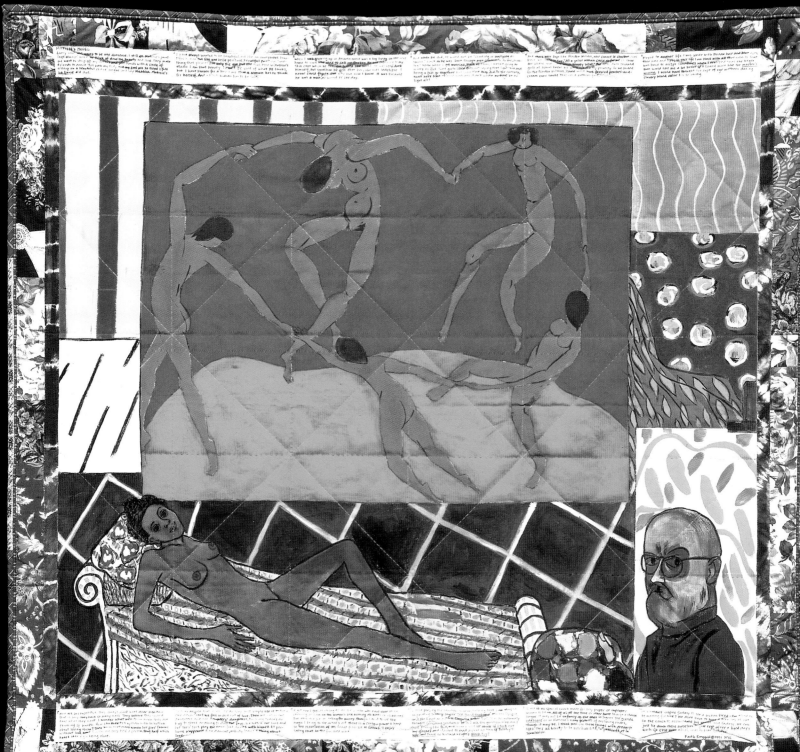

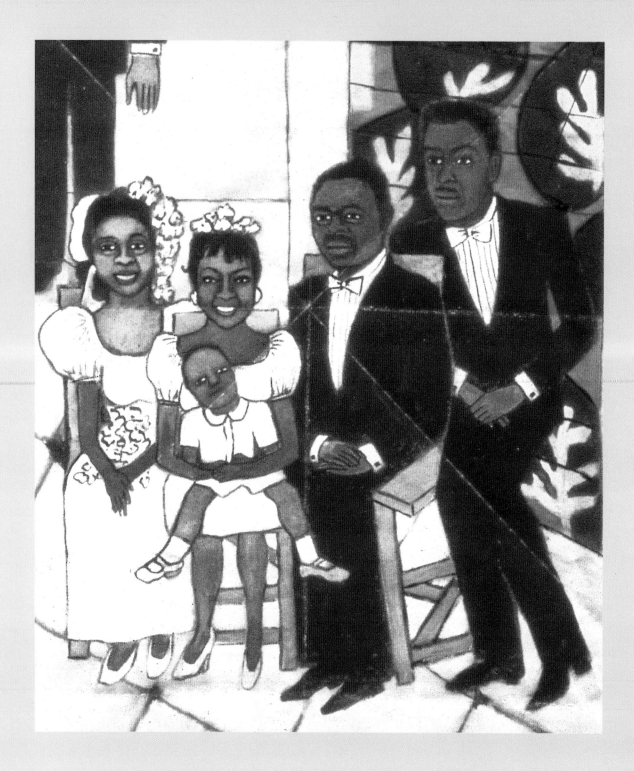

## Matisse's Chapel

### The French Collection, Part I: #6, 1991

Acrylic on canvas, printed and
tie-dyed fabric, 74 x 79½"

Collection of
Mr. George and Ms. Joyce Wein,
New York
Photo: Gamma One

Front row, left to right: Ida Posey
(grandmother), Susie Shannon
(great-great-grandmother),
Betsy Bingham (great-grandmother),
Professor Bunyon B. Posey (grandfather)
Middle row, left to right: Aunt Janie
(grandaunt), Uncle Peter (granduncle),
Barbara Knight (sister), Willi Posey (mother),
Ralph (brother), Andrew Louis Jones, Sr.
(father), Andrew Louis Jones, Jr. (brother)
Back row, left to right: Uncle Hilliard,
Uncle Cardoza, Aunt Edith, Aunt Bessie,
Mildred (cousin), Ida Mae (cousin),
Baby Doll Hurd (grandmother),
Rev. Jones (grandfather)

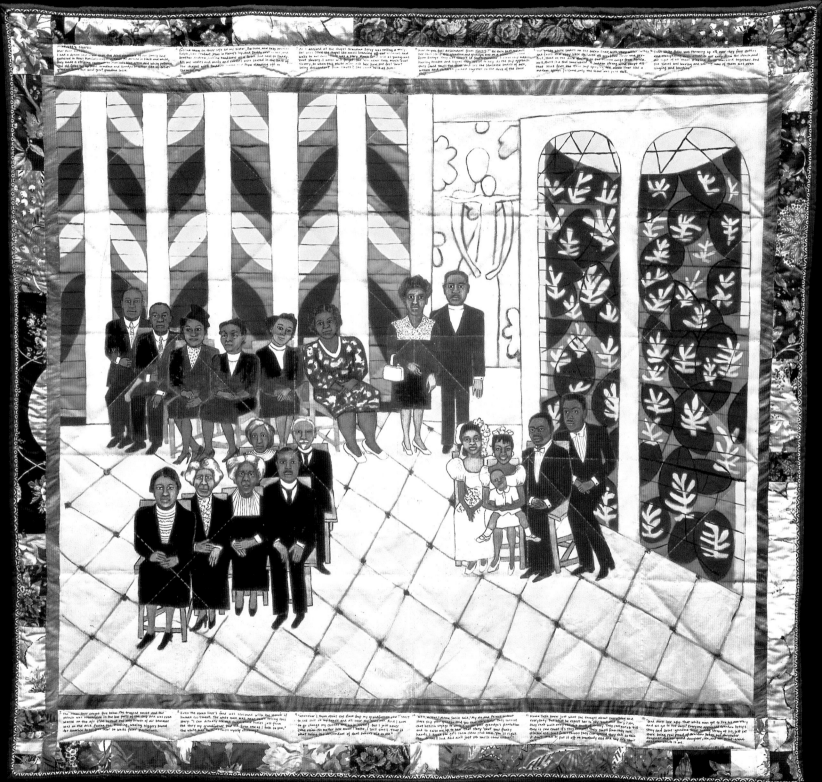

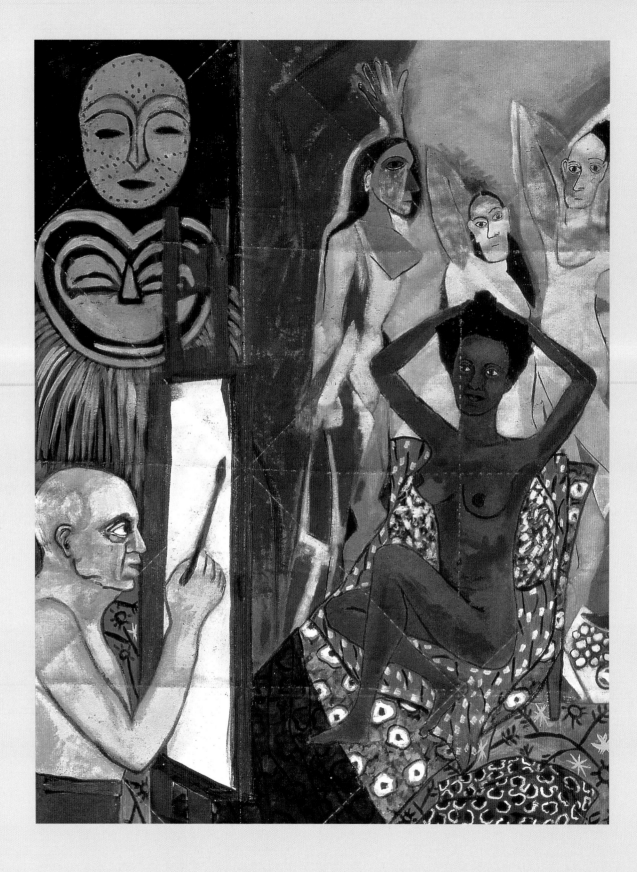

## Picasso's Studio

### The French Collection,
### Part I: #7, 1991

Acrylic on canvas, printed and
tie–dyed fabric, 73 x 68"

Courtesy of ACA Galleries,
New York and Munich
Photo: Gamma One

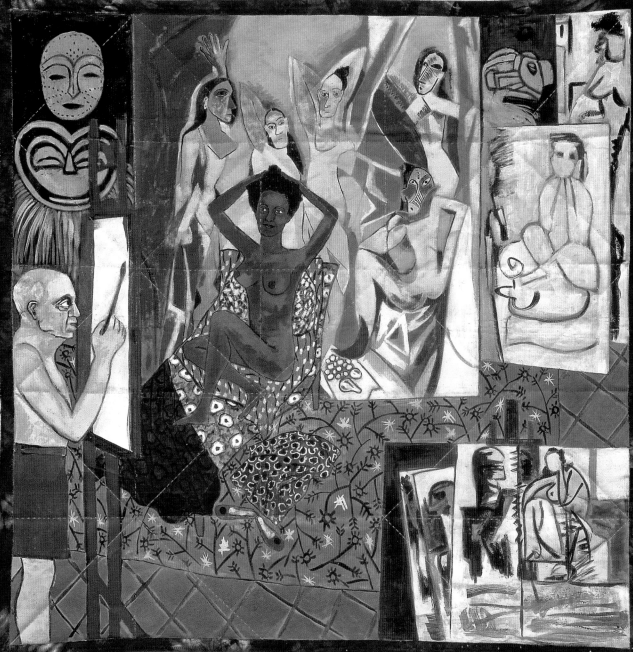

PICASSO'S STUDIO

Faith Ringgold ©1991 NYC

## On the Beach at St. Tropez

*The French Collection, Part I: #8, 1991*

Acrylic on canvas, printed and tie-dyed fabric, 74 x 92"

Courtesy of ACA Galleries, New York and Munich
Photo: Gamma One

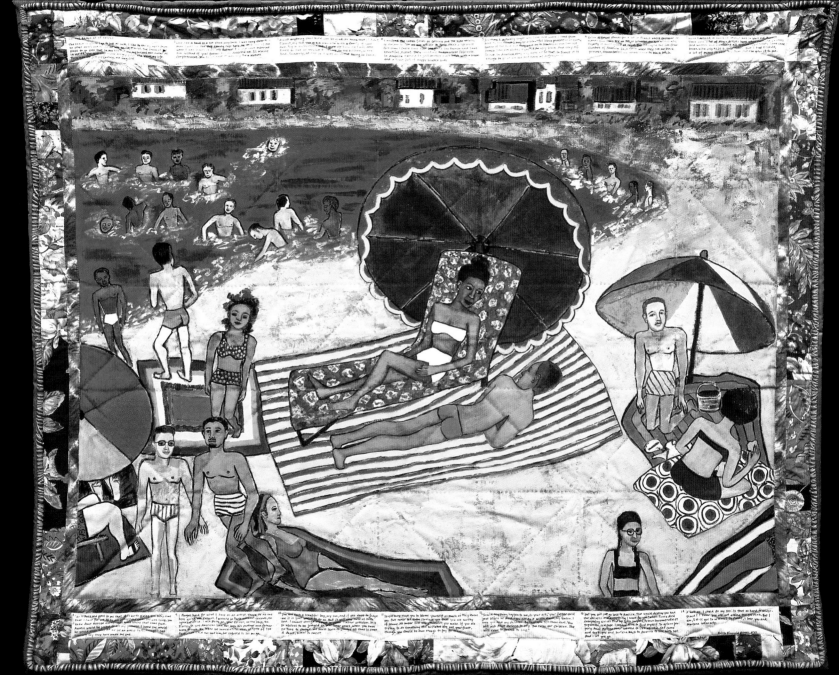

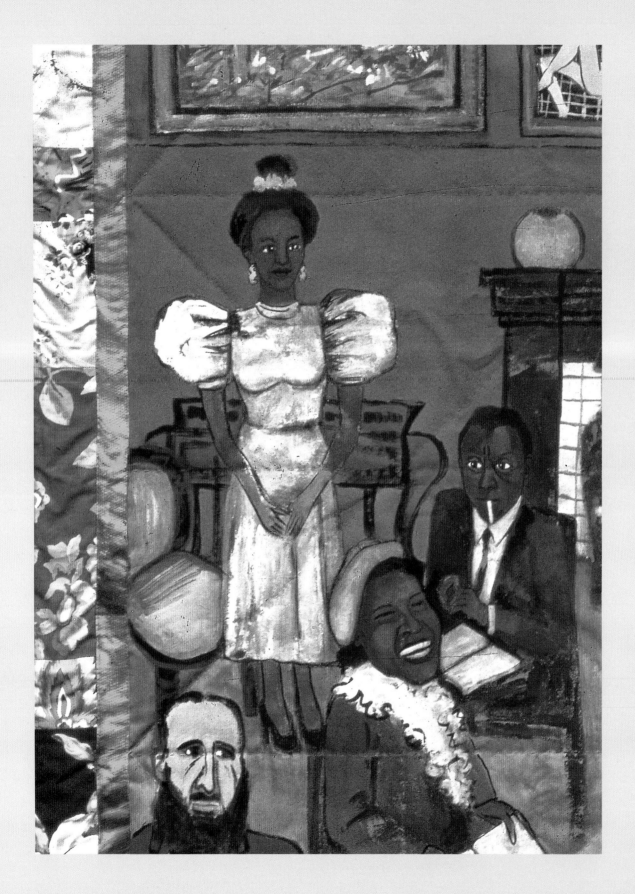

# Dinner at Gertrude Stein's

*The French Collection,
Part II: #9, 1991*

Acrylic on canvas, printed and
tie-dyed fabric, 79 x 84"

Collection of
Mr. Stanley and
Mrs. Mikki Weithorn,
Scottsdale
Photo: Gamma One

Left to right: Leo Stein, Willia Marie
Simone, Zora Neale Hurston,
James Baldwin, Alice B. Toklas,
Gertrude Stein, Pablo Picasso,
Richard Wright, Ernest Hemingway,
Langston Hughes

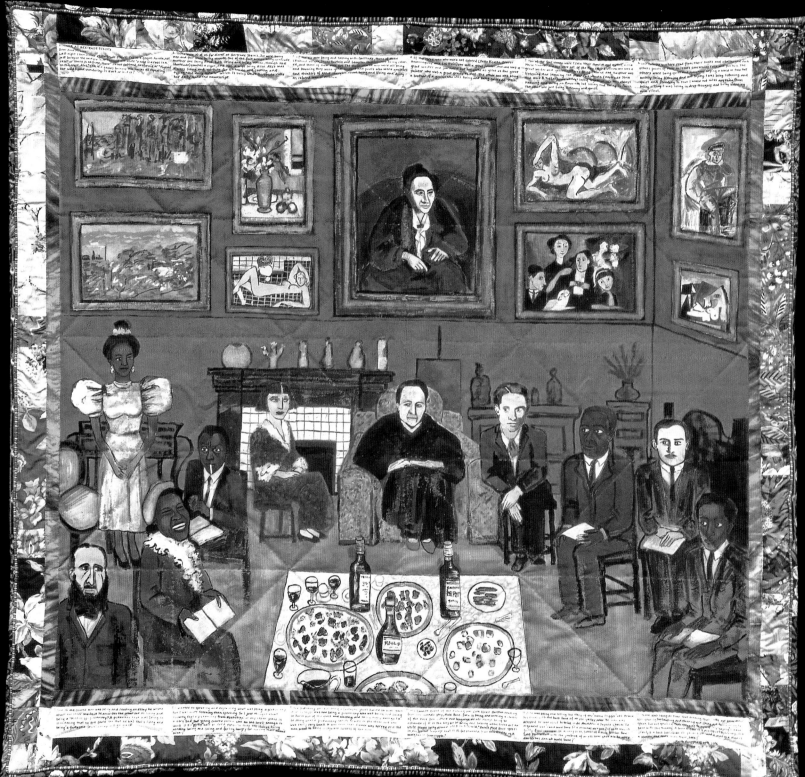

## Jo Baker's Birthday

### The French Collection, Part II: #10, 1993

Acrylic on canvas, printed and
tie-dyed fabric, 73 x 78"

Collection of The Saint Louis Art
Museum, St. Louis. Museum
Minority Artists Purchase Fund;
The Honorable Carol E. Jackson,
Mr. and Mrs. Steven M. Cousins,
Mr. and Mrs. Lester A. Crancer, Jr.,
Mr. and Mrs. Solon Gershman,
Mr. Sidney Goldstein
in Memory of
Chip Goldstein,
The Links, Inc., Gateway Chapter,
The Honorable and Mrs. Charles A. Shaw,
Donald M. Suggs,
Casually Off-Grain Quilters
of Chesterfield,
Thimble & Thread Quilt Guild,
and funds given in honor of
Questa Benberry
Photo: Gamma One

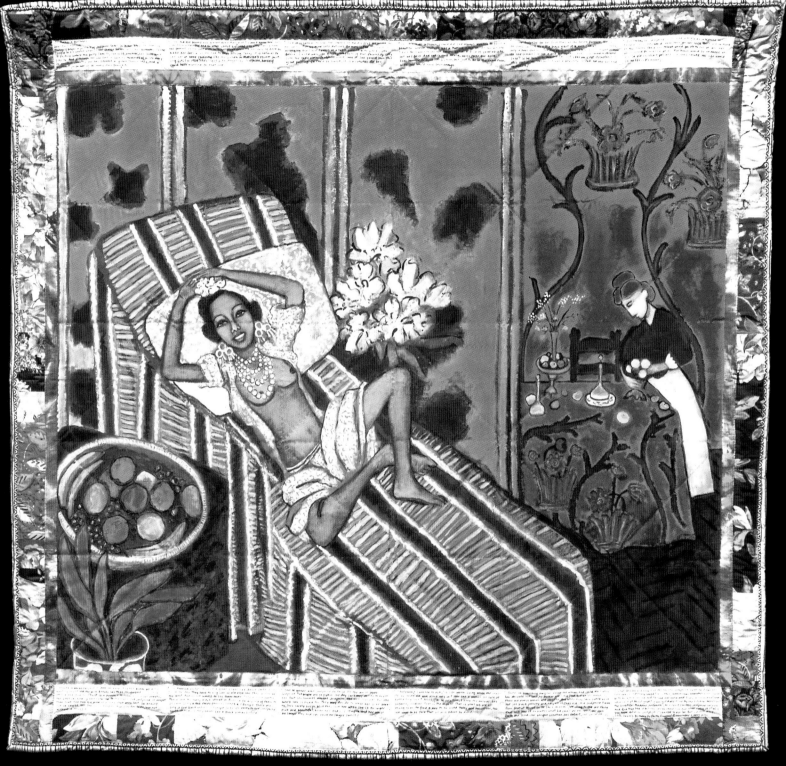

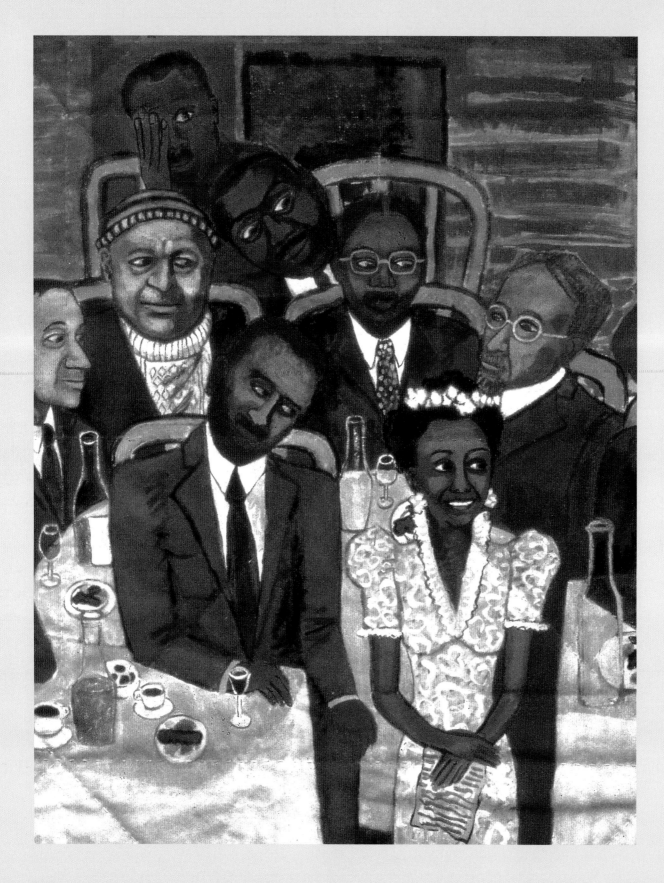

## Le Cafe des Artistes

### The French Collection, Part II: #11, 1994

Acrylic on canvas, printed and tie-dyed fabric, 79½ x 90"

Collection of Ms. Juanita and Mr. Michael Jordan, Chicago
Photo: Gamma One

Front row, left to right: William H. Johnson, Archibald Motley, Willia Marie Simone, Elizabeth Catlett, Lois Mailou Jones, Meta Vaux Warrick Fuller, Edmonia Lewis, Faith Ringgold
Middle row, left to right: Sargent Johnson, Romare Bearden, Aaron Douglas, Henry O. Tanner, Paul Gauguin, Vincent van Gogh, Augusta Savage
Back row, left to right: Ed Clark, Raymond Saunders, Jacob Lawrence, Henri de Toulouse-Lautrec, Maurice Utrillo

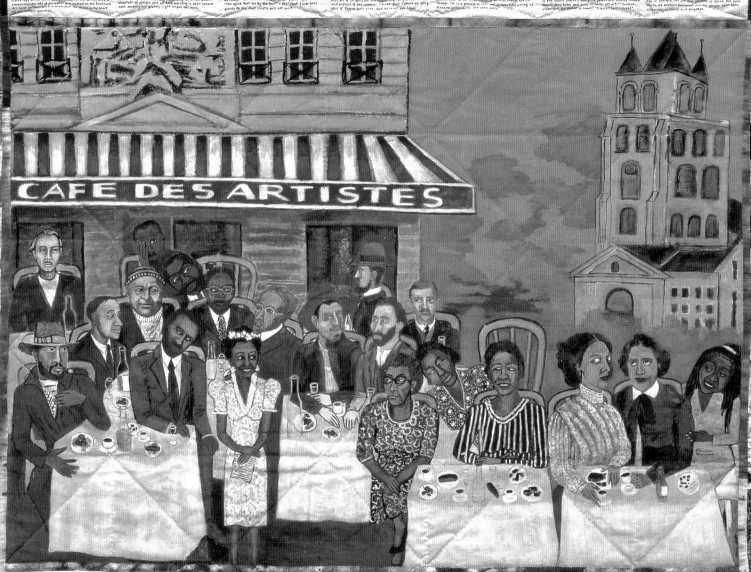

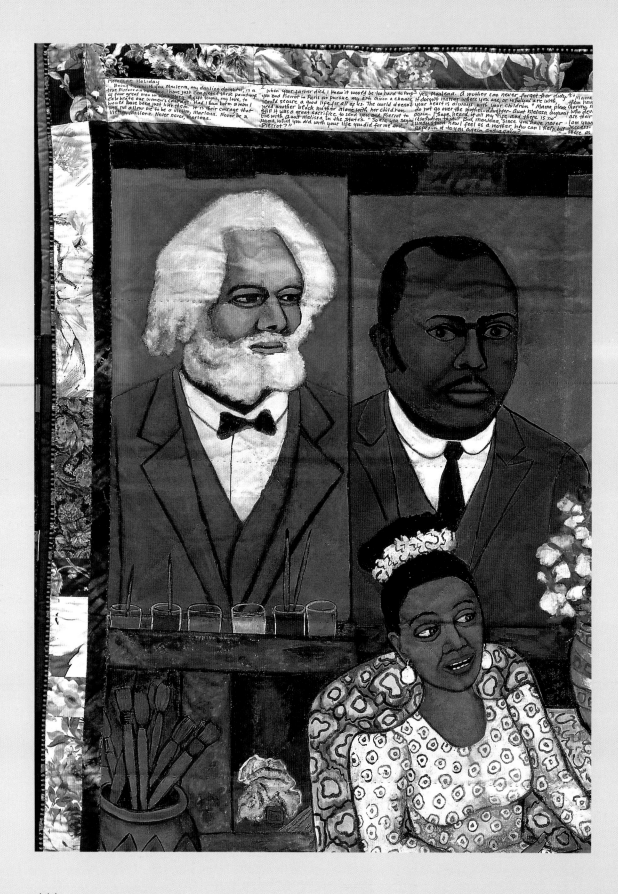

## Moroccan
## Holiday

*The French Collection,
Part II: #12, 1997*

Acrylic on canvas, printed and
tie-dyed fabric, 74¾ x 92"

Courtesy of ACA Galleries,
New York and Munich
Photo: Gamma One

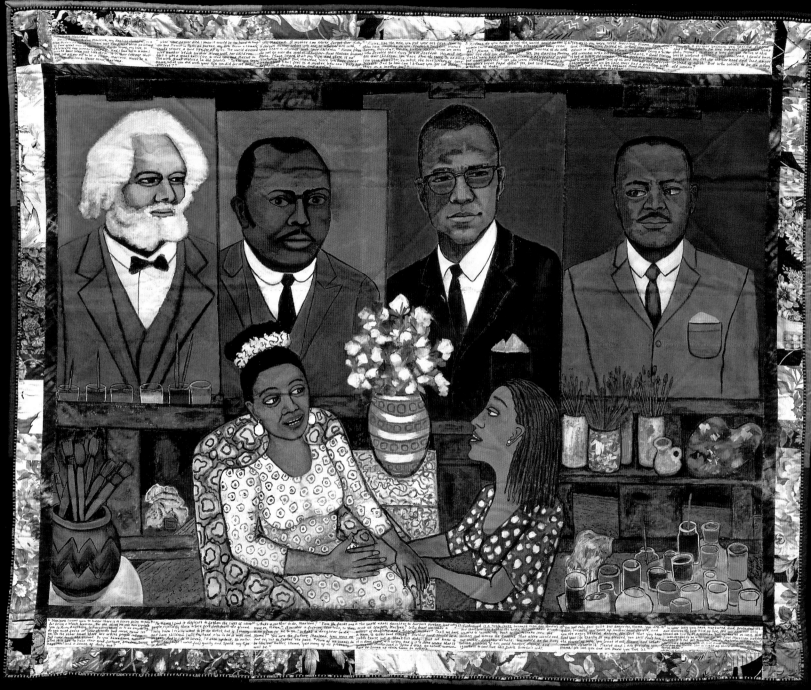

## We Came to America

*The American Collection: #1, 1997*

Acrylic on canvas, painted and tie-dyed fabric, 74¼ x 79½"

Collection of Ms. Linda Lee Alter, Philadelphia
Photo: Gamma One

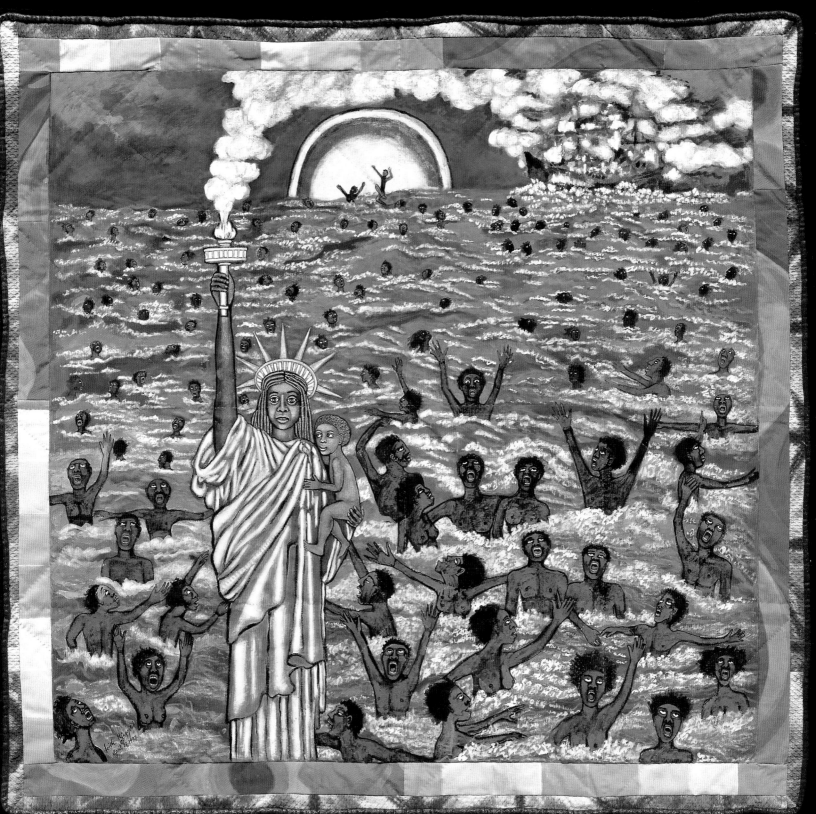

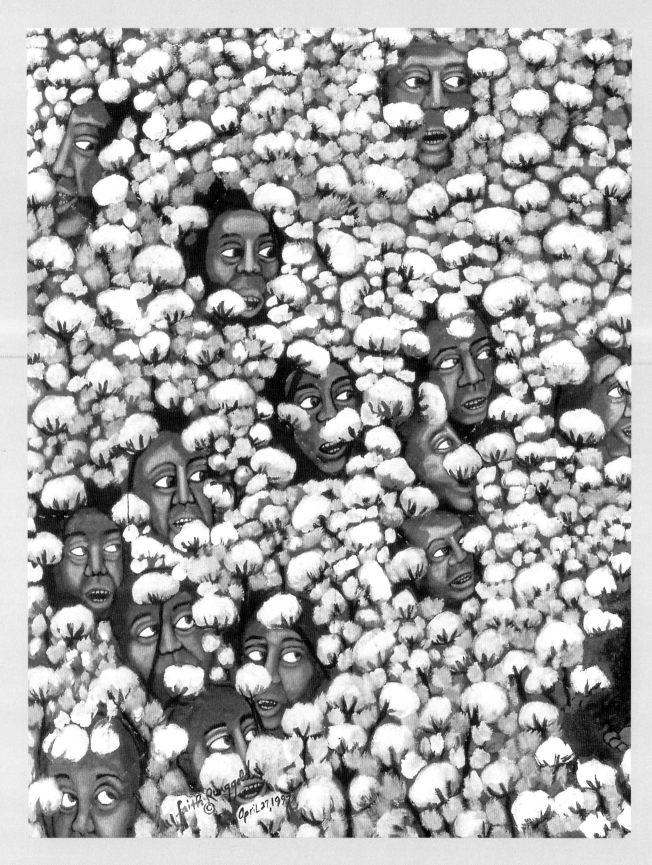

## Born in a Cotton Field

*The American Collection:*
#3, 1997

Acrylic on canvas,
painted and tie-dyed
fabric, 73½ x 79½"

Courtesy of ACA Galleries,
New York and Munich
Photo: Gamma One

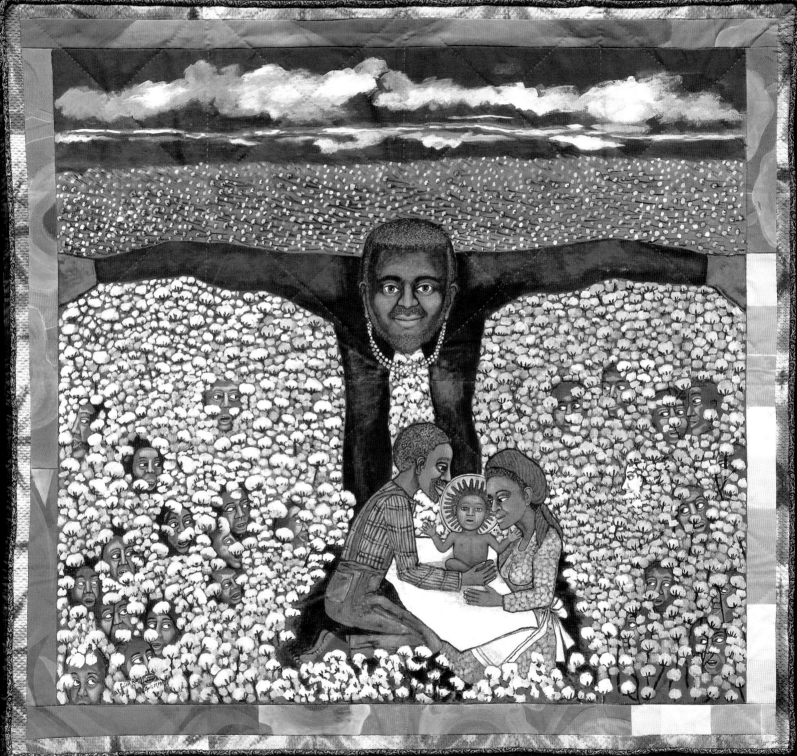

*Bessie's Blues*

*The American Collection:*
#5, 1997

Acrylic on canvas,
painted and tie-dyed
fabric, 76 x 79½"

Courtesy of ACA Galleries,
New York and Munich
Photo: Gamma One

*Two Jemimas*
*The American Collection:*
#9, 1997

Acrylic on canvas,
painted and tie-dyed
fabric, 77 x 81"

Courtesy of ACA Galleries,
New York and Munich
Photo: Gamma One

Sketch for
*Dancing
at the
Louvre*

*The French Collection,*
Part I: #1, 1990

Color marker
on paper,
8¼ x 10¾"

Private collection

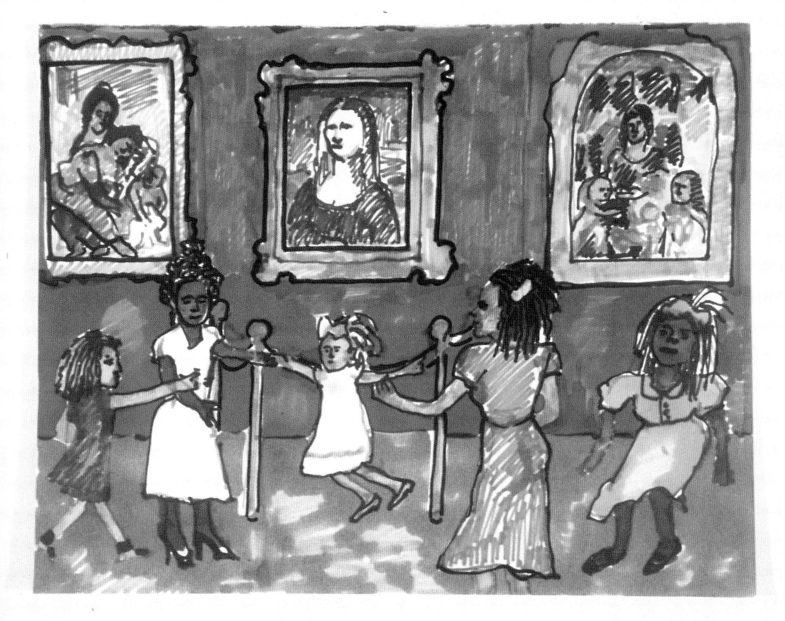

Sketch for
*Dancing
at the
Louvre*

*The French Collection,*
Part I: #1, 1990

Pen on paper,
10¾ x 14"

Courtesy of ACA Galleries,
New York and Munich

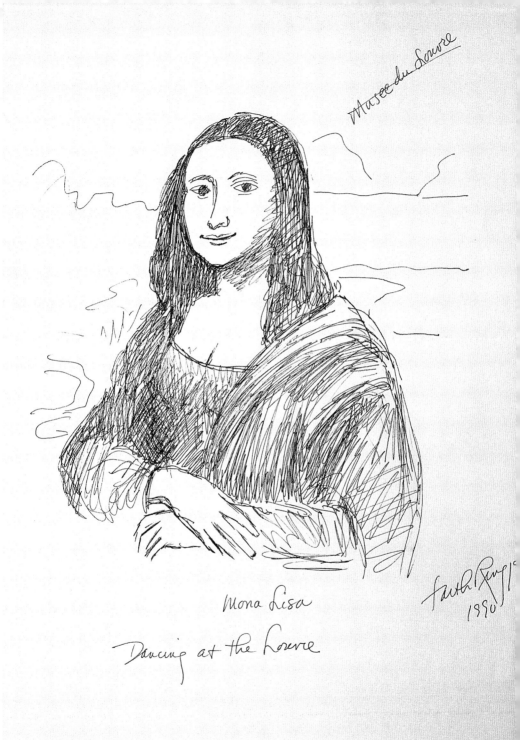

Musée du Louvre

Mona Lisa

Dancing at the Louvre

Faith Ringgold
1990

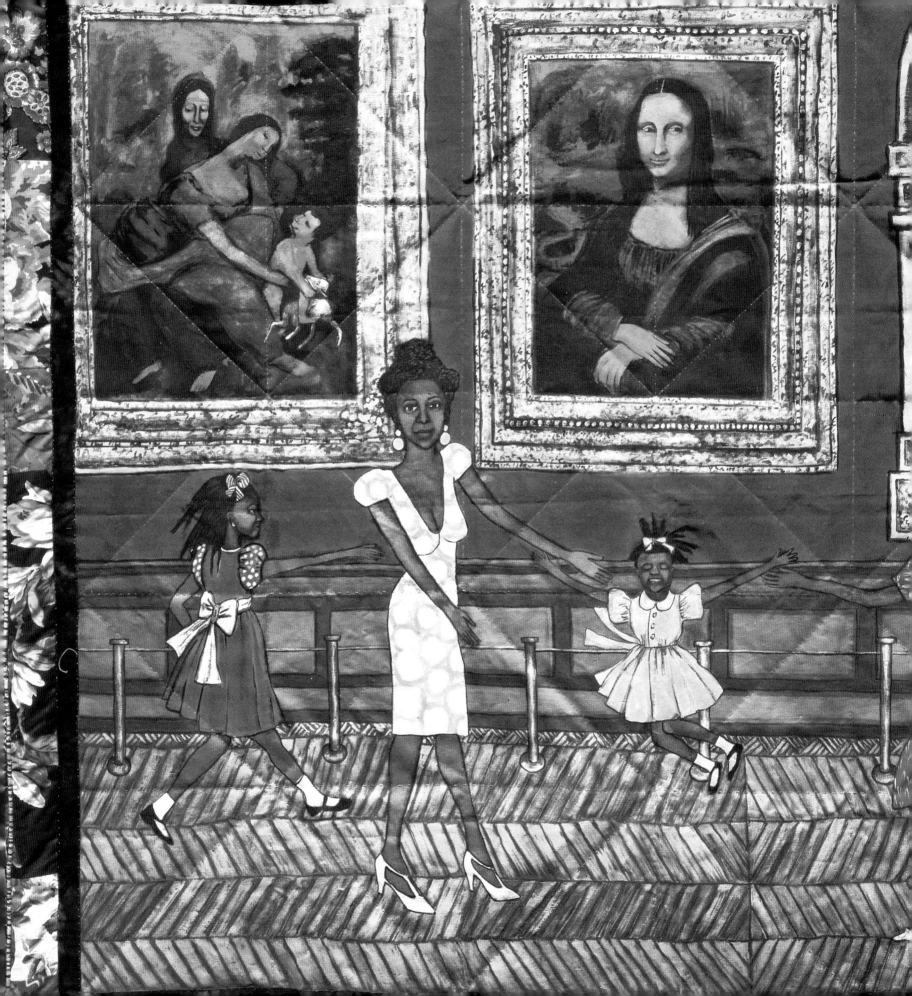

## Quilt Stories: A Selection

### Dancing at the Louvre

(The French Collection, Part I: #1)

Dear Aunt Melissa,

Marcia and her three little girls took me dancing at the Louvre. I thought I was taking them to see the Mona Lisa. You've never seen anything like this. Well, the French hadn't either. Never mind Leonardo da Vinci and Mona Lisa, Marcia and her three girls were the show.

2 They ran me ragged. Marcia wanted to go one way and the children another. The baby girl wanted to jump. The other two wanted to run, and did. Then they all just broke into a dance when we finally found the Mona Lisa.

3 Pierre used to say "Cherchez le fauteuil roulant, just get a wheelchair at the door of the Louvre, 'cause if you don't you're gonna need one going home." I've been to the Louvre a hundred times, but never have I seen it like this. It was like looking at all the pictures upside down from a racing car going 100 kilomètres à l'heure.

4 Now that Marcia is married to Maurice, and they have moved to Paris, she and her children are determined to speak le bon Français parfaitement by morning. I had to put her straight about me and the children. You know how it is with friends, they all want to tell you

whom they think you are and how to live your life, and why.

5 Well I told her straight out, "Marcia, you know damn good and well your papa never went past the third grade." And that was good in those days, 'cause he wasn't supposed to do that. But my papa was a school principal. He finished Lincoln Academy in Lynnsville. And I got the diploma to prove it.

6 Papa taught in Florida, South Carolina, and Georgia. I got all his licenses and test scores. Papa and Mama was both teachers. We didn't come up like no weeds. Not saying she did either. But I resent her telling me that my children belong in France. And that I should be raising them, not you.

7 Papa never allowed those Campbell boys in our yard. Chauncey, Buba, and Percy, none of Marcia's brothers was allowed in our yard. Now I'm not saying he was right 'cause Papa était un snob. But I remember Papa, in that little pinstriped coat he used to wear and his glasses on the end of his nose.

8 Papa was something. "No, young man, you go out of this yard. The Simone girls are doing their chores and they have their studies, supper and to bed. Allez vous en! Then

he'd hit that tail at the back of his coat like a period and turn at the same time. And those Campbell boys would fly out of our yard.

9  Papa wasn't too keen on Marcia either, but she always had a little way about her, like she thought she was très chic. Marcia doesn't remember any thing about growing up poor in Atlanta. As far as she is concerned she was born in a first class cabin on the S.S. Liberté on her way to Paris, sipping Möet and smoking a Gauloise.

10  You should hear the story she told us about how she used to set the table for dinner with silver service and cristal every night 'cause her father would get upset if he came home and the table wasn't formally set for supper. We were at a Paris party and her husband, Maurice, was present so I just "uh-uh'd" her.

11  But I remember the time we saw those Campbell boys coming out of Miss Baker's back door carrying food. They said they were cleaning out her ice box and the food was spoiled. Then Miss Baker came over crying to Papa that all the food in her ice box was gone. Papa sat Miss Baker down to our supper table and went straight over to Marcia's house.

12  And there was Mr. and Mrs. Campbell, and their three sons sitting at their kitchen table in the dark eating Miss Baker's food. When Papa came in they started coughing and gagging. They almost choked. But not Mademoiselle Marcia. Papa said she was on the back porch nursing un cristal de limonade and reading *Madame Bovary*.

# Wedding on the Seine

## (The French Collection, Part I: #2)

You could say, I ran comme un dératé, like a bat outta hell. There was only one thing I could think about. Get out of this church and get some air. Never mind what this crowd thinks about it. Run, girl, run. To the river fast as you can. And get rid of these damn flowers and this wedding veil and train. What is this, a funeral?

2  I've only been in Paris 6 months. I came to be une artiste, not a wife. I don't even know the language. Pierre is American born with French parents, so he speaks l'Anglaise et le Français parfaitement though he loves everything American, le plus noir que possible. But what about his family and his friends?

3  There is something in the way they look at me, as if to say: How did you get so far away from home, l'enfant? Will you become civilized, or will you remain just a beautiful savage dressed in a Paris frock? The French believe they are *the* unique civilization. But what about the Bastille, the Nazi collaboration, the Haitian and Algerian revolutions?

4  They will kill with a glass of wine raised for a toast. Vive la France! And you will be just as dead as if you had your throat cut in some back alley in Harlem over 25 cents and a bottle of beer. Is it because I am a little black girl from Harlem that I don't believe their charade?

5  Why did I marry this Frenchman? I hardly know him. He's more than twice my age, and white. We have very little in common. Il sera un bon mari. Il est très riche et généreux.

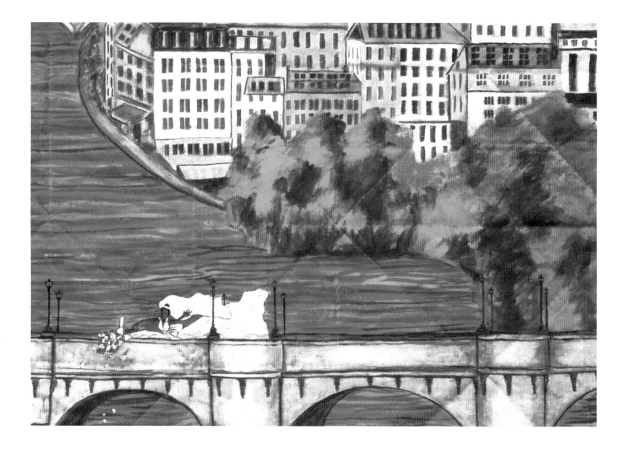

They all said. "You will be very happy with him, my dear. His family has been in Paris for three generations. He is practically French."

6 The wedding procession was hot on my heels. Pierre was holding up the rear puffing and blowing. Ne l'arrêtez pas d'aller! Elle reviendra. Elle est le mienne maintenant. "Let her go. She'll come back. She's mine." I ran even faster. "Pierre will make you a great husband," someone yelled at me. But will he leave me alone? Or will he make me over into his shadow?

7 Could I be une artiste and a wife? "Take a studio in Paris or in our château in the South," Pierre said. But I don't even know if I can paint. Now I may never find out. I ran even faster down the narrow streets to the Ile de la Cité past the Notre Dame Cathedral and on to the Pont-Neuf, overlooking the Seine.

8 I could have run forever. The wedding procession was gaining on me. I had to make a statement. Something more than "I obey" and "I do." Cause I don't, I won't! I hurled my bouquet into the river and it landed on the Bateaux Mouche and the crowd of tourists looked up and applauded me with Vive la France!

9 I made my statement. Would it be the last I'd make? Oh God, don't let me sink like those flowers. I want to live a life of making art, not babies and dinners and beds. I looked back at my wedding procession. They stood frozen, waiting for my next move. Pierre was in front now. An aging man, résolu.

10 What does Pierre know about me and the way I was raised in our little tiny apartment in Harlem? Does he understand what my mother and father sacrificed to give me the little they gave me? Does he know that as meager as our life was it was beautiful, and that we loved each other as if we were rich?

11 What do I know about Pierre's family and his life in the Fifth Avenue town house he was born in in New York City? Who was the pretty black girl who changed his diapers and took care of him? Did she look like me? When he is holding me and telling me how much he loves me, is it memories of her that make his voice tremble as it does?

12 Will our children be French? Or French speaking coloreds? And why have I waited till it is too late to ask these questions? Is it because the answers are not as important as amour? For whatever reason, I know he loves me. It may be because I am black that he loves me. But that's no reason to run away.

13 Later I learned that Pierre had a serious heart condition with only a few years to live. No wonder I never had to put up with a mistress. He had assez d'amour seulement pour moi. We were together—death do we part. Not much time for art or anything else but being with Pierre, and two babies—one a year and then . . .

14 I was again on the Seine, without flowers, applause, or a wedding procession in hot pursuit. I was remembering our wedding day. They were right all the time—Pierre was un bon mari. But would he leave me alone? Could I do my art? Within just three years Pierre died, leaving me alone with my art and two babies.

# The Picnic at Giverny

## (The French Collection, Part I: #3)

Dear Aunt Melissa,

Today I was invited to paint in the garden of the celebrated painter, Claude Monet at Giverny. There, in an area of the garden composed of water-lily ponds, with weeping willow trees and beautiful flowers everywhere, was a group of American women artists and writers having a picnic and discussing the role of women in art.

2 I strolled through the beautiful jardins, taking in the fantastic, beautiful flower beds and trees, passing over the matrix of Japanese bridges that connect the wildly wooded areas of the jardins with the fields of flowers near Monet's house. Then I settled on the same area near the water-lily ponds flanked by weeping willow trees near the American women who were picnicking.

3 I kept seeing Manet's *Le Déjeuner Sur L'Herbe*, the painting that caused such a scandal in Paris. It was not allowed at the salon because it showed Manet's brother-in-law and a male friend having a picinc with two nude women, all of whom were recognizable. I kept thinking: Why not replace the traditional nude woman at the picnic with Picasso in the nude, and the 10 American women fully clothed?

4 That would be crossing Monet's beautiful *Nymphéas* with Manet's scandal, and a reaction to the conversation of the American women about the rôle of women artists to show powerful images of women. They were discussing female nudes in the company of fully clothed men in paintings like Manet's *The Picnic*. Seeing it and wondering what to paint, this seemed a good idea to begin ma nouvelle conscience.

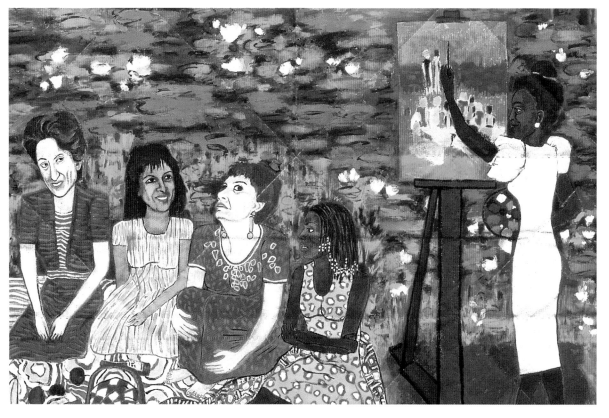

5 What to paint has always been my greatest problem as an artist. And then how to paint it? These were the questions I looked hard for answers to. Now there is the rôle of women artists? Some special niche we can occupy, like a power station? A woman artist can assume the rights of men in art? And be seen? I am very excited to meet these women. This may be the very first day of my life.

6 They are speaking of la libération et la liberté for women. Sometime we think we are free, until we spread our wings and are cut down in mid air. But who can know a slave by the mere look in her eye? Ordinarily I would just paint the jardin and include in it some of these women at a picnic. That was before the question of freedom came up. Is it just the beauty of nature I am after?

7 Monet painted his most wonderful masterpiece, *Décorations des Nymphéas*, of the garden and the water-lily ponds. Those paintings hang in the circular galleries of the Musée de l'Orangerie in the Tuileries Gardens in Paris. That must be wonderful, to have your work so approved and revered by people to have it hanging in a space specially made for it. What does that amount of respect feel like?

8 Can a woman of my color ever achieve that amount of eminence in art in America? Here or anywhere in the world? Is it just raw talent alone that makes an artist's work appreciated to the fullest? Or is it a combination of things, la magie par une example, le sexe par une autre, et la couleur est encore une autre, magic, sex, and color.

9 One has to get the attention one needs to feed the magic. There is no magic in the dark. It is only when we see it that we know a transformation has taken place, a wonderful idea has been created into art. If we never see it we never know, and it didn't happen. Isn't that why I and so many other negro artists have come to Paris—to get a chance to make magic, and find an audience for our art?

10 Should I paint some of the great and tragic issues of our world? A black man toting a heavy load that has pinned him to the ground? Or a black woman nursing the world's population of children? Or the two of them together as slaves, building a beautiful world for others to live free? Non! I want to paint something that will inspire—liberate. I want to do some of this WOMEN ART. Magnifique!

11 What will people think of my work? Will they just ignore it or will they give it some consideration? Maybe tear it apart and say that it is the worst ever and this artist should have her brushes burned and her hands, too. And isolate me as a woman artist because I am no longer trying to paint like, or to be like a man. Paris is full of these women artists who have no first names, wear men's trousers and deny they are married or have children.

12 I paint like a woman. I always paint wearing a white dress. Now I have a subject that speaks out for women. I can no more hide the fact that I am a woman than that I am a Negro. It is a waste of time to entertain such subterfuge any longer.

13 There are enough beautiful paintings of nude women in the world. I now want to see nude men painted by women, or nude men in the company of fully clothed women. C'est de la fantaisie pure. The men are expressing their power over women. But I am not interested in having power over anyone. I just want to see nude men in the company of fully clothed women for a change.

14 I am deeply inspired by these American women and their conversations about art and women in America. It makes me homesick for my country. And for their women's movement, I have created this painting *Picnic at Giverny* par le tribut. They have given me something new to ponder, a challenge to confront in my art, a new direction. And pride in being a Negro woman.

# The Sunflowers
# Quilting Bee
# at Arles

*(The French
Collection,
Part I: #4)*

The National Sunflower Quilters Society of America are having quilting bees in sunflower fields around the world to spread the cause of freedom. Aunt Melissa has written to inform me of this and say: "Go with them to the sunflower fields in Arles. And please take good care of them in that foreign country, Willia Marie. These women are our freedom," she wrote.

2 Today the women arrived in Arles. They are Madame Walker, Sojourner Truth, Ida Wells, Fannie Lou Hamer, Harriet Tubman, Rosa Parks, Mary McLeod Bethune and Ella Baker, a fortress of African American women's courage, with enough energy to transform a nation piece by piece.

3 Look what they've done in spite of their oppression: Madame Walker invented the hair straightening comb and became the first self-made American-born woman

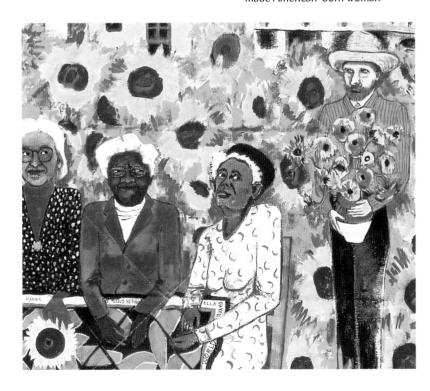

millionaire. She employed over 3,000 people. Sojourner Truth spoke up brilliantly for women's rights during slavery, and could neither read nor write. Ida Wells made an exposé of the horror of lynching in the South.

4 Fannie Lou Hamer braved police dogs, water hoses, brutal beatings, and jail in order to register thousands of people to vote. Harriet Tubman brought over 300 slaves to freedom in 19 trips from the South on the Underground Railroad during slavery and never lost a passenger. Rosa Parks became the mother of the Civil Rights Movement when she sat down in the front of a segregated bus and refused to move to the back.

5 Mary McLeod Bethune founded Bethune Cookman College and was special advisor to Presidents Harry Truman and Franklin Delano Roosevelt. Ella Baker organized thousands of people to improve the condition of poor housing, jobs and consumer education. Their trip to Arles was to complete *The Sunflower Quilt*, an international symbol of their dedication to change the world.

6 The Dutch painter Vincent Van Gogh came to see the black women sewing in the sunflower fields. "Who is this strange looking man?" they asked. "He is un grand peintre," I told them, "though he is greatly troubled in his mind." He held a vase of sunflowers, no doubt une nature morte, a still life, for one of his paintings.

7 "He's the image of the man hit me in the head with a rock when I was a girl," Harriet said. "Make him leave. He reminds me of slavers."

But he was not about to be moved. Like one of the sunflowers, he appeared to be growing out of the ground. Sojourner wept into the stitches of her quilting for the loss of her thirteen children mostly all sold into slavery.

8 One of Sojourner's children, a girl, was sold to a Dutch slaver in the West Indies who then took her to Holland. "Was that something this Dutch man might know something about? He should pay for all the pain his people have given us. I am concerned about you, Willia Marie. Is this a natural setting for a black woman?" Sojourner asked.

9 "I came to France to seek opportunity," I said. "It is not possible for me to be an artist in the States." "We are all artists. Piecing is our art. We brought it straight from Africa," they said. "That was what we did after a hard day's work in the fields to keep our sanity and our beds warm and bring beauty into our lives. That was not being an artist. That was being alive."

10 When the sun went down and it was time for us to leave, the tormented little man just settled inside himself and took on the look of the sunflowers in the field as if he were one of them. The women were finished piecing now. "We need to stop and smell the flowers sometimes," they said. "Now we can do our real quilting, our real art: making this world piece up right."

11 "I got to get back to that railroad," Harriet said. "Ain't all us free yet, no matter how many them laws they pass. Sojourner fighting for women's rights. Fannie for voter registration. Ella and Rosa working on civil rights. Ida looking out for mens getting

lynch. Mary Bethune getting our young-uns education, and Madame making money fixing hair and giving us jobs. Lord, we is sure busy."

12 "I am so thankful to my Aunt Melissa for sending you wonderful women to me," I said. "Art can never change anything the way you have. But it can make a picture so everyone can see and know our true history and culture, from the art. Someday I will make you women proud of me, too. Just wait, you'll see." "We see, Willia Marie," they said. "We see.""

# Matisse's Model

## (The French Collection , Part I: #5)

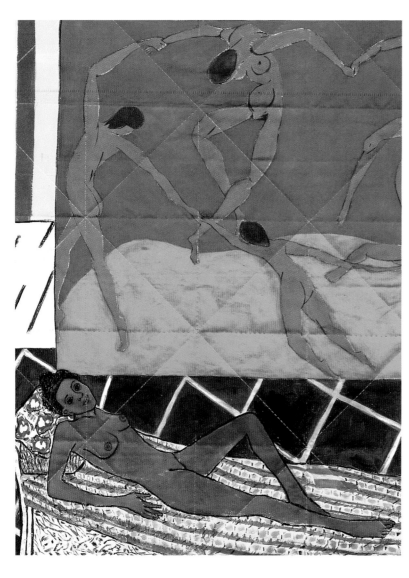

Every little girl wants to be une danseuse. I still do. Matisse's paintings always make me think of dancing, beauty and love. They make me want to strip off my clothes and join hands with a circle of friends to dance till both my body and my soul are so tired I fall asleep on a beautiful chaise longue and say Ahhhhhh. Matisse's *La Danse* did that.

2 I have always wanted to be beautiful, not like an anonymous beautiful woman but like une belle peinture, beautiful painting. Something that pleases not only the eye but the soul. Here in Matisse's studio I am that beauty. I can't be sure of what HE thinks, but I have known for a long time that a woman has to think for herself. And a black woman has to be sure.

3 When I was growing up in Atlanta there was a boy living in the next house to ours who used to call me Smokey. He was referring to my skin color which he thought looked like smoke. He was very dark himself but somehow he felt that his color was indelible. I never could figure out why, but now I know. It was because he was a man, or would be one day.

4 And when he did, he would not be "courting or marrying no smoke," black as he was. Even though men commonly do the choosing I knew when I got married, black as I was, I wasn't going to marry no fool. Some girls liked fools, not saying that favoring light skin and being a fool go together but sometime they did. To the contrary, there were light skinned boys who didn't waste no time on no light girl.

5 And there were boys like Preston Wilson, noir comme le charbon, coal black, who used to say, "All a yaller woman could do for me is show me where that little black beauty went." But still, dark skinned girls at school knew we were not the top priority. So we looked for the Preston Wilsons, 'cause most boys favored peaches-and-cream over smoke. That was a natural fact.

6 Maybe in another life I was white with blonde hair and blue eyes, thin nose and lips; in this life I am black with all that entails. That was hard to accept sometimes when I realized that the Negro man would like me a lot better if I looked more like the *master's woman*. I would have thought the rape of our mothers during slavery would color his thinking.

7 Men are so competitive. They always want what other men have. That is why they have so many wars. They believe they should take what they want. I wonder what men think when they are thinking of women. How can they betray them with deception about loving them? They know that many women live pour l'amour. Without love some women are only half a person, that half which hates itself for being alone.

8 Do they despise that in us? Or do they just simply use it to their own advantage? We fall in and out of love. Then we watch our daughters and our daughters' daughters, knowing there's no way to share anything to dull the pain. We watch our sons and our sons' sons play the same love games with women. Et personne n'apprend rien d'amour, nobody learns a thing about love.

9 Right now I feel as strong as all the women who have ever lived, reclining as I am on the women's bed evoking all kinds of illusions. But this is a job: modeling for money. Though I do it to see the magic I bring to the artist's art. There is a certain power I keep in the translation of my image from me to canvas. I enjoy seeing that in the finished work.

10 I love playing the beautiful woman, knowing that I am steeped in painting history: Ingres' The 'grande odalisque', Manet's Olympia, and the Egyptian godess Cleopatra before that. It is an extremely thought-provoking position to be in. I ask the question. Why am I here posing like this, and what would HE think if I took out my glasses and started to read a first edition of Tolstoy's War and Peace or Richard Wright's Black Boy?

11 There is no special couch made for only proper or improper women to lie on. All of us at one time or other have lain on a chaise longue. It may not be so fancy as the ones in Ingres' The 'grande odalisque' or in Matisse's many pictures of reclining nudes, though it may be. I think men see these things with dreamy eyes. They see beauty in la vulnerabilité, la passivité, et la soumission.

12 It wouldn't inspire fantasy to see a woman tired—too tired to be waiting for love? We don't have to have a man lay us out on the couch to accommodate his special love fantasy. We can just lie down there ourselves to just rest after a hard day's work. Ça c'est belle aussi. That is beautiful, too.

## Matisse's Chapel

*(The French Collection, Part I: #6)*

Dear Aunt Melissa,

I had a dream last night that the dead members of our family had gathered in Henri Matisse's chapel in Vence. All dressed in black and white, they made a striking contrast to Matisse's blue, green and white patterns. The old folks sat up front: Grandma and Grandpa on either side of Great-grandma Betsy and Great-great-grandma Susie.

2 Behind them on their left sat my sister, Barbara, and baby brother Ralph, like l'enfant Jesus in Mama's lap, and Daddy next to her, and brother Andrew, looking handsome as a Greek God next to Daddy. All

my uncles and aunts and cousins were seated in the back of the chapel with Daddy's Mama and Papa standing off to themselves.

3 As I arrived at the chapel Grandma Betsy was telling a story. Her voice filled the chapel like music bouncing off the windows and walls to our ears. "There was a story Mama Susie told us young-uns 'bout slavery. I never will forget. She ain' never talk much 'bout slavery, so when this white man ask her how she feel 'bout being descendent from slaves? She come back at him—

4 How you feel descendent from *slavers?* He turn beet red, tell her

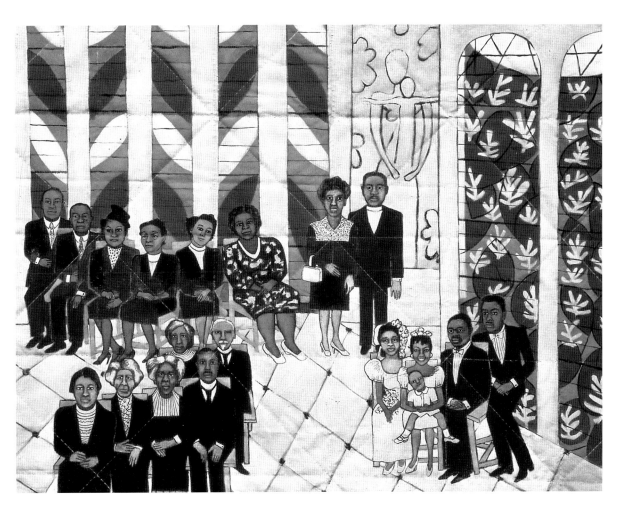

this story: His grandma and grandpa was on a ocean liner come from Europe. They was slavers in South Carolina. A slave ship was having trouble and signal they vessel to help. As the ship approach they could smell the stink and see the shackled bodies of men, women and children packed together on the deck of the slave ship.

5 The prissy white ladies on the ocean liner, with they white clothes and faces and they little children all scrubbed clean and perfect, stood on the deck glaring at the human cargo from Africa. Well, there is a God somewhere. A sudden strong wind swept all that stink from the slave ship spraying the ocean liner like a madam sprays perfume, only the scent was pure shit.

6 Them white folks was throwing up all over they fine clothes and stampeding each other to get away from the stench, and the sight of all them stinking slaves shackled together. And the slaves was waving and smiling, some of them was even singing and laughing.

7 The ocean liner caught fire below. The trapped smoke and the stench was unbearable in the low parts of the ship and was even worse on the aft side so that the only breath of air bearable was on the deck, facing the stinking, waving niggers bound for America to be free labor on white folks' plantations.

8 Even the ocean liner's food was seasoned with the stench of human excrement. The white man was near tears telling this story. "I can actually see and smell those bodies just from the story my grandfather told me. Even now as I talk to you," the white man said, "I smell myself stinking."

9 "Whenever I think about the slave ship my grandfather saw, I start to see shit on my own hands and all over my body, too. And I have to go change my clothes and wash myself. But I just never come clean. No matter how much I bathe, I still smell. That is what being the descendent of slave owners did to me."

10 "Well, mister," Mama Susie said, "My Ma and Pa was on that slave ship your grandpa told you that story 'bout. They survive that hellish voyage to work free on your grandpa's plantation and to raise me up to hear that story 'bout your funky hands. I hopes you gets them clean real soon. You is right. They do smell bad. And ain't just you smells them either."

11 Mama Susie knew just what she thought about everything and everybody. But what he expect her to say 'bout that story? No, they can't wash away the shit smell of slavery. They can scrub till they is raw cause it's they own shit they smell from they own stinkin' ass. Some folks thinks they can spread they shit so thin it don't stink or put it off on somebody else and say it's their shit."

12 "God don't love ugly. That white man got to live his own story and we got to live ours." Everyone applauded Grandma Betsy's story, and Great-grandma Susie, looking strong at 110, just sat there being real proud of Grandma Betsy, her storyteller daughter and her granddaughter, Ida, and her great-granddaughter which is me.

## Picasso's Studio
### (The French Collection, Part I: #7)

Dear Aunt Melissa,

I really think modeling is boring. Standing, sitting or laying down. Peu importe! Doesn't matter. You may know what to do with your hands, your feet, the look on your face. But what do you do with your mind, with your misplaced or mistaken identité? What do you do with time? Et l'artiste, what do you feel about him?

2 I started hearing voices from the masks and paintings in Picasso's studio but your voice, Aunt Melissa, was the clearest. "You was an artist's model years before you was ever born, thousands of miles from here in Africa somewhere. Only you'all wasn't called artist and model. It was natural that your beauty would be reproduced on walls and plates and sculptures made of your beautiful black face and body."

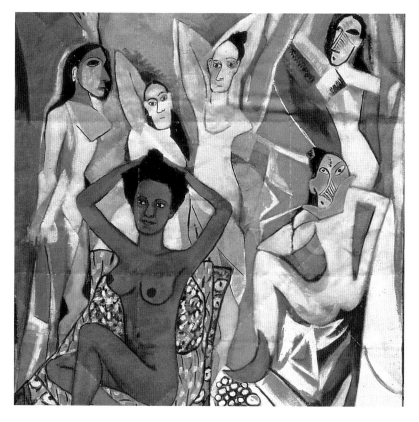

3 "Europeans discovered your image as art at the same time they discovered Africa's potential for slavery and colonization. They dug up centuries of our civilizations, and then called us savages and made us slaves. First they take the body, then the soul. Or maybe it is the soul, then the body. The sequence doesn't matter, when one goes the other usually follows close behind."

4 You asked me once why I wanted to become an artist and I said I didn't know. Well I know now. It is because it's the only way I know of feeling free. My art is my freedom to say what I please. N'importe what color you are, you can do what you want avec ton art. They may not like it, or buy it, or even let you show it; but they can't stop you from doing it.

5 Picasso's first cubist painting was called barbaric, la mort, the death of art! But that didn't stop him. In fact, it started le mouvement moderne du art. The European artists took a look at us and changed the way they saw themselves. Aunt Melissa, you made me aware of that. "Go to Paris, Willia Marie," you told me, "and soak up some of that Africana they using in those cube paintings."

6 It's the African mask straight from African faces that I look at in Picasso's studio and in his art. He has the power to deny what he doesn't want to acknowledge. But art is the truth, not the artist. Doesn't matter what he says about where it comes from. We see where, every time we look in the mirror.

7 The masks on Picasso's walls told me, "Do not be disturbed by the power of the artist. He doesn't

know any more than you what will happen in the next 5 seconds—in your life or his. The power he has is available to you. But you must give up the power you have as a woman. No one can have it all. What do you want, Willia Marie? When you decide that, you can have it," the masks said.

8 Les Demoiselles d'Avignon, with their tortured twisted faces Europeanized in Picasso's brothel theme, made a contre-attaque on the wisdom of the African masks. "You go ahead, girl, and try this art thing," they whispered to me in a women-of-the-world voice straight from the evening. "We don't want HIM to hear us talking, but we just want to let you know you don't have to give up nothing."

9 "And if they throw your art back at you, te fais pas de bile. Don't worry, 'cause you got something else you can sell. You was born with it, just in case. Every woman knows that. Some women will ask a high price and some men will pay it, all depends on the deal. Their wives don't have to know anything about it. That's been going on since Adam and Eve," the ladies of the painting said.

10 I can hear you now, Aunt Melissa. "Willia Marie, modeling ain't so-o boring you have to talk to masks and paintings. The only thing you have to do is create art of importance to YOU. Show us a new way to look at life." "You betta listen to Aunt Melissa, girl," the ladies from Avignon whispered. "She's the only one making any sense."

## On the Beach at St Tropez

*(The French Collection, Part I: #8)*

The beach is where I go to look at men. I like to see my men's faces on other men's bodies. J'aime l'amour, Pierrot. The beach is my place to go over that in my life. But you, my son, are mon amour de la verité. You and your sister are my flesh and blood, my life. These men are just my fantasy, ma fragilité.

2 Love, like a hand on a hot stove, may burn. I was very close to a man I met on the ship coming over here. He took care of me when I was homesick for my mother. I would have married him instead of your father, but he deserted me. Il m'aime complètement. Maybe because it was only for a minute.

3 Almost anything short-lived can be good. He knew that, I didn't. Pierrot, my son, you are a man now with a family of your own. Try to understand me. I grew up knowing I was destined to live in service to others, in the kitchen, in the bed. Suddenly, at age 16 I was an artist living in Paris.

4 I escaped the cotton fields of Georgia and the side streets of Harlem to live as une artiste in Paris. I had a life more full than I could have ever imagined. The French said I was beautiful, Pierrot. They called me Mademoiselle Précieuse. In America I would be just another black bitch with a broom and a house full of nappy headed kids.

5 Sometime I actually forget who I am and where I came from here. To the French I may be a beautiful black princess or an exotic Queen of the Nile, but they want me to remember that I am not French. I am not white; in fact, I am very black. And very different. In America, they may hate me for that. In France it is

enough to point me out and name me différente.

6 Being different stands for a lot in France where everyone descends from Louis XIV ou XVI, or whoever the hell aristocratic royalty is most grand et royal. But I escaped the Jim Crow clutches of America. So I smile when they call me black princess, remembering my former name is black bitch.

7 When I arrived in Paris in 1920, I was 16 years old, Pierrot. There were a lot of Negro artists here when I arrived, painters and writers and musicians all seeking opportunity. Some came broke with only $5.00 to their names. But I had $500.00, a lot of money in 1920. My Aunt Melissa gave it to me.

8 "Go to Paris and prove to me that it is worth giving you every dime that I have for you to be an artist," she said. She was lying, you know. Aunt Melissa always has more where that came from. Auntie would be proud to see my pictures. I know she would be proud that they let me be an artist here, though I can scarcely say they have made me one.

9 I fought hard for what I have as an artist. There is no one here giving out careers. I arrived in Paris without friends, an ignorant child. I met Pierre, Sr., your father, on the ship, too. Pierre, Sr. was American born, but both his mother and father were French. He liked me immediately, and, in spite of the fact that I did not love him, he refused to let me go.

10 You are such a beautiful boy, my son, and if you want to judge me it is your choice to do so. But it will only make us both sad. I cannot change my past or yours. I abhor criticism. It is so useless to be judged in your later years, when you have no time to change. We must learn to change all that is amer à doux, bitter to sweet.

11 People may want you to blame yourself as much as they blame you. But never let them convince you that you are worthy of blame. No matter how many mistakes you make. If you are trying to do something the mistakes are not your fault, though you should be man enough to pay for them.

12 "Should anything happen to me, do your art," your father said just before he died. "You can do it, Willia Marie, my Queen. I love you and my children. Be sure you tell them that. You will ask Aunt Melissa to help you raise our children. She will come to France to live."

13 "But you will not go back to America. That would destroy you and the children and everything I want for you." When Pierre died everything was all tied up with lawyers, French bureaucratie et paperasse, red tape. I needed time to find myself. To grieve properly. Aunt Melissa never wanted to live abroad. She came and took you and Marlena back to America to live with her. And I let you go.

14 It was all I could do, my son. Is that so hard to understand? I know you are not asking the question. But I am, Est-ce que tu m'aime? Je t'aime, I love you and Marlena intensely.

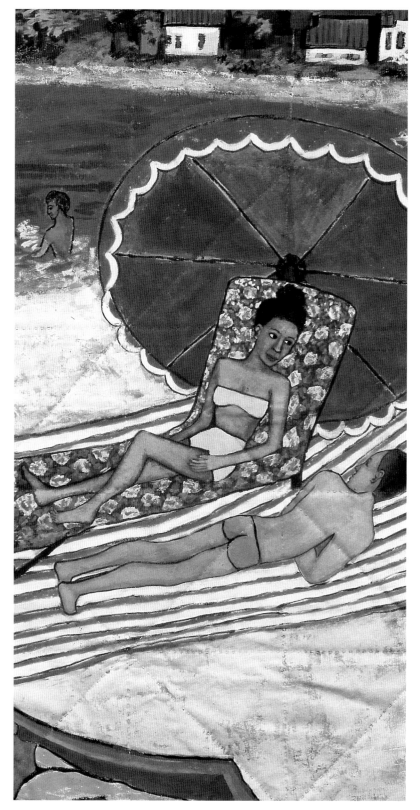

## Dinner at Gertrude Stein's

*(The French Collection, Part II: #9)*

Dear Aunt Melissa,

Last night I had dinner at Gertrude Stein's. She is a genius Auntie, not just because she said she is, or because she wrote "A rose is a rose is a rose" or "There is no there, there" about Oakland, California or "Pigeons on the grass, Alas." She is a genius because she has us all repeating her words and wondering—Is it is, or is it art?

2  There were 10 of us for dinner at Gertrude Stein's. Six were being men and four were being women. One of the four women being Gertrude another one being Alice. Both living and being women, though one (Gertrude) smokes a cigar, and has a wife being Alice. Alice was always living and working for Gertrude and cooking and typing "the daily miracle" which is being what Gertrude calls her daily unedited manuscript.

3  Of the six men being and talking with Gertrude, three of them (Richard Wright, James Baldwin and Langston Hughes) were being colored, and three of them were not. The three colored men were all being and knowing they were great writers and poets who were geniuses and thinkers of great thoughts about being and living and dying as colored men in America.

4  Of the three men who were not colored (Pablo Picasso, Ernest Hemingway and Leo Stein) one was a great painter, and one was a great writer and journalist but not quite as great as the great painter who was a great genius as well. The other one was being a brother of a genius who was living and being Gertrude Stein.

5  Two of the four women were colored (Zora Neale Hurston and myself, Willia Marie Simone) and two were not. Of the two colored

women one was a great writer and genius and was being colored and the other was listening and learning. The other two women (Gertrude Stein and Alice B. Toklas) were always being together. One was always knowing and being an American but living and being in Paris. The other one just being listening and quiet.

6  The colored writers read from their books and challenged each others points of view on issues concerning race and politics. The others were being quiet and sometimes saying a word or two but mostly being listening and not saying. I was being listening and quiet and standing so that I would not miss anything from being sitting. I was living in deep thoughts and being listening and silent.

7  One of the colored men was being and reading an essay he wrote about the other one. In it he describes the other one as living and being a "Mississippi pickaninny." A pickaninny that was being so threatening that no one could see that he was really living and being "a fantastic jewel buried in high grass."

8  I wanted to speaking and explaining what was being a pickaninny. But I was more listening than speaking. So I just thought about knowing that a pickaninny from Mississippi or any other place is a very sad but young colored person who no one loves enough to comb their "picky" hair or feed them. So they are always being needing loving and caring and feeling hungry for nursing their mama's "tittie."

9  The pickaninny who was being "a fantastic jewel buried in high grass" in Mississippi was now being

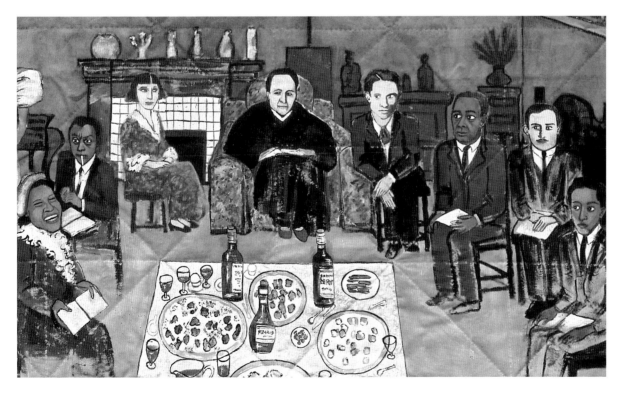

a pickaninny who was being in Paris out of the grass and wanting and being angry enough to be doing what a pickaninny can do so well to the other one who was really very small. It was then that dinner was served and the men went to being in separate corners of the room.

10 My favorite event of the evening was Zora Neale Hurston reading from her comedic play, Mule Bone. Zora is being and making a classic of the black folk culture and language we are always being so ashamed of. It is the way we be being talking when there are no white people being around. W.E.B. Du Bois said, "Zora's Mule Bone speaks in a . . . lyrical language that is as far removed from minstrelsy as a margaux is from ripple."

11 Zora was being and telling the story of the "bama Nigger" who struck his rival with the hock bone of an ole yaller mule. De man was arrested. De case went to trial in de Maca-demia Baptist Church. De argument was "Can a mule bone be a criminal weapon? If so de man is guilty if not innocent. De donkey is de father of a mule. Samson slew 3,000 Philistines with the jawbone of an ass. Now what kin be more dangerous dan uh mule bone?"

12 There was being no time that evening that I was not being there. Not speaking but laughing and thinking and liking and then want-ing to speak but not speaking. Then speaking to myself only saying "I leave here with this thinking— A bama Nigger is a Mississippi pick-aninny, is a jewel, is a hock bone, is an ole yaller mule—and a man is a man is a woman, and there is no there, here!"

## Jo Baker's Birthday

*(The French Collection, Part II: #10)*

Dear Aunt Melissa,

Today I began a portrait of Joséphine Baker. In it her beautiful body is lying à la six-quatre-deux on her chaise longue. It is her birthday so she is resting before the party. They say she is 25, however, she looks more like 16. And although she was born in poverty thousands of miles away in another country she has become a great French lady, and a brilliant performer of le music-hall français.

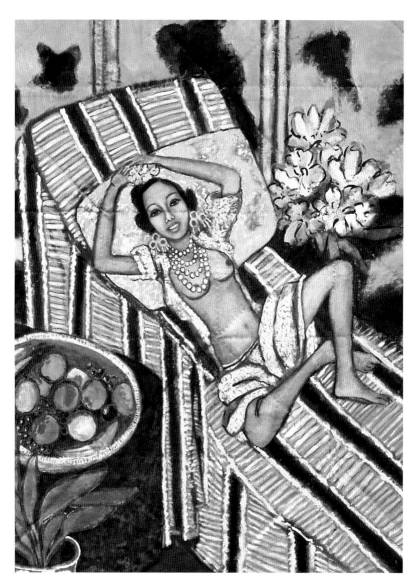

2 How did she become une grande dame française? I don't know how, but I do know why—She had no other choice she could live with. Coming from the poorest of the poor with only her *pieds dansants*, her dancing feet to make her feel alive she had to keep moving. Today it is natural to see her at home reclining like the woman in Matisse's recent painting (1923 or 1924) *Odalisque with Magnolias*. Joséphine herself could have mod-eled for that one.

3 And it is natural to hear the shuffle of maid's feet preparing for her party. But my mind sees Matisse's *Harmony in Red*. The maid is arranging fruit and flowers on a table covered with a red cloth. Behind is a red wall, its splashy bouquets of blue flowers spilling onto the tablecloth. Joséphine would love it. She should own this great painting. Ça coule de source, it is a natural for her.

4 Oh! this is all so French, I could die. I've always wanted to paint a beau-tiful woman reclining like a Matisse model. Unlike the artists I pose for I want to see her beauty not as a kind of vulnerability, but une force. And she is very strong, aussi forte que belle. I feel honored to paint her picture, but just to be in the same room with her would have been enough.

5 I saw Joséphine for the first time at the Folies Bergère. She came on stage carried by a big black giant of a man. She wore no clothes, only a huge feather. The audience was speechless. The giant was tremen-dous and very black. Est-elle un oiseau ou une femme? Is she a bird or a woman? Est-il un humain ou une bête? Is he a human or beast? Ça, c'est réel ou c'est l'illusion? Is

this real or an illusion? It was a beautiful dream. No one wanted to wake up.

6 But reality is—Joséphine is Coloured, a Negro, as Joséphine calls herself— And they would never have let her seek fame and fortune in the States. There her talent would be no talent at all. Her voice would be no voice at all. Her dance would be no dance at all. Her greatness would be no greatness at all. Sa vie ne serait pas une vie—Sans beauté. Her life would be no life—No beauty.

7 Beauty is wonderful, but it does not keep. It is the bloom we are all wanting to see, not the wilt. Beauty has to be recognized while it is still a bud. And though it is a pleasure to experience great beauty, the physical kind is often shallow to the touch. But Joséphine is deeper than that. She has the kind of beauty that does last. Sa beauté est la liberté. Her beauty is freedom. And freedom lasts, but not without a struggle.

8 In America Joséphine isn't a great singer like Bessie Smith and Billie Holiday. They have to sing like no one else can. They have to be the best. And no one wants to see them nude. They are not exotic. There are too many black women in America for any one of them to be rare. Il n'ya que rares femme noires à l'Europe. There are only a few black women in Europe. So Europe wants to see Joséphine nude. It is as if they never saw a black woman before.

9 Tout le monde aime Joséphine en Paris. All the world loves Joséphine. But people are so fickle. One day Paris may decide to forget her. Tout les hommes aiment Joséphine. The men love her. But the men's love is

fickle too. They may decide to leave her. Like beauty, love rarely keeps. Will they love her when she is no longer rich and beautiful, when her body is stooped and her waist no longer tiny and her voice no longer sweet?

10 "Joséphine," I want to ask her, "is life worth living when the reality of being old and alone sets in? How can a woman be sure of everlasting love?" Alors, j'ai la solution, I know the answer. Les enfants, children. That is the answer. That is what we are all trying to do, to find a way to be loved today and tomorrow, too. We want to be sure that we will never be alone.

11 There is something magical about the woman and child. No matter how desolate the land, no matter how little food and water there is, there are always women and children. And when they have hated us in our jet black poverty and despair, as they did little Joséphine Freda from Gratiot Street in St. Louis, Missouri, we cling to the one thing that will love us no matter what. La chair de nos chair, our own flesh and blood—Our unique creation—Nos enfants, our children.

12 What will be the result of the racism Joséphine suffered? Can she ever feel completely loved? Will this phenomenal woman tie her hands with an apron string, and shroud her mind and body with mother-hood?—Viellant et se fatiguant, growing old and tired by the kitchen table? Will the beautiful Madame Joséphine, the elegant Countess Joséphine survive and find true love, or will she forever chase love and never catch it? "Will you have children Joséphine?" I wanted to ask her. But didn't dare.

## Le Cafe des Artistes

*(The French Collection, Part II: #11)*

Dear Aunt Melissa,

Pierre left me as the owner of a Paris cafe, Le Cafe des Artistes, le rendezvous des arts et des lettres. It is located on the Boulevard des Saint Germain de Prés across from the church in the heart of the artists' quartier.

2 I am here every day now. We are a very popular café. Every Saturday nite we have le dancing le plus gai et le plus curieux de Paris. Today the tables are humming with the usual clientele of artists and writers nursing a cafe creme and making art history right before our eyes.

3 Pierre would be proud of my associations with the artists and writers. But still I have mixed feelings Sometimes I feel as though I am one of them; at other times I feel like "The Spook That Sat By the Door." I feel that I now have words to say that simply will not wait.

4 Today I will issue the Colored Woman's Manifesto of Art and Politics. What would Pierre have to say about that? His timid wife all of 20 years old and addressing the greatest artists and writers of the century. I doubt that I would be doing this if Pierre were alive. But he is not and I am.

5 Madames and Monsieurs, I said, may I have your attention? This is a momentous time in the history of modern art and I am excited to be in Paris, the center of cultural change and exchange. "It is a pleasure to have one so beautiful among us Madame Willia Marie. Bon chère noire."

6 Like the symbolists, dadaists, surrealists and cubists I have a procla-

mation to make for which I beg your indulgence. It is the Colored Woman's Manifesto of Art and Politics. "Women should stay home and make children not art." "Soulard, alcoolique." "*You* should go home!" "Silence! Taisez-vous!"

7 I am an international colored woman. My African ancestry dates back to the beginnings of human origins, 9 million years ago in Ethiopia. The art and culture of Africa has been stolen by western Europeans and my people have been colonized, enslaved and forgotten.

8 What is very old has become new. And what was black has become white. "We Wear the Mask" but it has a new use as cubist art. "But you are influenced by the French Impressionists." "No the German Expressionists." Modern art is not yours, or mine. It is ours.

9 There is as much of the African masks of my ancestors as there is of the Greek statuary of yours in the art of modern times. "No it is the Fauve that has influenced you Madame Willia Marie." And who made the first art . . . a doll maybe for an unborn child? A woman of course.

10 "You are a primitive but very pretty." Paris artists are shaping the culture of the world with their ideas. But modern art is much bigger than Western Europe or Paris. I am here (in Paris). I am there (in Africa) too. That is why I am issuing a Colored Woman's Manifesto of Art and Politics.

11 "You should learn French cooking. It will help you to blend your

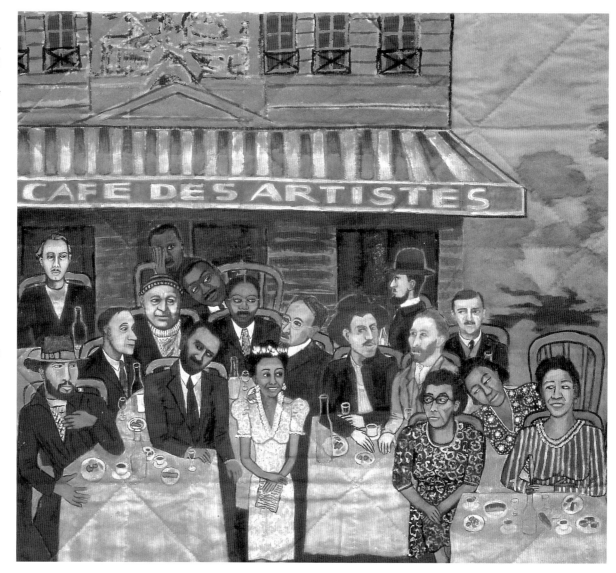

couleurs." "No she is a natural with couleur. Very Primitive." I will call a congress of African American women artists to Paris to propose that two issues be discussed: What is the image of the Colored Woman in art? And what is our purpose as modern artists?

12 No important change of a modernist nature can go on without the colored woman. "Her palette is too harsh, she needs to develop a subtle range of greys." Today I became a

woman with ideas of my own. Ideas are my freedom. And freedom is why I became an artist.

13 The important thing for the colored woman to remember is we must speak, or our ideas and ourselves will remain unheard and unknown. The cafe is my academie, my gallery, my home. The artists and writers are my teachers, and my friends. But Africa is my art, my classical form and inspiration.

14 "You will come to my studio Madame Willia Marie. I will show you how to make a rich palette of couleurs and teach you to paint like a master. But first you will model for me my African maiden! Earth Mama! Queen of the Nile!" C'est la vie Auntie. The price I pay for being an artist.

## Moroccan Holiday

*(The French Collection, Part II: #12)*

Being here with you Marlena, my darling daughter, is a true Moroccan holiday. I have just completed these paintings of four great men in our history. A gift to you, my love, to celebrate our women's courage. Had I been born a man I would have been just like them. It is their courage that will not allow me to be a victim, Marlena. Never be a victim, Marlena. Never never, Marlena.

2 When your father died I knew it would be too hard to keep you and Pierrot in Paris and pursue my art.

Given a chance, I could secure a good life for all of us. The world doesn't need another black mother alone with her children. Still it was a great sacrifice to send you and Pierrot to live with Aunt Melissa in the States. "So are you saying, Mama, what you did with your life you did for me and Pierrot?"

3 Yes, Marlena. A mother can never forget her duty. It doesn't matter where you are, or who you are with, your heart is always with your children. "Mama, please do not go over the mother–daughter–Aunt Melissa

argument again. I have heard it all my life and there is no resolution to it." But, Marlena, since you have never understood how I feel as a mother, how can I help but explain it to you again and again?

4 "Mama, like the men, you put your art first. None of them have anything on you. Frederick Douglass, Marcus Garvey, Malcolm X, Martin Luther King Jr., these are men who devoted their lives to our freedom. It is as if we are their children. You have done the same as an artist. I am your daughter, an artist, the beneficiary of your success. And so how can I blame you for not being there as a mother too?"

5 Marlena, do you know what the world would be like if women could do exactly as they please the way men do?

"Mama, is there something you wanted to do with your life that you did not do?" Yes, my darling Marlena, I would have had children, become a celebrated artist but never married. "Yet you were married for only a few years before Papa died." Yes, but still I had such a sense of duty.

6 "It's as if you were never married, Mama. Papa died and Aunt Melissa raised us. Where was your duty?" Admit it, Marlena, you blame me for not being a bitter old woman who never got her chance. "Aunt Melissa is not a bitter old woman. On the contrary she is a powerful woman who took care of us and had her own catering business too and we have never had a problem with this." Yes, but that is only because Aunt Melissa is your aunt and I am your mother.

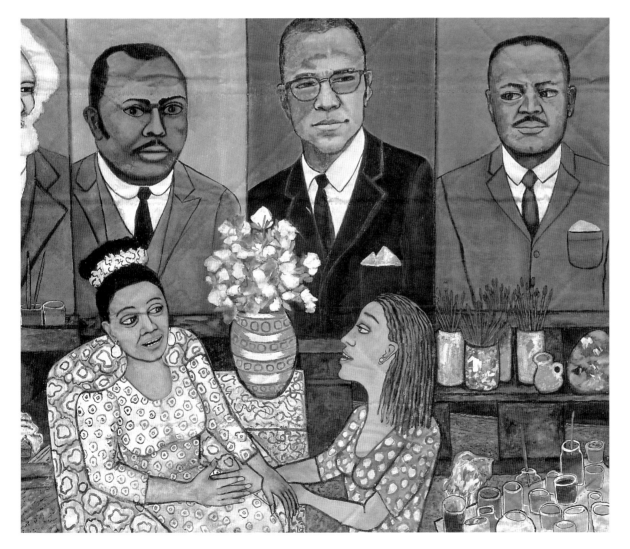

7 "You are a mother because you carried Pierrot and I in your belly for nine months? Was that your duty Mama? Is there a way for you to live in this world without guilt?" Yes, Marlena, I could have sacrificed my art for motherhood and had anger instead of guilt. But who wants to be an angry old woman?

8 Marlena I want you to know there is a heavy price to pay for being a black woman. For one thing no one ever expects you to know anything, to have anything or to be anything. So you must focus on your dreams and never, never let go. On the other hand there are white people whose feet never touch the ground. Do you sometime wonder what it is like to have their good fortune, freedom, success, happiness and a sense of duty too?

9 "No Mama. I find it difficult to fathom the lives of white people, especially those whose feet don't touch the ground. I only know I really want to be an artist, but if I marry and have children I will try hard also to be a wife and mother. And if I do it wrong, I'll face up to it. No matter what I do, I hope I won't feel guilty and spend my life in denial."

10 What's a mother to do, Marlena? "Face the facts and move on, Mama." A mother is forever, Marlena, so there is no place for me to go. "What's a daughter to do, Mama?" You are the future, Marlena, *you move on* and try not to repeat the past. "None of us wants to be like our mother, Mama, yet many of us probably will be."

11 The world wants daughter to surpass mother, but why must we compete, Marlena? Why must we make a

winner of daughter and a loser of mother? Can't we have a team, a sisterhood maybe? Motherhood should be a noble cause not a thankless duty. But we know if it is done right, it is wrong, and if it is done wrong that is wrong too. Motherhood is too often a trap, an excuse women have for giving up their lives to others.

12 Fatherhood *is a noble cause* because men are leaders and therefore can father the world, not just their brood. We need to rewrite the book of life to make men the mothers and women the fathers. That alone would end our mother-daughter debate. We would be too busy solving problems of war, world hunger, disease and ignorance to continue this futile women's war.

13 "You not only feel guilt but anger too, Mama. You are guilty because you gave up motherhood for art, and you are angry because despite the fact that you have lived your life exactly as you pleased, you still can't have the power of men. You want it all, Mama, and what's more you deserve it. Pierrot and I are proud of you, Mama. We love you and we know you love us."

14 "In your way you have nurtured and protected us and given us the best kind of life. And you have not only shown me how to be a woman but an artist as well. It is wonderful to be with you for my first Moroccan holiday. However it is not just Douglass, Garvey, Malcolm and Martin who should be here with us, but Aunt Melissa also. She is our courage too, Mama. She is right up there with you and these men."

## We Came to America

*(The American Collection: #1)*

Dear Mama,

I have just awoken from a hellified dream and I can't wait to tell you about it. So exhausted was I from our last whirlwind night in Paris, that I decided to take a nap before dinner. Pierrot had a date with a white girl named Morgan he met on the deck. She had actually dropped by his cabin to invite him to meet her folks. I heard her ask him, "Who's the pretty colored woman waving to you from the pier?"

"That's my Mama," said Pierrot proudly.

"That lady is your Mammy. Wanta see *my* Mammy?" she asked as she fumbled in her bag for a picture.

Then I heard Pierrot say, "Nope! Don't wanta see no Mammies. Just show me your mind baby."

"You mean...that colored lady *is your Mother*?" the white girl stammered in disbelief.

"Yes, the lady's name is Willia Marie Simone, the celebrated expatriate artist," answered Pierrot. "And I am Pierrot Frederick Douglass Simone, her son. And my sister, Marlena Truth Simone, is sailing with me back to America and is in the next cabin."

"Oh my God!" gasped the white girl.

"God? Oh yeah. He's colored too!" chuckled Pierrot.

And that's all I remember before I dropped off to sleep smiling.

My dream began with a knock on my cabin door. It was the ship's captain. He had come to invite me to a deck party. "We are all waiting for you," he said.

"Me?" I gushed.

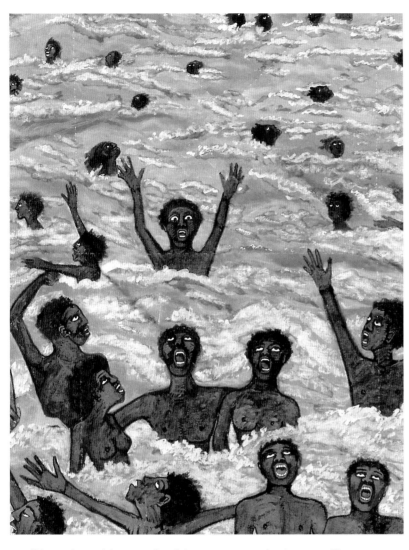

"Yes, my beautiful princess," said the handsome captain. "You!"

I got dressed in my pretty red and white French frock you bought me, freshened up my makeup, brushed my hair and stepped out on the deck.

"You look radiant," whispered the captain and he disappeared.

True enough, the passengers were waiting for me on the deck. Pierrot and Morgan stood in the center of the crowd. I couldn't see anyone's face, but Morgan was pointing her finger at me and calling me names in another language. The passengers roared with laughter and applauded her hostile remarks. Pierrot rushed to the side of the deck and threw up. The passengers were now screaming in that language I did not understand and waving their fists and rushing towards me. I turned to run back to my cabin when the captain's voice came over the loudspeaker:

"Princess Marlena Truth Simone," he bellowed, "We are waiting for you on the slaves deck."

"Slaves deck?" I shuddered in surprise.

"Yes slaves deck! slaves deck! slaves deck!" chanted the jeering band of passengers and in one ferocious body charged straight for me.

Pierrot reached out to me, but when I took his hand it was a cold dead fish. I dropped the fish and ran right into a crowd of slaves all shackled together.

I was now in nightmare-hell, aimlessly meandering between the sickening sweet smell of "Miss Ann's" perfume, and the slaves' funk of human excrement and unwashed bodies; the awesome sting of the passengers' hateful screams, an unrelenting whip lash, and the clanging and banging of the slaves' chains as they tried to free me from the bondage of slavery.

There were times when I could feel my head being cradled against a bare black chest. It was heady, heart-rendering, and smelly but sweet. I wanted to kiss my saviors in struggle, but this was no time for love.

I still couldn't see anyone's face, but I knew I was engaged in a God-awful exchange between black and white and my very freedom was at stake. I recalled Great-Grandma Susie's slave story in your painting *Matisse's Chapel* and I cried, "Oh God let me go free!"

The ship tipped and dipped as great gusts of ocean water rushed on deck and mercifully carried us overboard. It was like being on a massive hurricane ride at an amusement park, only it was not amusing. Our shackles and our clothes were ripped off our bodies but, thank God: we landed on our feet and walked the water like Christ at Galilee—one mass of ecstatic black bodies, shinning like diamonds in the murky sea.

I knew neither my name nor the language I spoke. All around me I could hear ear-splitting laughter and shrieks of joy. We were off that terrible ship and in clear sight of a black Statue of Liberty. "The Lady" held a black baby high up in her great arms. We swam through blood but no one was wounded. A rainbow lit the sky and the white heat from The Lady's torch ignited the ship. We laughed and cried and prayed as the burning slaves ship sailed away from us.

The captain was now a handsome black man. "You look radiant, my beautiful princess," he whispered as he took me in his arms and kissed me. And as fate would have it— damn it—I woke up. But, Mama, I was in the most peculiar pose: my left arm was holding my pillow, like The Lady held the baby, and my right arm was straight up in the air like it was holding a torch. I must have looked awful silly but I felt great, though tears were streaming down my face.

Pierrot was standing over me with the customary drink in his hand.

"What's tickling you Sis? You know I love ya," he said jokingly, "Wake up and meet Miss Morgan Lou Ann Van Camp. She's got enough scratch to sink this ship. Now why don't we just sell her that bad dream you just had."

I rolled over on my stomach and pressed my tear-drenched face into the pillow. Pierrot would never understand what I've been through and neither would Ms. Morgan Lou Ann Van Camp.

## Born in a Cotton Field

*(The American Collection: #3)*

Dear Mama,

When Pierrot and I were children I used to make up spooky nighttime stories to scare him. One night he cried uncontrollably and said he hated my ugly stories. So I made up a fairytale about a brave prince who was the savior of his people. Pierrot loved that story and he'd beg me to tell it to him over and over again. Hearing that story made Pierrot feel like a prince. I've always wanted to feel like a princess so I have written a story about a beautiful black princess who is the savior of her people, and I want you to be the first to read it.

1 Long ago in the tiny Village of Visible way down in the deep deep South there lived two slaves named Mama and Papa Love. They were called that because of the great love they shared for children, though they had never had any children of their own for fear that Captain Pepper, the mean old slave master, would sell their child, and destroy their loving family.

2 One day the Great Lady of Peace came to tell Mama Love that in spite of all her fears she was soon to have a baby girl who would be so beautiful that she would be the envy of all who saw her. She

promised that this little girl would grow up to be a princess who would bring peace, freedom and love to the slaves' Village of Visible. Mama Love was very happy but she was frightened too, for she knew if Captain Pepper got wind of this he would want to make the baby princess a slave. So Mama Love begged the Great Lady of Peace to promise she would hide her baby and protect her freedom. And so the Lady of Peace got the Prince of Night to conceal the beautiful princess in his great black cloak of night and keep her forever safe from human eyes.

3 On the morning the baby was to be born the sun shone brightly and the flowers blossomed and the birds sang sweetly, and the bees swarmed and buzzed in chorus, and everyone in the tiny slaves' Village of Visible could feel a strange sense of peace and love that they had never felt before.

4 As the beautiful baby princess came into the world, the Prince of Night appeared and spread his great black cloak across the sky, turning day into the blackest night. The sudden darkness spread swiftly across the sky and woke the Terrible Storm King, who flew into a thunderous rage, releasing tumultuous rains and hurricane winds on the tiny slaves' Village of Visible. It was during the Terrible Storm that the Prince of Night wrenched the beautiful newborn baby from Mama Love's arms and her tiny body vanished into the stormy night.

5 Ever since that day Mama Love, Papa Love and all the slaves in the tiny Village of Visible mourned the loss of the beautiful baby princess. They made a secret shrine in the

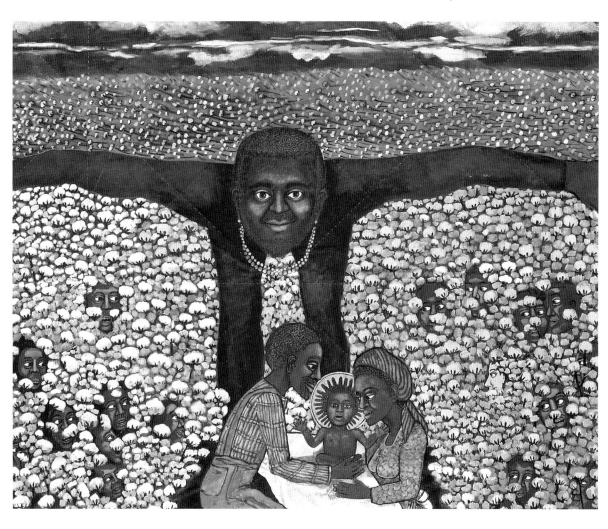

cotton fields in her memory. They went there each day to remember the promise of the Great Lady of Peace.

6 Captain Pepper's plantation was known as the richest and most beautiful plantation in the South. Although there were white and black people there, all the black people were slaves who worked from sun up till sun down for no pay and lived in broken-down shacks, wore rags and had only discarded scraps of food from the slave master's table to eat.

On the other hand all the white people wore splendidly tailored clothes, ate fine foods and lived in the beautiful houses. They sent their children to school, while the slave children worked all day in the cotton fields and were forbidden to read or write.

7 One day, Patience, Captain Pepper's blind daughter, was playing in the cotton fields and she saw a little girl her own age, and it made her so surprised and happy that she could see her that she ran home and told her father about the beautiful little girl she had seen in the cotton field.

"Patience, my little blossom, you cannot see," said Captain Pepper. "But Father," said Patience, "I can see *her*." "What does she look like?" asked Captain Pepper. "She has nutbrown skin, shiny brown eyes, long black curls and the most beautiful smile," said Patience. "Everything around her glows. I know she must be a Princess. Don't you believe me, Father?" "No," growled the mean old slave master, "I have never seen a beautiful slave, and neither have you. You must promise

me never to go to the cotton fields again." "But why, Father?" asked Patience.

"Your mother was struck by lightning in those cotton fields during the Terrible Storm," roared Captain Pepper. "But why was mother there?" asked Patience. "She said she went to see a miracle," responded Captain Pepper. "Mother went to see the beautiful princess who was born in the cotton fields, didn't she, Father?" asked Patience. "No!" screamed the Captain. "Enough about this Invisible Princess." "Yes, Father," thought Patience, "that *is* just who she is, not a slave but an Invisible Princess."

8 Captain Pepper didn't want Patience to know it, but he had heard about the beautiful baby who had been born in the cotton fields, and now he was beginning to believe it. "But could there really be a beautiful slave, an Invisible Princess? Well, if there is, that slave is mine," shouted Captain Pepper. "And I will find her."

Captain Pepper summoned his overseers to search the cotton fields, the slaves' shacks and all the surrounding woods to find the Invisible Princess. But she was nowhere to be found. Captain Pepper was convinced that the slaves were hiding the princess from him. He vowed to punish them by selling Mama Love and Papa Love to different plantations very far away so that they would never see each other or their beautiful Invisible Princess again.

9 Patience, hearing her father's vow, went to warn the Invisible Princess that her parents were in danger. "I can see you," whispered Patience,

"you are the beautiful Princess who was born in the cotton fields. My mother came to see the miracle of your birth, but she was struck by lightning during the Terrible Storm and later died. Some people think you died too. But I know you are alive because I can see you, even though I am blind. And now my father, Captain Pepper, knows too and he is trying to find you. He has threatened to sell Mama and Papa Love so that they will never see you again."

10 The Invisible Princess realized she had to warn her parents. She found Mama and Papa Love praying at the shrine. "I have come out of hiding to help you," she began. "The Great Lady of Peace saved me just as you asked her to, Mama. I am invisible but you can hear me and I want you to know that I am alive and well, but now you and Papa are in danger," she said. "Captain Pepper has threatened to sell you to a plantation far away," she went on, tugging at her mama's apron.

"Oh my beloved daughter, we have prayed for this day. Tell us, what happened to you?" pleaded Mama Love. "On the day I was born the Prince of Night appeared and hid me in his great black cloak of darkness, and during the Terrible Storm he carried me away so that no one saw me leave. I was afraid, Mama, but the Prince of Night is very gentle and he quickly replaced my fears with restful sleep."

"But who is the Prince of Night and where did he come from, daughter?" asked Papa Love. "He escaped from a slave ship by turning day into night. He is cold black and very handsome, Mama—and he is rich too. His great black cloak is studded

with diamonds that sparkle like stars. If Captain Pepper could see him, he would try to make him a slave. But no one can ever see the Prince of Night."

"But you were just a newborn baby when we lost you. Where have you been and how did you become invisible, my child?" asked Papa Love. "The Great Powers of Nature take care of me, Papa. The Giant of the Trees made me a beautiful castle high up in his branches. And the Dream Queen visits me each night and brings me sweet sweet dreams of freedom, Papa, that one day will come true.

11 "And the Sun Goddess wakes me each morning with fresh fruits and vegetables and keeps my days warm and beautiful. And the Sea Queen brings me fresh water to drink and bathes me in the mountain springs.

12 "And the Great Lady of Peace teaches me to be loving, strong and wise. But it is the Queen of Bees who brings me fresh baked honey cakes made with her special honey that keeps me invisible.

13 "I am not afraid of Captain Pepper because his power to destroy is no match against the creative powers of the Prince of Night, the Giant of the Trees, the Dream Queen, the Sun Goddess, the Sea Queen, the Great Lady of Peace, the Queen of Bees and all of the other wonderful and treacherous powers of nature who have come to help us," said the Invisible Princess.

At that, the Great Powers of Nature make themselves heard. "Hear, hear!" chorused the Great Powers of Nature. "No one will harm any of you ever again. And from this day

on, all the slaves of the Village of Visible will be free."

14 "But Captain Pepper is a very mean and powerful slave master. How can we ever be free of him?" asked Mama and Papa Love.

"I will personally make a batch of fresh baked honey cakes with my special honey that is bittersweet," said the Queen of Bees. "And anyone who is stung by my bees and then eats my fresh baked honey cakes will become invisible."

"And I will spread my great black cloak and make the day into the blackest night," said the Prince of Night. "And the slaves' Village of Visible will disappear." "And the Invisible Village of Peace, Freedom and Love will be born," said the Great Lady of Peace.

15 The next morning in the slaves' Village of Visible, great bowls of fresh baked honey cakes were left at the doors of all the slave shacks. A mighty army of bees led by the Queen herself swarmed the cotton fields and stung the slaves, who then fled to their shacks and, seeing the bowls of fresh baked honey cakes, ate the cakes and became invisible.

Then Captain Pepper discovered that not only was there no one working in the cotton fields or in the plantation houses, but Patience, his beloved daughter, was gone too. "Patience, Patience," roared Captain Pepper, "where are you? I command you to come to me at once."

But Patience had been in the cotton fields and had been stung and had eaten the fresh baked honey cakes and was now in the Invisible Village of Peace, Freedom and Love. There, she could see the sun in the sky and the flowers in the fields and the trees in the forests and the people everywhere and she was happier than she had ever been before. Captain Pepper went every day to the deserted cotton fields in search of his beloved Patience. But all he could find were the bowls of stale honey cakes with bees swarming everywhere. Captain Pepper could not hold back his tears as he cried out in grief for the loss of his only child and in repentance for all the cruelty and pain he had brought to the lives of his slaves. Now that they were free of him, what would he do?

16 The Great Lady of Peace, hearing Captain Pepper's cries of remorse, came to his aid. "Patience, the Invis-

ible Princess, and all your former slaves have a new life in the Invisible Village of Peace, Freedom and Love, where everyone is free and lives in peace. To go there you must be stung by the bees and eat the fresh baked honey cakes, and you too will be carried to the Invisible Village of Peace, Freedom and Love. There you will lose all desire to enslave and inflict misery on others. You have only a few minutes to decide," said the Great Lady of Peace.

17 "Oh please, Great Lady, let the bees sting me," cried Captain Pepper. "I am ready to go and live in peace." Captain Pepper was stung by the bees and gobbled up the fresh baked honey cakes. And the Prince of Night appeared and spread his great black cloak turning day into the darkest night. As the Terrible Storm circled the village, there were loud cracking sounds and the heavens split, and the Giant of the Trees bowed his head and lifted Captain Pepper up, up, up above the jet black clouds of night into the Invisible Village of Peace, Freedom and Love.

18 Patience was there with the Invisible Princess, Mama Love and Papa Love, and all the men, women and children who had been slaves in the cotton fields and in the plantation

house and were now free. There was music and dancing and storytelling, and everyone was happy for ever after.

Whenever you hear the buzzing of bees and you smell fresh baked honey cakes and then suddenly day becomes the darkest night and a Terrible Storm circles a village, you can be sure that an Invisible Village of Peace, Freedom and Love has been born and that the Invisible Princess lives there. There are many such villages all over the world. And if you listen very carefully you can hear the people of the villages singing.

We live in a peaceful village

of freedom and love

In harmony with our brothers and sisters

by all the stars above

We live in a beautiful village

full of happiness and joy

Dedicated to the freedom of

Every man and woman

and every girl and boy.

# Chronology for Faith Ringgold

1930 Born October 8 at Harlem Hospital in New York City, to Andrew Louis Jones, Sr., and Willi Posey Jones. Has two older siblings, Andrew and Barbara. Frequently sick with asthma as a small child; art becomes a major pastime.

1942 Family moves from the "Valley" to Sugar Hill in Harlem.

1950 Marries Robert Earl Wallace, a classical and jazz pianist, while majoring in art at the City College of New York. Obtains first studio space for independent oil painting projects. Has two children: Michele Faith Wallace, January 4; Barbara Faith Wallace, December 15.

1954 Permanent separation and divorce proceedings begin, completed in 1956.

1955 Graduates from City College with B.S. in Fine Art. Begins teaching art in the New York City public schools (until 1973). First hears of James Baldwin through one of her students: Baldwin's baby sister, Paula.

1957 Spends first of many summers in Provincetown, Massachusetts, doing oil paintings of houses, landscapes, fishing boats, and the ocean.

1959 Completes M.A. in art at City College.

1961 First trip to Europe (with mother and daughters) aboard the S.S. *Liberté*. Tours the museums of Paris, Nice, Florence, and Rome. Brother dies while they are in Rome, causing them to return abruptly to the United States. Makes the dining area in her home a studio space.

1962 Marries Burdette Ringgold, May 19.

1963 Does first political paintings. Spends summer in Oak Bluffs on Martha's Vineyard, where develops first mature painting style, which she calls "super realism"; content influenced by writings of James Baldwin and Amiri Baraka (then Leroi Jones). Starts the *American People* series of oil paintings (1963–67).

1964 Begins search for a New York gallery. Writes letters to Romare Bearden and Hale Woodruff in an attempt to join Spiral, the black artists group, and to exhibit in the first Black Arts Festival in Senegal. Unsuccessful on both counts.

1965 Meets Leroi Jones at his Black Arts Repertory Theatre and School in Harlem.

1966 Participates in the first exhibition of black artists in Harlem since the 1930s. Meets Romare Bearden, Ernie Crichlow, Norman Lewis, Charles Alston, Hale Woodruff, and Betty Blayton; first real contact with black artists. Joins Spectrum Gallery on 57th Street, run by Robert Newman.

1967 Paints first murals, *The Flag Is Bleeding, U.S. Postage Stamp Commemorating the Advent of Black Power*, and *Die*, while daughters are in Europe for the summer. First one-person show at Spectrum Gallery. Meets James Porter of Howard University, who buys a painting from *American People* series. Begins development of "black light" using palette of darkened colors, in pursuit of a more affirmative black aesthetic.

1968 Participates in benefit exhibition for Martin Luther King, Jr., at the Museum of Modern Art. Meets Jacob Lawrence, Henri Ghent, and Ed Taylor. Initiates first demonstration of black artists at the Whitney Museum of American Art. Joins Art Workers' Coalition. Meets Lucy Lippard, Carl Andre, and Lil Picard. Demonstrates with light sculptor Tom Lloyd, demanding MoMA open a black artists wing in honor of Martin Luther King, Jr. Their efforts result in two blacks on the museum's board of trustees and major exhibitions for two black artists in 1971.

1969 *Flag for the Moon: Die Nigger* as a response to first U.S. moon walk. Begins series of political posters. Daughters in Mexico for the summer. Father dies.

1970 Second one-person show, "America Black," featuring "black light" paintings, at Spectrum Gallery. Begins teaching at Bank Street, Pratt Institute, and Wagner College. Meets Robert Morris and Poppy Johnson through Art Strike. Participates in demonstrations of Ad Hoc Women's Art Group against the Whitney Museum. Her contributions result in the inclusion in the "Whitney Sculpture Annual" of Betye Saar and Barbara Chase-Riboud, among the first black women ever exhibited at the Whitney.

**1971** Cofounds black artists group Where We At. Guest curator of "Where We At" show at Acts of Art Gallery in New York City. Meets Kay Brown and Dinga McCannon. Does *United States of Attica* poster. Wins CAPS grant from New York State Council of the Arts to do mural for the Women's House of Detention. As a result of doing the television show *On Free Time* (PBS), hosted by Julius Lester, meets Louise Nevelson, Alice Neel, and Pat Mainardi.

**1972** Permanent installation at the Women's House of Detention on Riker's Island of *For the Women's House*, which uses all-female imagery for the first time in Ringgold's work. As a result of this piece, Art Without Walls (an artists' group to bring art to prison inmates) is formed. Develops tankas (soft cloth frames) after seeing an exhibition of Tibetan art at the Rijks Museum in Amsterdam. Puts political posters and feminist papers in "Documenta" in Kassel, Germany. Participates in "First American Women Artists Show" in Hamburg. Begins lecture tours and traveling exhibitions to colleges and universities around the United States.

**1973** Ten-year retrospective at Voorhees Gallery at Rutgers University. Resigns from teaching position in New York City public schools to continue touring and to make art full time. Makes first dolls and *Family of Woman Masks* and *Slave Rape* series of paintings. Collaborates with Willi Posey (her mother, a fashion designer) on costumes for masks and on tankas for paintings.

**1974** Develops hanging soft sculptures: *Wilt* series and *Couple* series, both featuring painted coconut heads. Does *Windows of the Wedding* series, abstract paintings based on African Kuba design, and uses them as environment for soft sculptures. Michele graduates from City College.

**1975** Curates "11 in New York," black women's show at Women's Interarts Center. Begins art performances with masks and costumes. Creates first stuffed figures, *Zora and Fish* (bag man and woman), as well as first portrait masks of *Harlem* series, including Adam Clayton Powell, Jr., and Martin Luther King, Jr. Develops appliqué soft masks for workshop at University of Wisconsin. Barbara graduates with B.A. in linguistics from the University of London.

**1976** Artist in residence at Wilson College in Pennsylvania, where she develops *The Wake and Resurrection of the Bicentennial Negro,* an environmental performance piece. Codirector with Monica Freeman, Margo Jefferson, Pat Jones, and Michele Wallace of "The Sojourner Truth Festival of the Arts," held at Women's Interarts Center in New York City; it includes exhibition of *Dear Joanna Letters,* a documentation piece. Goes to Africa for the first time. Tours Ghana and Nigeria to see art and people.

**1977** Participates in "Festac 77" in Lagos, Nigeria. Does first free-standing soft sculptures, the *Women on a Pedestal* series. Begins writing autobiography *Being My Own Woman.* Barbara receives graduate diploma from the University of London, returns to the United States to pursue a Ph.D. in African linguistics at City University Graduate Center. Mother, Willi Posey, remarries. Meets Moira Roth.

**1978** Receives National Endowment for the Arts award for sculpture. Develops Ringgold Doll, a series of soft sculptures, and *Harlem '78,* a public participation graffiti mural.

**1979** Develops *International Dolls Collection* and *Ringgold Doll Kits* ("Sew Real"). Michele publishes first book, *Black Macho and the Myth of the Superwoman,* and appears on the cover of *Ms.* magazine with picture of family inside.

**1980** With her mother, begins work on their final collaborative project, *Echoes of Harlem,* a quilt for "Artist and Quilt" show. Completes first draft of autobiography. Michele begins Ph.D. in American studies at Yale University. Barbara marries and receives a master of philosophy from the City University of New York.

**1981** With her mother, works on packaging the *Ringgold Doll Kits.* Does *Atlanta* series in memory of the children killed in Atlanta. Mother dies. Barbara divorces. Michele leaves Yale and returns home.

**1982** Curates the "Wild Art Show" at P.S. 1 exhibition space for the Women's Caucus for Art. First grandchild, Baby Faith, born. Begins painting again at MacDowell Colony: *Emanon* series and *Baby Faith and Willi* series. With Michele, performs *No Name Performance #1* at Kenkeleba House. Makes painted dolls. Sister dies.

**1983** Begins *Dah* series of paintings. Initiates "Upstream Women" series of workshops and panels. First excerpt from autobiography published in *Confirmation: An Anthology of African American Women,* edited by Amiri Baraka and Amina Baraka. Does *Mother's Quilt* and first story quilt, *Who's Afraid of Aunt Jemima?* Wins Wonder Woman Award from Warner Communications. Performs *No Name Performance #2,* in which audience dances, speaks out, and, in the finale, takes over the stage.

**1984** Has twenty-year retrospective at Studio Museum in Harlem. Michele Wallace edits the accompanying catalog. Is a visiting associate professor at University of California in San Diego. Continues painting *Dah* series (*California Dah*), used as a backdrop for *No Name #2*. Does series of aquatints called *The Death of Apartheid* and participates in exhibitions organized by Artists Against Apartheid. Begins printmaking as visiting artist at Bob Blackburn's Printmaking Workshop in New York City. Does etching on canvas to be used to make story quilts. Michele begins

teaching at University of Oklahoma in Norman.

**1985** Continues story quilts and develops new storytelling performance, *The Bitter Nest.* Appointed to a tenured position as full professor in the visual arts department at the University of California in San Diego. Sets up bicoastal living pattern, spending half the year in San Diego and half in New York. Exhibits *Flag* series of paintings from 1960s in group exhibition "Tradition and Conflict: Images of a Turbulent Decade, l963-1973." Barbara marries and has second baby girl, Theodora Michele.

**1986** Receives first honorary doctorate from Moore College of Art. Joins the Bernice Steinbaum Gallery in New York City and prepares for solo show of story quilts in January 1987. Loses weight (over 100 pounds), documenting this in a videotape, quilt, and performance entitled *Change: Faith Ringgold's Over 100 Pounds Weight Loss Performance Story Quilt.* Receives Candace Award from One Hundred Black Women.

**1987** Has solo show at Bernice Steinbaum Gallery with *Change: Over 100 Pounds Weight Loss Performance* and catalog, followed by major articles in *Arts, Art in America*, and other periodicals. Meets Eleanor Flomenhaft. Receives fellowship from John Solomon Guggenheim Memorial Foundation and Public Art Fund Award from the Port Authority of New York and New

Jersey. Awarded honorary doctorate at the College of Wooster, Wooster, Ohio. Has three one-person shows, including one at the Baltimore Museum, and is in twenty-one group shows. Curates "Home Show" at New York's Goddard Riverside Community Center. Travels to Japan for exhibit.

**1988** Has solo show at Bernice Steinbaum Gallery, where exhibits *Tar Beach* as part of the *Woman on a Bridge* series. Performs *Change 2: Faith Ringgold's Over 100 Pounds Weight Loss Performance Story Quilt.* Receives New York Foundation for the Arts Award; is included in Leslie Sills's *Inspirations: Stories of Women Artists for Children.* Barbara has third child, Martha.

**1989** Receives National Endowment for the Arts award for painting, the La Napoule Award (to spend four months in France), and the Mid-Atlantic Arts Foundation Award. Commissioned to create a story quilt to celebrate the hundredth anniversary of the first black graduate of Williams College: Gaius Bolin. Included in "Stitched Memories: African American Story Quilts" at the Williams College Museum, Williamstown, Massachusetts, and in a major traveling survey of women's art, "Making Their Mark: Women Artists Moving into the Mainstream." Receives honorary doctorate from alma mater, City College of New York.

**1990** Has a major retrospective, "Faith Ringgold: A Twenty-

five Year Survey," curated by Eleanor Flomenhaft, which travels to thirteen museums, beginning at the Fine Arts Museum of Long Island, followed by the High Museum of Art in Atlanta and the Arizona State Art Museum in Tempe. Completes her first children's book, *Tar Beach* (published by Crown Publishers in January 1991), and a silkscreen edition of twenty-four quilts titled *Tar Beach 2,* printed at the Fabric Workshop in Philadelphia. Begins *The French Collection* series in studios in Paris and at the La Napoule Château in southern France. In La Napoule meets Linda Freeman, who videotapes Ringgold for *The Last Story Quilt.*

**1991** Returns to Paris and takes an apartment at the Hotel Ferrandi on rue de Cherche Midi. Makes sketches for part 2 of *The French Collection* series (on Gertrude Stein and Josephine Baker) and completes nine quilts in the series. Creates *Change 3*, a "nude" appraisal of forty years of weight loss and gain. Moves to a studio in New York's garment district to work on a large-scale mural for Public School 22 in Crown Heights, Brooklyn. Retrospective travels to Miami University Art Museum, Oxford, Ohio; Albright Knox Art Gallery, Buffalo, New York; Pensacola Museum of Art, Pensacola, Florida; and African American Museum of Fine Arts, Los Angeles.

**1992** Receives a *New York Times* Best Children's Book Award, a Caldecott Honor for the best

illustrated children's book of 1991, and the Coretta Scott King Award for the best illustrated book by an African American. Her second children's book, *Aunt Harriet's Underground Railroad in the Sky*, is published by Crown Publishers. *The French Collection* exhibition opens at Bernice Steinbaum Gallery; afterward severs relations with this gallery and resumes self-representation. Buys a ranch house in Englewood, New Jersey, with plans to build a studio in the country. Receives a commission from the Metropolitan Transit Authority to create two thirty-foot mosaic murals on the platform of the 125th Street IRT subway station. Retrospective travels to Museum of Art, Davenport, Iowa; University of Michigan Museum of Art, Ann Arbor; Women's Center Gallery, University of California, Santa Barbara; Mills College Art Gallery, Oakland, California; and Tacoma Museum, Tacoma, Washington.

**1993** Receives a National Endowment for the Arts travel award to collaborate with Moira Roth on *Moroccan Holiday,* the last piece in *The French Collection*. Travels to Tangier to prepare texts and drawings for the quilt. Returns to apartment at the Hotel Ferrandi in Paris. Meets Michel Fabre at the Sorbonne and talks about the African American in Paris. Publishes *Dinner at Aunt Connie's House* (Hyperion Books), based on *The Dinner Quilt* (created in 1988).

Receives an honorary doctorate from the California College of Arts and Crafts and meets Marlon Riggs, the celebrated filmmaker. Creates *The Black Family Dinner Quilt*, a tribute to Mary McLeod Bethune and Dorothy Height, and donates it to the museum of the National Association of Negro Women. The Children's Museum of Manhattan mounts an exhibition of *Tar Beach*. Receives commission to create a nine-by-seventeen-foot painted mural, *Eugenio Maria de Hostos: A Man and His Dream,* for Hostos Community College (completed in 1994).

1994 Begins rewriting autobiography *We Flew over the Bridge* with Moira Roth as editor. The first editing session is in Paris in January during the "African American in Paris" conference at the Luxembourg Gardens, organized by Raymond Saunders and Maïca Sancone and attended by Howardena Pindell, Lorna

Simpson, Betye Saar, Sam Gilliam, and others. Moves studio back to Harlem in preparation for building a new studio in Englewood, New Jersey. Participates in two major exhibitions abroad: "Cocido y Crudo," curated by Dan Cameron, at the Museo National Centro de Arte Reina Sofia in Madrid, and the Cairo Biennial, curated by Debbie Cullen of the Printmaking Workshop, which opens in Cairo and later travels throughout East Africa and the Middle East. Attends Cairo opening with Bob Blackburn, Mel Edwards, Kay Walking-stick, Juan Sanchez, and Micheal Kelly Williams. Completes *Le Cafe des Artistes* of part 2 of *The French Collection* and *Marlon's Quilt,* a painted quilt in memory of Marlon Riggs, who died of AIDS in 1994. Proceeds from the sale of the latter quilt benefit AIDS care and research. Receives seventh honorary doctorate, from Rhode Island School of

Design. On June 10, at a black-tie dinner in the Rose Garden of the White House, is seated next to Hillary Rodham Clinton.

1995 On May 19, attends the 75th Anniversary of the Women's Bureau of the Department of Labor at the White House. Is commissioned to create a benefit poster, titled *Women's Work Counts,* to celebrate the occasion; the original is exhibited at the White House and later at the Department of Labor. Receives the Townshend Harris Medal from the City College of New York Alumni Association. Publishes four books: *We Flew over the Bridge: The Memoirs of Faith Ringgold* (Little, Brown), her first adult book; two children's books, *My Dream of Martin Luther King* and *Faith Ringgold's Talking Book* (Crown), an autobiography for children with Nancy Roucher and Linda Freeman; and an artist's book, *Seven Passages to a Flight* (Brighton

Press). Visits Damascus when the Cairo Biennial tours the Middle East. Is represented by the ACA Galleries in New York and has first solo show there.

1996 Publishes fifth children's book, *Bonjour, Lonnie* (Hyperion). Exhibits *Flag for the Moon: Die Nigger* (1967) in "Face à L'Histoire" at the Pompidou Center in Paris. Returns to Paris for exhibition and stays in Hotel le Bretonnerie on St. Croix de Bretonnerie. Receives her ninth honorary doctorate, from Russell Sage College. *Crown Heights Children's History Quilt* is installed at Public School 90 in Crown Heights, Brooklyn. Begins painting *The American Collection*.

1997 Receives honorary doctorate in education from Wheelock College in Boston, a doctor of philosophy from Molloy College in New York, and the New Jersey Artist of the Year Award from the New Jersey Center for the Arts.

# Selected Recent Exhibitions

ONE-PERSON EXHIBITIONS

"Stories for Children: Faith Ringgold." Boehm Gallery at Palomar College, San Marcos, California. February–March 1996.

"Faith Ringgold: Story Quilts." Bowling Green State University, Bowling Green, Indiana. February 1996.

"Faith Ringgold: Masks and Dolls." Indiana University of Pennsylvania, Indiana, Pennsylvania. November 1995.

"Faith Ringgold: Paintings and Drawings Spanning Four Decades." ACA Galleries, New York, New York. October–November 1995.

"Children's Stories by Faith Ringgold." Athenaeum: Music and Arts Library, La Jolla, California. July–September 1995.

"Currents 57: Faith Ringgold." St. Louis Art Museum, St. Louis, Missouri. March–May 1994.

"Dinner at Aunt Connie's House and Aunt Harriet's Underground Railroad in the Sky." Hewlett–Woodmere Public Library, Hewlett, New York. December 1993–February 1994.

"Tar Beach." Children's Museum of Manhattan, New York, New York. May 1993–December 1995.

"Inspirations: Exploring the Art of Faith Ringgold." Textile Museum, Washington, D.C. April–September 1993.

"Faith Ringgold: A Twenty-five Year Survey." Fine Arts Museum of Long Island, Hempstead, New York. April–June 1990, traveling exhibition.

"Change: Painted Story Quilts." Bernice Steinbaum Gallery, New York, New York. January–February 1987.

"Faith Ringgold: Painting, Sculpture, Performance." College of Wooster Art Museum, Wooster, Ohio. August–October 1985.

"Faith Ringgold: Twenty Years of Painting, Sculpture and Performance (1963–1983)." Studio Museum in Harlem, New York, New York. April–September 1984.

GROUP EXHIBITIONS

"American and European Painting and Sculpture and Contemporary Art." ACA Galleries, New York, New York. July–September 1997.

"Unraveling the Mask: Portraits of 20th Century Experience." Trout Gallery, Dickinson College, Carlisle, Pennsylvania. February–March 1997.

"Community of Creativity: A Century of MacDowell Colony Artists." National Academy Museum, New York, New York. January–March 1997, traveling exhibition.

"Threads: Fiber Art in the 90's." New Jersey Center for the Arts, Summit, New Jersey. January–March 1997.

"Uncommon Threads: Weaving Narrative and Collaboration." Sleeth Gallery, Buckhannon, West Virginia. January–February 1997.

"Face à l'Histoire." Centre Georges Pompidou, Paris, France. December 1996–April 1997

"Profound Playthings." Hudson, New York. December 1996–January 1997.

"Community of Creativity: A Century of MacDowell Colony Artists." Currier Gallery of Art, Manchester, New Hampshire. September–December 1996.

"Heralding the 21st Century: Contemporary African American Women Artists." Spelman College Museum of Fine Art, Atlanta, Georgia. May–December 1996.

"The Oklahoma City Children's Memorial Art Quilts." Oklahoma City, Oklahoma. April–June 1996, traveling exhibition.

"Soul Full: The Personal and Political." Mary Wood College Art Gallery, Scranton, Pennsylvania. April–May 1996.

"Labor of Love." The New Museum of Contemporary Art, New York, New York. January–April 1996.

"Quilts and Oral Traditions in Black Culture." Museum for Textiles, Toronto, Canada. January–March 1996.

"Art, Design and Barbie: The Evolution of a Cultural Icon." World Financial Center, New York, New York. December 1995–February 1996, traveling exhibition.

"Love Flight of a Pink Candy Heart: A Compliment to Florine Stettheimer." Holly Solomon Gallery, New York, New York. October–November 1995.

"Artists on Artists." Gallery Swan, New York, New York. September–October 1995.

"The Illustrators Art." Dairy Barn, Athens, Ohio. September–October 1995.

"The Reconstructed Figure: The Human Image in Contemporary Art." Katonah Museum of Art, Katonah, New York. June–September 1995.

"Women's Work." White House, Washington, D.C. May 1995.

"Illustrations from Caldecott Books." Chicago Institute of Art, Chicago, Illinois. April–October 1995.

"UCSD Faculty Exhibition." UCSD University Art Gallery, San Diego, California. March–June 1995.

"Ancestors." Asian American Arts Center, New York, New York. March–May 1995.

"10 X 10: Ten Women, Ten Prints, a Portfolio of Silkscreen Prints." Berkeley Art Center, Berkeley, California. March 1995.

"'Rainbow' Bob Blackburn's Printmaking Workshop Exhibit." Lagos, Nigeria. February 1995–September 1996, traveling exhibition.

"Making Faces: The American Portrait." Hudson River Museum, Yonkers, New York. February–August 1995.

"Division of Labor 'Women's Work' in Contemporary Art." Bronx Museum, New York, New York. February–June 1995, traveling exhibition.

"Fashion Is a Verb." Fashion Institute of Technology, New York, New York. February 1995–April 1995.

"(In) Forming the Visual: (Re) Presenting Women of African Decent." Montgomery Gallery, Pamona College, California. January–March 1995.

"…it's how you play the game." Exit Art / The First World, New York, New York. December 1994–February 1995.

"Cocido y Crudo." Museo National Centro de Arte Reina Sofia, Madrid, Spain. November 1994–March 1995

"Strategies of Narration: The Fifth International Cairo Biennale 1994." Aknaton Gallery, Cairo, Egypt. November 1994–March 1995, traveling exhibition.

"The Impact of Slavery: 'It's More Than Just Another Art Show.'" Firehouse Art Gallery, Garden City, New York. November–December 1994.

"Girls and Girlhood: A Perilous Path." UNICEF, United Nations, New York, New York. October–November 1994, traveling exhibition.

"Odun de- Odun de-." California College of Arts and Crafts, Oakland, California. October 1994.

"Art for Learning: Percent for Art Commission." Municipal Art Society, New York, New York. September–November 1994.

"Political Imagery from the Black Arts Movement of the1960s and 1970s: Black Power: Black Art…and the Struggle Contin-

ues." San Francisco State University Art Department Gallery, California. September–October 1994.

"Between Two Worlds: African American Identity." Strong Museum, Rochester, New York. August 1994–August 1996.

"Art en Route, MTA, Arts for Transit." Metropolitan Transit Authority Arts for Transit, Paine Webber Group, New York, New York. July–September 1994, traveling exhibition.

"Old Glory: The American Flag in Contemporary Art." Cleveland Center for Contemporary Art, Cleveland, Ohio. June–August 1994, traveling exhibition.

"1969: A Year Revisited." Grey Art Gallery and Study Center, New York University, New York, New York. June–July 1994.

"Women's Caucus for the Arts Honor Awards." Queens Museum of Art, Flushing, New York. January–March 1994.

"The American Family Inside Out." Creative Arts Workshop, New Haven, Connecticut. September–October 1993.

"Interior Vision: The Illustrator's Eye." Cinque Gallery, New York, New York. September–October 1993.

"25 Years." Cleveland Center for Contemporary Art, Cleveland, Ohio. July–November 1993.

"The Definitive Contemporary American Quilt." Southern Ohio Museum, Portsmouth, Ohio. July–August 1993.

"New Developments in American Fiber Art: USA Today." Museum of the Applied Arts, Helsinki, Finland. June–August 1993.

"Dolls in Contemporary Art." Haggert Museum, Marquette University, Milwaukee, Wisconsin. March–June 1993.

"USA Today: In Fiber Art." Netherlands Textile Museum, Tilburg, Netherlands. March–June 1993.

"Reflections of a King." National Civil Rights Museum, Memphis, Tennessee. January–March 1993.

"A Common Thread." Bomani Gallery, San Francisco, California. January–February 1993.

"Fiber Art." National Institute of Art and Disabilities, Richmond, California. January–February 1993.

"American Women Artists." Foster Harmon Gallery, Sarasota, Florida. October 1992–March 1993.

"Dream Singers: Story Tellers: An African American Presence." New Jersey State Museum, Trenton, New Jersey. August 1992–March 1994, traveling exhibition.

"Ancestors Known and Unknown: Boxworks by Coast to Coast National Women Artists of Color." Women and Their Work Center, Austin, Texas. August–September 1992, traveling exhibition.

# Selected Bibliography

PUBLICATIONS BY FAITH RINGGOLD

"All Mom's Can Fly." *Child Magazine* (May 30, 1993): 61–62.

"An Open Show in Every Museum." *Feminist Art Journal* (April 1972): 10.

"Anyone Can Fly." *L.A. Times Magazine* (December 1992): 28–29.

*Aunt Harriet's Underground Railroad in the Sky.* New York: Crown Publishers, 1992.

"Aunt Harriet's Underground Railroad in the Sky." *Jr. America's Magazine* 2 (February/March 1995): 34–39.

"Being My Own Woman." In *Confirmation: An Anthology of African American Women,* compiled by Amiri and Amina Baraka. New York: William Morrow, 1983.

"Black Art: What Is It?" *Art Gallery Guide* (April 1970): 35–36.

*Bonjour, Lonnie.* New York: Hyperion Books for Young Readers, 1996.

"Dear Girls, a Letter Inspired by Dr. Martin Luther King." In *Confessions of the Guerrilla Girls.* New York: Harper Perennial, 1995, p. 91.

*Dinner at Aunt Connie's House.* New York: Hyperion Books for Children, 1993. CD ROM: New York: Scholastic, 1996.

"Documenta." *Feminist Art Journal* (Winter 1973): 15–16.

*Faith Ringgold's Talking Book.* New York: Crown Books for Young Readers, 1995.

*My Dream of Martin Luther King.* New York: Crown Publishers, 1995.

*Seven Passages to a Flight.* San Diego: Brighton Press, 1995.

*Tar Beach.* New York: Crown Publishers, 1991.

*We Flew over the Bridge: Memoirs of Faith Ringgold.* Boston: Little, Brown, 1995.

"What's More Important to Me Is Art for People." *Arts Magazine* (September/October 1970): 28.

"You Were Too Young to Remember What We Must Never Forget." In *The Eye of the Beholder.* Boston: Isabella Stewart Gardner Museum, 1994, pp. 10–13.

REFERENCES TO FAITH RINGGOLD

Briggs, Stephanie Bissel, and Janis Bunchman. *Pictures and Poetry.* Worcester, Mass.: Davis Publications, 1994.

Broude, Norma, and Mary Garrard, eds. *The Power of Feminist Art.* New York: Harry N. Abrams, 1994.

Cooper, David J., and John J. Pikulski. *Quest: Invitation to Literacy.* Boston: Houghton Mifflin, 1995.

Davis, Marianna W. *Contributions of Black Women to America: The Arts.* Columbia, S.C.: Kenday Press, 1982

Day, Frances Ann. *Multicultural Voices in Contemporary Literature: A Resource for Teachers.* Portsmouth, N.H.: Heinemann, 1994.

Fax, Elton C. *Seventeen Black Artists.* New York: Dodd, Meade, 1971.

Fichner-Rathus, Lois. *Understanding Art.* Englewood Cliffs, N.J.: Prentice-Hall, 1995.

Fine, Elsa Honig. *The Afro-American Artist.* New York: Holt, Rinehart and Winston, 1973.

———. *Women and Art: A History of Women Painters and Sculptors from the Renaissance to the Twentieth Century.* Montclair, N.J.: Allanheld and Schram, 1978.

Flomenhaft, Eleanor, ed. *Faith Ringgold: A Twenty-five Year Survey.* Hempstead, N.Y.: Fine Arts Museum of Long Island, 1990.

Fonvielle-Bontemps, Jacqueline. *Forever Free.* Normal: Illinois State University, 1980.

Gouma-Peterson, Thalia. *Faith Ringgold: Painting, Sculpture, Performance.* Wooster, Ohio: College of Wooster Art Museum, 1985.

Heller, Jules, and Nancy Heller, eds. *North American Women of the Twentieth Century: A Biographical Dictionary.* New York: Garland Publishing, 1995.

Hobbs, Jack, and Richard Salome. *The Visual Experience.* Worcester, Mass.: Davis Publications, 1995.

Innis, Doris, and Juliana Wu. *Profiles in Black.* New York: Core Publishing, 1976.

Lippard, Lucy R. *From the Center.* New York: E. P. Dutton, 1976.

———. *Get the Message: A Decade of Art for Social Change.* New York: E. P. Dutton, 1983.

Miller, Lynn, and Sally S. Swenson. *Lives and Works: Talks with Women Artists.* New York: Simon and Schuster, 1981.

Munro, Eleanor. *Originals: American Women Artists.* New York: Simon and Schuster, 1979.

Pierce Rosenberg, Judith. *A Question of Balance: Artists and Writers on Motherhood.* Watsonville, Calif.: Papier-Mache Press, 1995.

Robinson, Charlotte. *The Artist and the Quilt.* New York: Alfred A. Knopf, 1983.

Roth, Moira, Thalia Gouma-Peterson, Alice Walker, and Faith Ringgold. *Change: Painted Story Quilts.* New York: Bernice Steinbaum Gallery, 1987.

Seto, Nobuaki, ed. *Eighty-eight Leaders in the Quilt World Today.* Tokyo: Tadanobu Seto, 1994.

Slatkin, Wendy. *Women Artists in History.* Engelwood Cliffs, N.J.: Prentice-Hall, 1984.

Turner, Robyn Montanta. *Portraits of Women Artists for Children: Faith Ringgold.* Boston: Little, Brown, 1993.

Unseld, Teresa S. *Portfolios African-American Artists.* Palo Alto, Calif.: Dale Seymore Publications, 1994.

Von Blum, Paul. *The Critical Vision: A History of Social and Political Art in the U.S.* Boston: South End Press, 1983.

——. *Other Visions Other Voices.* Lanham, Md: University Press of America, 1994.

Wallace, Michele, ed. *Faith Ringgold: Twenty Years of Painting, Sculpture and Performance (1963–1983).* New York: Studio Museum in Harlem, 1984.

Wallace, Michele, Moira Roth, and Faith Ringgold. *The French Collection, Part I.* New York: Being My Own Woman Press, 1992.

ARTICLES, INTERVIEWS, AND REVIEWS

Aird, Engola G. "Children's Books/Black History." *New York Times Book Review* (February 21, 1993): 22.

Ards, Angela. "Portrait of an Artist as a Black Woman: Faith Ringgold Tells It Like It Was." *QBC: The Black Book Review* 3 (November/December 1995): 14.

Baraka, Amiri. "Faith." *Black American Literature Forum* (Spring 1985): 12.

Bellos, Alexandra. "Dream Weavers." *Riverfront Times* (April 13, 1994).

Berman, Avis. "Women Artists '80: Could a Female Chardin Make a Living Today?" *Art News* (October 1980).

Brooks, Mandy. "The Making of a Quilt." *University Journal: Southern Utah University* (February 8, 1995).

Brown, Doris E. "Artist Molds Proud Heritage into Soft Sculpture." *Home News* (April 2, 1978).

——. "Social Commentary Rings True." *Home News* ( March 4, 1973).

Burkes, Betty. "Creating a Sense of Empowerment." *Cape Cod Times* (August 1993).

Carmalt, Susan. "Students Take Part in Art Performance: Faith Ringgold Exhibits a Celebration of the Black Experience." *Austin American-Statesman* (December 8, 1978).

Chambers Lori. "Renaissance Women." *Rutgers Magazine* (Fall 1993): 15.

Clevert, Leslie Johnson. "Her Art Reflects 'I Am Woman.'" *Milwaukee Journal* (October 23, 1975).

Cohen, Roger. "Black Americans Visit an Indifferent Paris." *International Herald Tribune* (February 8, 1994).

——. "Once Welcomed, Black Artists Return to an Indifferent France." *New York Times* (February 7, 1994).

Cotter, Holland. "Feminist Art, 1982 until Tomorrow Morning and International." *New York Times* (March 17, 1995).

——. "Horace Pippin Captured History with Joy and Acid." *New York Times* (February 3, 1995).

Damsker, Matt. "Performance Art Creates a Tableau." *Los Angeles Times* (February 1984).

Deegan, Carol. "Books to Celebrate February as Black History Month." Associated Press release (January 21, 1994).

Dunlop, Beth. "The Gift of Reading Can Last All Year: No Batteries, No Assembly, Just Hours of Pleasure." Review of *Dinner At Aunt Connie's House* by Faith Ringgold. *Miami Herald* (December 10, 1993).

Dupuy, Marigny. "Come Fly with Me, Books Soar with the Spirit of Black History Month." [New Orleans] *Times Picayune* (January 24, 1993).

Fields, Nancy. "Chit-Chat." *St. Louis Argus* (March 31, 1994).

Freudenheim, Betty. "Faith Ringgold: Branching Out." *Fiberarts: The Magazine of Textiles* (Summer 1994).

——. "A Quiltmaker's Art Tells Stories of Childhood and Family." *New York Times* (December 5, 1993).

Gable, Mona. "Lessons in Reality." *Los Angeles Times* (April 23, 1993).

Glassman, Molly Dunham. "Children's Books Explore History of Black Americans." *Orlando Sentinel* (February 28, 1993).

——. "Now Boarding the Underground Railroad." *Morning Sun* (Febuary 20, 1993).

Glueck, Grace. "An Artist Who Turns Cloth into Social Commentary." *New York Times* (July 29, 1984).

——. "Nude Art in Halls of Justice Stirs a Storm in Bronx." *New York Times* (February 20, 1975).

Graft, Roberta "A Story Teller with a Brush." *Museum Beat* (January 6, 1994): 7.

Gragg, Randy. "Against the Grain." *Sunday Oregonian* (January 10, 1993).

Graulich, Melody, and Mara Witzting. "The Freedom to Say What She Pleases: A Conversation with Faith Ringgold." *NWSA Journal: A Publication of the National Women's Studies Association* 8 (Spring 1994): 1–27.

Guy, Jen, and Christian Bourge. "Ringgold Kicks off Women's History Month." *Florida Flambeau* (March 1, 1995).

Guyer, Niki. "Woman on a Pedestal and Other Everyday Folks." *Fiber Arts* (March 1981).

Hammonds, Evelynn. "Confirmation: An Anthology of African

American Women." *Women's Review of Books* (Summer 1983): 5–6.

Hess, Elizabeth. "The Woman." *Village Voice* (November 8, 1994).

Hicks, Ann. "Artist Faith Ringgold Puts Talents into Inspiring Tale." *Cincinnati Enquirer* (April 14, 1991).

———. "'Railroad' a Ticket to Freedom." *Cincinnati Enquirer* (February 28, 1993).

Hinson, Mark. "Fabricating Stories." *Tallahassee Democrat* (February 26, 1995).

———. "Women's History, Music, Poetry, Art and More Celebrated in March." *Tallahassee Democrat* (Februaury 24, 1995).

Holland, Laura. "Art Gets Active: The Politics of Women Artists." *Valley Advocate* (March 10, 1980).

Howlett, Margaret. "Echoes of Harlem." *Art and Man* (February 1983): 7.

Jackson, Earl. "Call and Response: Faith Ringgold Is One of Our Most Significant Contemporary African-American Visual Artists." *Tri-State Defender* (March 25, 1995).

Jones, Vanessa E. "Artist Unfolds Quilts as Canvas for Tales, Stimulus for Books." *Commercial Appeal* (March 26, 1995).

———. "Author's Just-Sew Stories." *New York Daily News* (October 21, 1993).

Kimmelman, Michael. "Constructing Images of the Black Male." *New York Times* (November 11, 1994).

———. "Hudson Valley, Crop: Portraits and di Survero." *New York Times* (July 14, 1995).

Krasilovsky, A. R. "Feminism in the Arts: An Interim Bibliography." *Artforum* (June 1972): 74.

La Badie, Donald. "Moss Lecture Series to Focus on Art by Ringgold, O'Keeffe." *Fanfare* (October 16, 1994).

Larkin, Kathy. "Mother, Daughter, Artist." *New York Daily News* (November 20, 1983).

Leimbach, Dulcie. "Summer Outings." *New York Times* (June 25, 1993).

Leslie, Tonya. "She Quilts Stories." *Scholastic News* 63 (February 3, 1995): 3.

Liebenson, Bess. "Introspective Works in Cloth Illuminate Raw Family Issues." *New York Times* (October 17, 1993)

Lippard, Lucy R. "A Child's Garden of Horrors." *Village Voice* (June 24, 1981).

———. "Faith Ringgold Flying Her Own Flag." *Ms.* (July 1976): 34–39.

Louie, Elaine. "Using Textiles to Tell Many Stories." *New York Times* (April 1, 1993).

Loupais, Bernard. "Black Art at the Palace of Luxembourg." [Paris] *Observateur* (February 1994).

Love-Graves, Jeri. "Unique Dinner Guests: Faith Ringgold's Magical Surprise." *Quarterly Black Review of Books* (Winter 1993).

Lucas, Bonnie. "USA Today in Fiber Art." *Knipselkrant* (June 29, 1993).

Marcus, Leonard. "The Best Books of 1993." *Parenting* (December 1993).

Marquez, Jeremiah. "Black Women Present Art at Montgomery." *Arts and Entertainment: The Student Life* (February 3, 1995).

Marvel, Bill. "Woman's Place is in the Center." *National Observer* (August 16, 1975).

McEvilly, Thomas. "Dream Singers, Story Tellers." *Artforum* (March 1994).

McKenzie, Gail R. "Mothers and Daughters, Black Style." *Women Artists News* (December 1978).

McWilliams, Martha. "Power Source." *Washington City Paper* (September 10, 1993).

Mellow, James R. " 'Against the Wall': From the Revolution to Watergate." *New York Times* (July 15, 1973)

Miller, Stuart. "It's Heads Up, Commuters: Art Is Going Underground." *New York Newsday* (July 26, 1994).

Moss, Merideth. "Kids' Books on Black History Enrich Us All." *Dayton News* (Febuary 7, 1993).

Myers, K. C. "What to Do: Art Close to the Heart." *Cape Codder* (August 13, 1993).

Olten, Carol. "The Dazzling Colors of Faith Ringgold." *On Air Magazine, KPBS* (July 1995): 5.

Phinney, Molly. "Inside Out and Upside Down." *New Haven Advocate* (October 1993).

Pincus, Robert. "Art of the Stories." *San Diego Union Tribune* (July 20, 1995).

Raymond, Allen "Faith Ringgold: 'It's Like Being a Kid All Over Again!'" *Teaching K-8* (March 1993): 37–38.

Raynor, Vivien. "Bringing Out the Work of So-Called 'Outsiders.'" *New York Times* (November 28, 1993).

———. "'Making Faces,' Fun and Pedagogy at Hudson River Museum." *New York Times* (February 26, 1995).

Rhoades, Jane. "Teaching Art: Quilting as an Art Form." *Teaching K-8* (April 1993): 66–67.

Rickey, Carrie. "Ringgold Keeps Faith: At 65, Artist and Storyteller Has No Thoughts of Retirement." *Beacon Journal* (December 5, 1995).

———. "She's Been Creator and Civil Rights Champion." *Philadelphia Inquirer* (November 14, 1995).

Robinson, Debra A. "Faith Ringgold Arrives: Artists Tells Stories with Her Quilts." *St. Louis American* (March 17, 1994).

Robinson, George. "Paging along Fifth Avenue." *New York Newsday* (September 18, 1992).

Rose, Barbara. "Black Art in America." *Art in America* (September/October 1970): 63.

Rovenger, Judith. "Great Gift Books." Review of *Dinner at Aunt Connie's House* by Faith Ringgold. *Sesame Street Parents* (December 1993).

Rowe, Douglas. "Life's a 'Tar Beach' at Children's Museum Exhibit." *Cedar Rapids Gazette* (August 13 1993).

———. "'Tar Beach' Is Child's Delight." *Star Beacon* (September 1, 1993).

Rule, Sheila. "Museum as Cultural Anchor: The Studio at 25." *New York Times* (November 23, 1993).

Sancone, Maïca. "Noire Amérique." *Beaux Arts* (October 1992): 54–57.

Santiago, Chiori. "Celebrating Faith." *Oakland Tribune* (September 16, 1992).

Saunders, Wade. "Making Art; Making Artists." *Art in America* (January 1993).

Seiberling, Dorothy. "A New Kind of Quilt." *New York Times Magazine* (October 3, 1982): 43.

Siegel, Jeanne. "Philadelphia: in Her Own Focus." *Art in America* (July/August 1974): 99.

Sims, Lowery S. "Black Women Artists." *Artforum* (April 1973): 68.

———. "Third World Women Speak." *Women Artists News* (December 1978).

Singleton, John. "The Black Female Artist: A Self-Portrait in Anger." *New York Daily News* (June 18, 1972).

Slone, Cookie. "Celebrating Black History Month." *Middlesex News* (February 7, 1993).

———. "Children's Gifts That Will Last." Review of *Dinner at Aunt Connie's House* by Faith Ringgold. *Middlesex News* (November 28, 1993).

Smith, Roberta. "The New, Irreverent Approach to Mounting Exhibitions." *New York Times* (January 8, 1995).

Stapen, Nancy. "Inspiring 'Visions' of Women Artists." *Boston Globe* (March 21, 1993).

Stokes, Stephanie. "Faith Ringgold Makes Dolls an Art." *Essence* (July 1979).

Tapley, Mel. "Faith Ringgold and Her Daughters." *Amsterdam News* (February 25, 1978).

———. "Harlem '76 Steals the Show." *Amsterdam News* (December 27, 1975).

Tarlow, Louis. "Faith Ringgold: Rewrite History." *Art: New England* (August/September 1993): 29–32.

Tate, Mae. "Art That (In)forms." *Inland Valley Daily Bulletin* (March 15, 1995).

Taylor, Karen. "Juvenile Gems, and the Little Child Shall Read Them." *Emerge* (June 1993): 56–57.

Thompson, Jim. "Barrow BOE Considering Request to Remove Library Book." *Athens [Ohio] Banner-Herald*, (January 6, 1994).

———. "Board Rejects Book Ban." *Athens [Ohio] Daily News* (February 2, 1994).

Thompson, Sally Ann. "Choice Books for Children: The Pick of Last Year's Publications." *Catholic Library World* (January 1992).

Trescott, Jacqueline. "Black Artists: Role and Responsibility." *Washington Post* (March 12, 1975).

Turner, Robyn Montana. "Portraits of Women Artists." *Kirkus* (August 1, 1993).

Wallace, Michele. "And What Happened…" *Esquire* (May 1976): 80–81.

———. "Black Macho and the Myth of the Superwoman." *Ms.* (January 1979): 45–91.

Ward, Barbara. "Faith Ringgold: The Last Story Quilt." *Audio Visual Review* (February 1993): 47.

Wei, Lilly. "Feminists in the Art World." *Art in America* (February 1995): 35, 37.

West, Charles. "Are Black Artists Prejudiced toward Women?" *Amsterdam News* (January 30, 1971).

Wilde, Susie. "Exploring the African-American Life." *Book Page* (February 1993): 23.

———. "Hope—'You Need a Daily Dose of It,' Children's Author Faith Ringgold Says." *Book Page* (February 1994): 22.

Withers, Josephine. "Faith Ringgold: Art." *Feminist Studies* (Spring 1980): 207–212.

Wolff, Theodore F. "The Creations of Faith Ringgold: From Harlem, with Power and Grace." *Christian Science Monitor* (August 20, 1984): 25.

Wylder Thompson, Viki. "The Politics of Women's Textiles." *Florida State University Museum of Fine Arts* (February 17, 1995).

FILMS AND VIDEOS

*Faith Ringgold.* Black-and-white film, sound, 16mm. 1975. Distributed by Women's Archive, Women's Interarts Center, New York.

*Faith Ringgold.* Color video, sound, 6 min. 1990. Distributed by Random House, New York.

Freeman, Linda (producer). *Faith Ringgold Paints Crown Heights.* Color video, sound, 28 min. 1995. Distributed by Home Visions, L&S Video Enterprises, Chappaqua, New York.

———. *Portrait of an Artist: Faith Ringgold: The Last Story Quilt.* Color video, sound, 28 min. 1991. Distributed by Home Visions, L&S Video Enterprises, Chappaqua, New York.

Holmes, Oakley, Jr. (producer and director). *Black Artists in America, Part III.* Color film, sound, 16mm. 1970.

———. *Black Artists in America, Part IV.* Color film, sound, 16mm. 1974.

Killen, Rosemary (producer). *Tar Beach with Faith Ringgold.* Color video, sound, 15 min. 1994. Distributed by Scholastic, New York.

Leslie, Stanley (producer and director). *Sexual Imagery and Censorship.* Color film, sound, 16mm. 1975. Distributed by Art Documentation, Queens College Library, New York.

*Masks.* Color film, sound, 16mm. 1978.

*No Name Masked Performance #2.* Color film, sound, 16mm. 1983. Distributed by San Antonio College, Texas.

# Contributors

Dan Cameron, senior curator at The New Museum of Contempoary Art, has published over 200 texts on art in various periodicals, including *Artforum, Frieze, Parkett,* and *Flash Art.* He has contributed to numerous museum catalogs for such institutions as the Royal Academy of Art, London; Stedjelik Museum, Amsterdam; Carnegie Museum, Pittsburgh; Center for Contemporay Art, Glasgow; and Berkeley Art Museum, Berkeley. As an independent curator, Cameron has organized large-scale exhibitions of contemporary art at several major venues, including the Aperto at the Biennale di Venezia (1988), "Cocido y Crudo" (Centro Renia Sofia, Madrid, 1994–95), and "Threshold" (Fundacao de Serralves, Oporto, 1995). He attended Syracuse Unviersity and Bennington College, earning a B.A. in 1979.

Ann Gibson is an associate professor and the associate director of publications of the Humanities Institute at the State University of New York at Stony Brook; her most recent book is *Abstract Expressionism: Other Politics* (Yale University Press).

Thalia Gouma-Peterson is a professor of art history and the museum director at the College of Wooster, Wooster, Ohio. Her articles on Byzantine painting and contemporary art have appeared in the *Art Bulletin, College Art Journal*, and *Arts* magazine, among other publications. She has organized exhibitions and written about numerous women artists including Miriam Schapiro, Joyce Kozloff, Michelle Stuart, and Emma Amos. She coauthored, with Patricia Matthews, "The Feminist Critique of Art History" (*Art Bulletin*, September 1987). She is the primary author of *Breaking the Rules: Audrey Flack, A Retrospective 1950–1990* (1992) and served as guest curator for Flack's touring retrospective exhibition organized by the J. B. Speed Art Museum, Louisville, Kentucky.

Patrick Hill, a native of Memphis, Tennessee, is a visual artist and doctoral candidate in the Program in American Culture at the University of Michigan, Ann Arbor. He is currently writing a dissertation on masculinity, modernity, and African American visual culture since World War I.

Richard J. Powell is chairman and associate professor of American art and the arts of the African diaspora in the Department of Art and Art History at Duke University. He earned a B.A. in fine arts at Morehouse College and an M.F.A. in printmaking at Howard University before completing his M.A. in Afro-American studies and Ph.D. in art history at Yale University. He is the author of several books in the field of African diasporal arts including *The Blues Aesthetic: Black Culture and Modernism* (1989), *Homecoming: The Art and Life of William H. Johnson* (1991), and *Black Art and Culture in the 20th Century* (1997). His essays on topics ranging from primitivism to postmodernism have appeared in the *Art Bulletin, International Review of Aftican American Art, New Observations, Transition, American Art, African Arts,* and other publications. Beyond his scholarly focus on black visual arts in the United States, he has conducted art historical research in Denmark, Barbados, and Nigeria, and has lectured widely in the United States, as well as in Europe. In addition, Powell has organized major exhibitions in his fields of expertise for the Studio Museum in Harlem, the Field Museum of Natural History, the National Museum of American Art, the Whitney Museum of American Art, and many other art museums and galleries.

Moira Roth is Trefethen Professor of Art History at Mills College in Oakland, California. She has written extensively on Ringgold and edited *We Flew over the Bridge: Memoirs of Faith Ringgold.* The first of two volumes of her writings, *Difference/Indifference: Musings on Postmodernism, Marcel Duchamp and John Cage, 1971–1997* (with commentary by Jonathan Katz), will be published in the spring of 1998.

Michele Wallace is a professor of English, women's studies, and film studies at the City College of New York and the CUNY Graduate Center. She is the author of *Black Macho and the Myth of the Superwoman* (reissued Verso, 1990), and *Invisibility Blues: From Pop to Theory* (Verso, 1990), and is the daughter of Faith Ringgold.

# Index

design & composition: Seventeenth Street Studios

text type: Stempel Schneidler

display type: ITC Highlander

printing & binding: Friesens